THE ARTS EXPLOSION

THE
ARTS
EXPLOSION

By the Arts Staff of The National Observer

Edited by Clifford A. Ridley

DOW JONES BOOKS
PRINCETON, NEW JERSEY

Contents

CONTENTS

CONTENTS

THE ARTS EXPLOSION

FANFARE

Like the week-to-week arts coverage of the publication in which they first appeared, the articles in this book are dedicated to several propositions:

First, that the arts do matter—that they mirror the world we live in and help create the world we live in. And that therefore they ought to be taken seriously.

Second, that no art is immutable, that even the very idea of what constitutes art is subject to change from generation to generation and even from year to year.

Third, that what was once a relatively orderly pro-

cess of mutation has become a bewildering jumble of esthetics and styles—offensive to some, perplexing to many.

And fourth, that it is the arts writer's function to serve as a buffer between artist and audience—interpreting the one, guiding the other. Particularly between the new artist and the old audience.

In exercising this function, we tend at The National Observer—and thus in this book—to define "the arts" rather broadly. Mostly, this is because many contemporary artists themselves tend to broad definitions—defining "music," for instance, as any sound to which a meaning or feeling can be attached.

But the matter goes deeper than that. If there is a single over-all trend in American culture today, it is that the once-sharp distinction between "serious" art and "popular" art is becoming blurred past all recognition. Only a minority will now argue, for instance, that the best rock music does not constitute a valid art form. Or that our commonest cultural denominator isn't that box in your living room.

So we cover rock, and we cover television, and we happily call them art. We could as easily call them entertainment, or sociology, and in fact we write about them from these points of view as well.

And then the next week we may be writing of Leonard Bernstein's *Mass,* or that fine, nostalgic movie *The Last Picture Show.* And there, of course, is the point, for where would these things be without the underpinnings of rock and television?

Our "beat," then, is all of American culture—a tall assignment to handle in something less than 10,000 words a week. How do we handle it? Basically, by applying a criterion we share with almost all the rest of our colleagues on the paper: Is it news?

There are different kinds of news, of course. A Thing is news—a smashing first novel, perhaps, or a

numbing 20th novel by a writer who knows better. An event is news—a Woodstock, a Sinatra farewell. A trend is news; so is a new face. We try to cover them all.

In so doing, we interpret as we go; there's really no other answer. If you're talking of a way station on a line of evolution, you must perforce deal not only with where you are, but with where you've been and where you're going. If you're talking of a new creation, you must perforce explain the motives of the creator.

In articles that are basically reportorial, we try to leave matters at this point—to find the pieces, fit them together, and let you pass judgment on the result. But when we're dealing with specific creations in essays or reviews, we offer you an opinion. We hope it's an informed opinion, with the reasoning behind it clearly evident, and we emphasize that we only "offer" it. Dogmatism is not our line.

Even among ourselves, in fact, we are known to disagree—sometimes in print. This book contains one such dispute, in which some harsh words about *No, No, Nanette* (by me, as it happens) are followed by our drama critic's enthusiastic review of the show. We're both entitled.

So are you, of course; this is an opportune moment to note that in both reportage and commentary, we hope that you'll use us as a springboard to take off on an investigation of your own. The arts, after all, are not susceptible of objective measurement. We can only provide a subjective yardstick or two; we hope you'll provide another.

A word or two about the selection of the material here, for which I accept full responsibility. First of all, the pieces cover approximately three years, from August 1969 (Woodstock) to the present. Woodstock seemed a handy point of demarkation; in some senses, at least, it changed the arts forever. Basically, though, the date is arbitrary.

The selection is less so. To be useful, it seemed to me, a survey of the arts ought to look not backward but ahead. It ought to address itself to where we are and where we're going, with particular attention to those areas that are most misunderstood. And for the most part it ought to deal not in specifics but in trends, bringing together those artistic developments that reflect a common impulse or esthetic—regardless of their surface dissimilarities.

Thus I have attempted to organize the book not by disciplines—books, movies, and the like—but by commonalities either of beginnings (the *avant-garde*) or ends (the youth revolution, the New Freedoms). I hope the logic behind the sections here is mostly self-evident; but as a hedge, I have appended a brief preface to each.

Because it does deal in trends, the book is unrepresentative of The Observer's weekly arts section in one respect: Although about half of our ongoing coverage is devoted to reviews—of new books, movies, and so on—there is only a scattering of them here. Reviews, after all, tend to be narrow in focus and brief in life; I hope this book is neither of those. Where a review seemed right on target, however, you will find it in these pages.

For the rest, saving only some occasional editing for space and the amending of a small fact or two (yes, we slip up now and then), the articles appear here as they did originally. No second thoughts—in print, anyway.

The book is mostly the work of four writers—Bruce Cook, Bill Marvel, Michael Putney, and myself—who collectively make up The Observer's full-time arts staff based in Washington, D.C. To a degree, the pieces reflect our individual interests and assignments; yet having said that, I should note that none of us is or cares to be a specialist. We trespass on each other's territory

with almost unseemly regularity, and I think we all profit therefrom.

My thanks to the other Observer critics and staff writers who have contributed to the book—in particular to Haskel Frankel and Herbert Kupferberg, our drama and music critics in New York, for their invaluable contributions. Much of their work, too, is grounded in the specific, otherwise they would be far more generously represented in this collection.

Thanks, too, to David Seavey, our staff artist, whose work decorates the book with the same style and felicity with which it regularly decorates our weekly pages. And to the various assorted National Observer editors who over the years have granted their arts department an enviable freedom—doubtless often in the firm conviction that they were abetting sacrilege, lunacy, or both.

Finally, of course, thanks to each and every artist who provided the ideas and experiences that are the real source of this book. We critics may regularly have at them in profound ingratitude, but they sustain all of us in our most parasitic calling.

—CLIFFORD A. RIDLEY
Arts Editor

April 1972

In 1969, as part of an Observer series that attempted to divine the quality of American life in the 1970s, we had ourselves a look at where the arts might be going. The result was the following piece—and even if we were wrong, it's not a bad touchstone for what has happened since.

In fact, however, our projections look pretty good —so far. The piece has dated remarkably little, and none of its broad speculations has proved inaccurate. In some instances, the trends we espied have even arrived so quickly that our forecasts seem a little tame: Imagine, after *Woodstock,* thinking *Monterey Pop* revolutionary!

Indeed, this piece prefigures many of the phenomena that are treated in separate articles later in this book, particularly with respect to the mixing of media and the technological revolution. No great clairvoyance there, of course; lots of people saw those things coming. But it's nice to have been in at the beginning.

We were weakest, perhaps, in the plastic arts, where no sane prognosticator dares to tread. Yet although we foresaw a return to abstract expressionism where "sharp-focus realism" emerged instead, the faddish dictates of the New York galleries may yet prove us right.

After all, we have almost eight years to go.

The Slippery Seventies

WHITHER the activity roughly defined as "the arts"? No simple question, that. The novelist can scarcely tell you what his next book will be, much less speculate on what other writers are up to. The dedicated film director may prefer to take a "personal," $500,000 flier, but the exigencies of financing may persuade him to do a studio's $10,000,000 blockbuster instead. By nature artists are visionary, flexible, quixotic, and not a little secretive. Consider, by way of illustration, three vignettes:

✔ Assembling the program for a coming concert, a member of an experimental-music group fingers a score and suggests, "It would be nice to have a historical piece." Another member demurs: "We have a historical piece already," he says. A listener boggles. The first piece under consideration was written in 1964, the second in 1965.

✔ Pressed to predict the condition of the arts in another decade, medium-and-message man Marshall McLuhan drops a few aphorisms:

"Planet equals theater."

"Satellite equals proscenium arch."

"There will be no more audience, only actors."

Meaning, he says, that "the effect of moonshine on our literature will be considerable." End of interview.

✔ And Bryan Forbes, the distinguished British film director, considers a question for a moment and replies, "If I knew what the cinema would be doing 10 years from now, I sure as hell wouldn't tell you."

It is dangerous, clearly, to attempt to paint the portrait of tomorrow using the palette of today. In the

1960s, much was made in the critical fraternity of so-called Theater of the Absurd, of "black humor," of Pop art, of rock and roll. Yet as a movement, each of these things today is dead or dying. Much from each of them, to be sure, has been incorporated into the movements that followed it. But the man who saw theater of the ab·surd, say, as prefiguring drama for the rest of this century was quite wrong.

Although the specifics of the changes being wrought in the arts are unclear, the broader trends are not. These trends, moreover, are not unlike current disturbances in politics, in education, in religion, in many other areas of contemporary life. Clearly the practitioners of each of these disciplines are dissatisfied with the forms and structures within which they are expected to work—whether the political party, the four-year college, the institutional church . . . or the painting, the symphony, and the novel. And so they are moving away from these forms, creating new forms and new ways of working within them. On this basis, several predictions about the arts in the 1970s can be made with some assurance.

1. The distinctions between what have been considered separate branches of the arts, or separate leaves on the branches, will continue to break down. Just within the past year or so, for instance, the "mixed-media" presentation has emerged from the rock emporium and entered the theater and concert hall. A mixed-media production was a blue-ribbon event at the June opening of Canada's National Arts Centre, with a *haute-monde* audience seated among the actors and bombarded by films, slides, roars, and quavering music from an electric synthesizer; at one point, part of the audience disappeared below the floor. Shows such as *Hair* and *Your Own Thing* have added rear-screen projection and kinetic rhythm to the drama, melody, and dance of tradi-

tional musical comedy—which was itself, in a sense, America's original mixed-media form.

Rock music has become almost a commonplace on movie sound tracks, with *The Graduate* the most conspicuous but far from the most daring example; sometimes, as in the documentary *Monterey Pop,* rock music is the movie, period. Rock, which is itself an amalgam of country-and-Western and rhythm-and-blues, is merging with jazz—and in the hands of groups like the Beatles, whom one critic has called "the great syncretists and mixmasters of our day," with Indian and baroque music as well. "Concerts" of serious music, meanwhile, are likely to involve mime, spoken word, everyday sounds— almost anything but music. "I'd hate to do *two* things with notes," a member of the Fresh Music Group at the University of Maryland said at that planning session noted earlier, not at all facetiously.

If these developments seem to elevate sensation at the expense of language, other signs indicate that words are making a kind of comeback as well. Poetry, for instance, had little place in the naturalistic theater of the early 1960s, being regarded largely as "literary." Today, says George C. White, founder and director of the Eugene O'Neill Memorial Theater Foundation in Connecticut, "playwrights are interested in language just as O'Neill was. John Guare, Edward Albee . . . you need classically trained actors to perform their stuff. Or Sam Shepard: His work may be kooky, far out, sometimes unintelligible, but boy, it's all words. Poetry, if you will." Poets such as Robert Lowell, Mr. White points out, are now writing for the stage, and playwrights are writing poetry on the side.

The lyrics of rock songs, too, are sometimes considered poetry and marketed as such; the work of rock balladeer Rod McKuen, for instance, has sold extraordinarily well in hardcover editions. Even some nonfiction

writing, including journalism, has acquired a new, respectable image. "I think we'll see the line between fiction and nonfiction become less and less important," prophesies Eliot Fremont-Smith, editor in chief for trade books at Little, Brown and Co., to The National Observer's Bruce Cook. "More fiction is being published that falls somewhere between the two, and I think we will see a good deal of the personal journalism that has already come into books and magazines. On the other hand, I wouldn't be surprised to see the genre novel drop out altogether; or, at least, certain kinds of mysteries and so forth will just go into the movies."

The plastic arts, too, will likely continue to push against the edges of what has been considered their limitations. Paintings with canvases "shaped" to suggest sculpture were a development of the 1960s, as was sculpture that moved and made noise. Stage settings became less pure decoration, more artistic elements existing in their own right. Such hard-won freedoms are not likely to be sacrificed, although their specific uses may change with time.

2. The "importance" of the various arts, as determined by both critics and public, will undergo some marked shifts—rock music and movies upward; "serious" music, theater, and possibly literature downward. "I don't think theater in the future will be the central art form of society," black playwright Douglas Turner Ward suggested to staff writer Marion Simon, citing the artistic potential of movies and television. "But that doesn't diminish its importance in addressing itself to a significant minority."

Aaron Asher, director of general books for Holt, Rinehart and Winston, strikes much the same note in his own discipline. "What we see going out now," he says, "are the kinds of fiction—light fiction, adventure, that sort of thing—that television and movies can do

better. What book publishers must recognize is that they have a large elite audience to serve, but not a mass audience. The number of book readers is not going up and up and up with no ceiling in sight; it may not increase at the exact rate that the population does. McLuhan may be right about the visual media pulling some portion of the potential audience away. But certainly the absolute number will continue to increase."

Theater and literature, of course, are in no danger of extinction. "Serious" music, on the other hand, may well be—at least in a contemporary context. In his book *Serious Music—and All That Jazz!*, critic Henry Pleasants describes his alienation from serious music, which he still feels, this way:

"It was during [the] postwar period that I began to have misgivings about the validity of the new music, and of the new serial music particularly. It gave me no pleasure, no sense of any salutary esthetic reward. Nor did it seem to give pleasure to anyone else. . . . What makes a music contemporary . . . is acceptance by a considerable audience, documenting the musician's communicative success and his mastery of a musical vernacular. . . . The serious composer, good or bad, was not finding acceptance even with his own serious music public."

The situation is no different today. Said August Hecksher, administrator of cultural affairs for New York City, in a speech last year to the National Music Council: "At the time we had expected to gather in a vast new audience, we find the audiences perplexed by the contemporary composers and ready to fill the hall only when the museum pieces of opera and symphony are wheeled out."

But rock, in Henry Pleasants' phrase, has become "a musical revolution of imposing dimensions and implications. The new younger generation, both black and

white, is making its own music on its own terms—not just on the musician's terms, but on terms valid for the entire generation." There is no sign of the revolution's abating, for "the new younger generation" is increasing in numbers daily. There is little general agreement, however, on what form it will take. Forecasts critic Richard Goldstein, editor of the new youth magazine Us: "Rock probably will join the other popular arts and become part of the general culture of repression. The Top-40 stuff will be simplistic and reassuring, trying to get people to forget reality. In 'underground' music, I think you'll get a return to root forms, a sort of new classic approach to rock."

Clearly whatever lies ahead for both rock and films will be determined by the unpredictable tastes of youth. The accessibility, the relative cheapness, and the directness of these art forms make them particularly attractive to the under-30 generation. "Movies are the art form most like man's imagination," says film director Francis Ford Coppola (*The Rain People*), himself barely 30, to which the under-30s would probably add, "And rock is the form most like his soul."

3. In content, the arts generally will become more personal, warmer, perhaps more polemical—although there is disagreement over that last. "The real changes in the novel," says Seymour Lawrence, who publishes books under his personal imprint through Delacorte Press, "are coming in the treatment of time and continuity and in the increasingly personal style being used by the authors who appeal most to younger readers—Kurt Vonnegut, J. P. Donleavy, Robert Coover, for instance."

Contributes John Schlesinger, the Britisher who directed such films as *Darling* and *Midnight Cowboy*: "There are directors who make films because they're asked to make them, and there are directors who make

films because they have a particular thing they want to do, and the majority of films still are made by people who are asked to do them. It's not so easy to go into some companies and say, 'Look, I've got a great idea; will you do it?' But they are doing it more, because they're finding that the old theories don't quite work. There is a growing audience for something that deals more truthfully with life."

Most such films, he agrees, will be "small" in budget and scope. "There aren't many 'big' personal films. I think Stanley Kubrick made a big personal epic with *2001,* the most extraordinary film of the [1960s], and it was very important for the entire industry that he commercially succeed: He proved that you can invest millions with a personal vision, the most personal epic that I can remember seeing. But it's the only film of that sort of scale or cost that has turned out personally."

To a large extent, the "personalization" of the arts will likely go hand in hand with a fragmentation or decentralization of the large institutions that control much of the country's artistic output—Broadway, the movie studios, the record companies, and so on. Not without pains, however. "Broadway is shrinking," agrees playwright Robert E. Lee, who collaborated with Jerome Lawrence on such hits as *Auntie Mame* and *Inherit the Wind,* "but across the country, there's such chaos!"

There's little doubt, however, that regional theaters will continue to grow in importance, often producing significant plays that have not been done on Broadway —and perhaps sending them to Broadway later, as with *The Great White Hope* (first produced in Washington, D.C.), *In the Matter of J. Robert Oppenheimer* (Los Angeles), and *We Bombed in New Haven* (New Haven). Like most similar institutions, regional theaters are in financial trouble, with ticket revenues seldom meeting

production costs. "But the buildings are there," says the O'Neill Foundation's Mr. White. "The townspeople have a stake in them. They won't let them stay idle."

Ellen Stewart, founder of the La Mama Experimental Theater in New York's Greenwich Village, puts in a plug for her own bailiwick: "Growth is going to be in all theaters, each one contributing to the other. Off-Off-Broadway is going to force the others to grow despite themselves."

In Hollywood, the major studios are in major trouble. "Ten years from now," forecasts one movie maker, "there won't be a major studio." The studios' decline is a direct result of the trend toward more personal cinema: They have insisted on continued production of high-cost, often unsuccessful pictures while the youthful moviegoing audience has preferred smaller films with something to say, frequently made by independent producers.

Something of a demurrer to this trend, however, is offered by Charles Koppelman, of the independent record-producing team of Koppelman and Rubin: "In the music business, I think we'll see a trend away from independent production as such. After all, the major labels have learned from their mistakes. They are hiring their own young people to go out and get the talent, and of course, they've got more resources."

The plastic artists are less in need of "institutions" to expose their work; the relationship of the individual artist to the small gallery seems secure. Yet here, too, the trend toward personalization seems clear. After a decade of dry, formal, "cool" art—everything from soup cans to optical dazzlers to geometrical shapes and contrasting bands of "hard-edge" color—the signs now point to a return to loose, expressive forms. Dripping and pouring paint, the abstract-expressionist techniques of the 1950s, are back in vogue, along with much

more free and subjective conceptions. Robert Morris, the sculptor, recently put it this way in an article that is widely quoted by younger artists:

"Certain art is now using as its beginning and as its means, stuff, substance in many states—from chunks to particles, to slime to whatever—and prethought images are neither necessary nor possible. Alongside this approach is a chance, contingency, indeterminacy—in short, the entire area of process. Ends and means are brought together."

Most people in the arts, but not quite all, predict that the new artistic "personalization" will encompass a growing concern with social and political matters. "We shouldn't take one step," says *avant-garde* composer John Cage, "which doesn't in some way help to change the world." Asks a member of the Fresh Music Group: "Do sound programs (not "concerts") have any right to exist if they don't have any social comment?"

Publisher Asher forecasts that "we will continue to see books of dissent, books that raise issues. Why, books were being written on the issues in Vietnam years before the other media began to become even moderately critical." Agrees Mr. Fremont-Smith of Little, Brown: "The light once-overs on a subject simply will no longer do." Playwright Lee sees "a whole new crop of exciting young playwrights coming up," and adds: "They're good because they care. You have to be passionate to be good."

4. The traditional relationship between performer and audience will continue to break down; the audience will be asked to assume an increasingly large role in the "creation," in a sense, of a work of art. "The conventions are changing," says Francis Ford Coppola. "You don't have to resolve a film any more, for instance." Adds John Schlesinger: "A great deal less specific needs to be said. You can say something much

more pertinent and personal and an audience will get it; you don't need to explain everything you're doing as much as you used to. We're dispensing with all sorts of old-fashioned means of story telling, or character telling, or explanation. It's partly due to the fact that people are so used to turning on a TV program and sort of tuning in quickly."

This kind of audience involvement, however, is minor compared with what is happening in the theater and the plastic arts. In theater, experimental troupes such as the Living Theatre and the Performance Group (*Dionysus in 69*) wander the aisles and actually invite audience participation in their dramas, to the point of suggesting the audience shed its clothes. "The best of what the experimentalists are doing," says Mr. White of the O'Neill Foundation, "will feed into the mainstream. The only thing that bothers me is when these people insist 'This is it.'" Bridging the gap between theater and art, the Happening likely will continue to attract a certain number of practitioners, though the new-style happening is less "programed," more informal, than the original conception; it is more often called a "street event" or "street work" than a "happening."

It is just a step from the "happening" to the "environment" and its allied forms, which is where the real audience-involvement action will be in the new decade. The "environment" is just that—an area the size of a room, or bigger, to which the spectator is supposed to relate in some emotional or metaphysical way—sometimes predetermined, sometimes random. Iain Baxter, for instance, a Vancouver artist who bills himself as The N.E. Thing Co., recently took over almost the entire first floor of the staid National Gallery of Canada for a "company" environment complete with freezers, dresses, and so on, in which the visitor could create his own "art" on a Xerox machine or by stamping a piece of

paper with the legend "Aesthetically Claimed Thing."

Other artists are going further, creating with the help of modern technology—surely a force to be reckoned with in any prognosis of art in the 1970s—works that change color, shape, or sound as the viewer manipulates them or sometimes just approaches within range. In schools such as the Massachusetts Institute of Technology and through organizations spearheaded by Experiments in Art and Technology, Inc., artists are joining with scientists to utilize new discoveries in creating artistic pieces. Under the auspices of the Los Angeles County Museum of Art, for instance, artists Robert Irwin and James Turrell are working with the Garrett Corp. on the design of a "chamber" that would alter the perception of whoever enters it. "We wanted to work not so much with a company that builds things," says Mr. Turrell, "but with one that deals with states of consciousness."

Technology doubtless will revolutionize the dissemination of several art forms before the decade is over. The widespread distribution of dramas and other materials in videotape, to be played at one's convenience at home on a more or less conventional TV set, is close to reality, with both publishers and TV companies mining the possibilities. Computer firms are working on means by which books could be fed into central computers, then "purchased" by anyone with access to a computer keyboard by simply dialing the computer and asking for the text.

Francis Ford Coppola waxes eloquent on the possibilities of mass dissemination of movies. "Movies will be an integral part of life in 10 years," he predicts ebulliently, "comprising all kinds of information and entertainment. You'll be able to buy a $2 film in the drugstore, just as you buy a paperback book today, take it home, shove it in a slot, and see it on the wall."

Yes, art in the home will surely flourish, and so will art in the street. To create the mass audience needed for the arts to grow, more and more theatrical troupes, singers, instrumentalists, and painters have been transporting themselves and their art into the parks and ghettos of the major cities. New York's experience, outlined by August Hecksher, is not atypical:

"We have had," he said, "a program of artists in the neighboring parks and playgrounds . . . which permitted the community to determine what it wanted to do —paint a mural, construct a giant sculpture, write poetry, compose music, make a film—and then do it with sensitive and affectionate professional help. . . . We are experimenting with a festival truck. This provides for the neighborhood the raw material of booths and stages and gates and grandstands, letting the people themselves work out the substance of the performance.

"A city alive with this kind of spontaneous artistic endeavor," he concluded, "will not have to worry in the future about audiences restricted to a narrow class, about music or painting representing only the private doubts of their creator."

Two final contemporary trends deserve consideration—one of them very difficult to prophesy about, the other very easy.

The tough one is the present abundance of nudity and eroticism in the theater and the movies. What is probably the prevailing view is expressed best by George C. White: "I see no going backward unless, which seems impossible, the courts completely reverse themselves. It's like the day after Prohibition right now, however. Everyone went out and got stinking drunk, but eventually they settled down. You can only watch nudity for so long and then you begin to cry for content. In the new decade, you'll see a lot less nudity, and it will be used for dramatic effect rather than sensationalism. The

movies are 'way ahead of the theater here; they've already started using nudity in meaningful ways."

Finally, the easy prophecy: The art of the black American will grow hugely as an autonomous force—largely, of course, because with the exception of rock music it has almost no place to go but up. The notable artistry of Gordon Parks' autobiographical feature *The Learning Tree* will likely stimulate financial backing for more films by Negroes. Museums and galleries showing the art of the black man, such as the Studio Museum in Harlem, will surely become more common. And the black theater, which already has a splendid start in the Negro Ensemble Company of New York, should almost explode in activity.

Douglas Turned Ward, cofounder of the Negro Ensemble Company, says: "All things being equal, probably one of the most interesting developments of the 1970s will be the rise of black playwrights far out of proportion to their percentage in the population. With the intensity of their energy, they're right now more interesting than any other playwrights around. I would hope that the white theater would attempt being as relevant in its own development as the black theater is attempting to be."

Which is a good note to end on, for "relevance" is a subject dear to the heart of almost every artist around. It means, however, quite different things to quite different people: introspective little dramas or angry big ones, cajoling the spectator or snubbing him, using language as a mind-expander or a bludgeon. It is safe to predict the arts in the 1970s will be "relevant," and it should be fun to stick around and find out how.

—CLIFFORD A. RIDLEY

September 1969

Nothing is more vital to an informed coverage of the arts than keeping a trained eye on the pathways of the *avant-garde*. It's a job that we take seriously. Well, *pretty* seriously.

Which is to say there's a tenuous balance involved here, for on the face of it, much avant-garde experimentation looks pretty nutty. When we've dug deeper, we've sometimes concluded that it isn't nutty at all. And we've sometimes concluded that it's even nuttier than it looks.

The only way to find out is to meet each story and each trend on its own terms, with a genuine curiosity about what the artist is trying to do. That's no job for the arm's-length reporter; it's a face-to-face undertaking. To discover what underground TV is all about, Michael Putney spent a week in Greenwich Village squinting at little sets. To really experience experimental theater, Bill Marvel leaped smack into the middle of an audience-participation drama. To determine why someone would want to drape a four-ton curtain across a Colorado chasm, Bruce Cook went out and asked—and also asked Coloradans what they thought about it.

In this cross-section of the Very New in art, books, theater, and TV, our writers don't end up endorsing everything they see. Sometimes they find themselves with unanswered questions, and they pass them on to you. In other words, they weigh the evidence—which means they've done a lot of work to gather the evidence in the first place.

Occasionally it's short-lived. After Bruce Cook wrote of the plans for that Colorado curtain, the thing got halfway up before gale-force winds blew it down. The spirit behind it, however, survived—and that's what really interests us.

Art That Isn't There

L AST year the Institute of Contemporary Art in Boston received the following letter from artist Saul Ostrow:

> *Dear Sir:*
>
> *I wish to donate this work to the permanent collection of the Institute of Contemporary Art in the name of Frank Lincoln Viner.*

Institute officials were unable to find the work Mr. Ostrow was donating, so they dropped the matter. Shortly afterward a second letter arrived from the artist. "Due to the fact that as yet I have not heard from you concerning my donation, I must assume it has been rejected and would appreciate the return of my piece."

The letter came to the attention of the institute's director, Andrew Hede, who wrote Mr. Ostrow: "I was unaware that you had offered the institute a donation. I would be willing to hear about the particulars!"

The particulars came by return mail. "Enclosed," wrote Mr. Ostrow, "you will find a photostat of the work in question. Since the original was either lost or never delivered, this photostat is now to be considered as the work I wish to donate."

Enclosed was a photostat of Mr. Ostrow's first letter.

At this point Mr. Hede might have suspected he was the victim of a put-on. Not so. Mr. Ostrow was being very serious—in a sly sort of way. His donation was an example of a new kind of art, conceptual art.

This wacky exchange of letters is preserved in a scrapbook that the artist has contributed to *Conceptual Art and Conceptual Aspects,* a comprehensive exhibit of

the new art at the New York Cultural Center. Visitors to the exhibit seem as puzzled as Andrew Hede, and the puzzlement is bound to spread. Recent shows of conceptual art—also called software art, post-object art, and, incorrectly, neo-Dada—have been held in Washington, Seattle, and Chicago, and more exhibits are planned.

It's easier to explain what conceptual art is *not* than to explain what it is. It is not painting or sculpture. It is not art objects at all in any conventional sense. Although exhibits of conceptual art may include tape recorders, photos, scrapbooks, telegrams, and sheet after sheet of dense, long-winded prose, none of these is a work of art itself, but merely evidence that the works of art exist.

Like the emperor's new clothes, conceptual art exists in the mind of the beholder—the artist who creates them and the viewer who takes the time to study their documentation. Thus a work of conceptual art may not be known in its totality by any one person. Frederick Barthelme's *Being,* for example, invites viewers to contemplate the mental and physical conditions represented by the words hungry, eating, and sated. Since any number of persons might encounter Mr. Barthelme's work in the New York show, each with his own ideas, memories, and personality, the work is potentially unlimited.

Being, like most of Mr. Barthelme's work, is presented by means of a mimeographed form, but this is purely arbitrary. It could as well be whispered into visitors' ears by exhibit guards, or boomed over the public-address system. The physical medium is a necessary evil at best, argues sculptor Jack Burnham. "Conceptual art's ideal medium is telepathy," he says.

One of the purists of conceptual art, Joseph Kosuth, communicates his works by means of gummed labels stuck to gallery walls. When Washington's new

Protetch-Rivkin Gallery held an exhibit of conceptual art not long ago, Mr. Kosuth contributed a series of labels bearing declarative sentences such as "Logicians who eat pork chops are not likely to lose money." The propositions are pure nonsense, having nothing to do with logicians or pork chops in the real world. Neither do they add up to anything. They form, rather, a self-contained system not unlike a series of propositions in geometry. This demonstrates Mr. Kosuth's contention that art is a closed system, referring only to itself.

He traces conceptual art back to Marcel Duchamp's first *Readymade* sculptures—household items, such as bottle racks, purchased off the shelf and exhibited as art. Before Duchamp modern artists had drastically changed the language of painting and sculpture, replacing impressionism and expressionism with cubism. Duchamp scrapped the language altogether and concentrated on what was being said.

He believed that an original artist was distinguished not by his fidelity to "nature," nor by his facility with a brush, but by the quality of his ideas. A fanatical chess player as well as an artist, Duchamp said the artist's work consists in making a series of important choices; the finished work exists as a record of those choices. Every choice an artist makes becomes significant. If he chooses to buy and exhibit a bottle rack, that object becomes a work of art.

Inevitably someone has taken Duchamp at his word. If every choice the artist makes is an artistic act, then the choice not to make a work of art must be an artistic act too. Sure enough, in both the Washington and New York shows Frederick Barthelme has exhibited a series of mimeographed forms that begin "Instead of making art today I . . ." Mr. Barthelme has completed the sentence by typing, ". . . filled out this form."

Art, according to sculptor Donald Judd, is whatever

the artist chooses to call art. By bringing the viewer into the equation, Joseph Kosuth goes a step further. One of his first conceptual works was *One Of Three Chairs*, a wooden folding chair flanked by a photograph of the same chair and a photostat of the dictionary definition of the word chair. The chair raises some of the same questions as does Duchamp's *Readymades*: Does a chair in an art exhibit cease to be a chair when it becomes a piece of sculpture? Mr. Kosuth complicates matters by encouraging visitors to sit in his chair, suggesting that what is a work of art one moment becomes something else at another.

Art, then, is a matter of function, and function, here, is a matter of point of view. A Jackson Pollock painting dropped into the middle of a civilization that had never heard of painting might be taken for something quite different from a work of art.

Tantalizing as such questions are for the philosopher, they do not make for very interesting art exhibits. Fortunately, however, not all conceptual art is so grim. Although none of them is beautiful, beauty being a visual attribute of physical objects, after all, many of the best conceptual works have a kind of elegance and wit about them that offsets their emotional austerity.

A clear example of wit at work is Christine Kozlov's *Tape Recorder (Erasure)* in the New York show. The recorder continuously records every sound in the gallery on an endless loop of tape. Then, as the tape completes its circuit, it erases the sound without ever playing it back. Of course, there is no proof the machine is actually recording the sound, Miss Kozlov points out, only the artist's word.

Then there is On Kawara, an artist's artist who has just about turned his life into a work of art. He has checked into both the Washington and the New York shows by means of sporadic telegrams posted on the

wall, reassuring everybody that "I am still alive." Mr. Kawara constantly bombards his friends, mostly other artists, with post cards from everywhere, stamped with the exact time he awoke the day the card was sent.

What is one to make of all this? Even if a conceptual art masterpiece were to arrive, it's hard to imagine what it might be like. Opening-night visitors to the New York Cultural Center show glanced at the exhibits, shook their heads, then sidled up to the champagne table for a refill. Joseph Kosuth has no illusions. "One of my pieces," he says, "is not to be considered equivalent to one Vermeer painting. If my work exists at all, it exists in influencing other artists."

Mr. Kosuth, who is one of the movement's theoreticians, compares what is happening in art to logical positivism, that branch of philosophy invented by Ludwig Wittgenstein. Logical positivists converted philosophy from a system of metaphysical speculation on such matters as the existence of God into a hard-nosed tool for the analysis of philosophical propositions themselves.

Logical positivism arrived at a time when it seemed that science had taken over all the legitimate functions of philosophy, leaving nothing behind but dreamy speculation. Conceptual art likewise arrives at a time of crisis, when many artists believe that the traditional forms of painting and sculpture have been used up. Putting it bluntly, they say there is nothing left to paint or sculpt unless an artist wants to mince variations of the old forms in new materials.

Perhaps, perhaps not. Art has a way of springing to life just when it seems to have been drained. In the meantime, conceptualism gives everyone concerned a chance to do some deep thinking about the nature of that human activity we call art.

—BILL MARVEL

July 1970

FOEW & OMBWHNW
& Other Titles

SOMETHING Else Press lives up to its name. While other publishers rush to board the sexio-eco-astrological bandwagon, Something Else goes its own kinky way with titles like:

✔ *FOEW & OMBWHNW*, which looks like a prayer book but which contains essays, poems, an abstract drama, and scenarios for happenings arranged in four parallel columns that can be read horizontally or vertically according to the reader's mood.

✔ *An Anecdoted Topography of Chance*, an inventory of the items on poet Daniel Spoerri's breakfast table one morning, explaining how they got there and the images and associations they suggest.

✔ *I Was Telling Marianne*, a collection of memories and observations by Robert Filliou, printed on 96 cards that can be reshuffled and reread.

✔ *The Big Book*, literally poet-painter Allison Knowles' magnum opus. The single copy of the book was eight feet tall and had a working telephone installed in its pages before it was worn out by visitors who came to see it at the Jewish Museum in New York City.

It may not sound like it, but Something Else Press will not publish just anything. Its modest inventory of titles includes works by Gertrude Stein, composer John Cage, Claes Oldenburg, Allan Kaprow, inventor of the happening, and dozens of other artists on the fringes of the *avant-garde*. Dick Higgins, the Press' president and founder, likes to think of such works as experimental

books, or, as the jacket of one proclaims, "[explorations of] the ways and means of communicating."

The press is really nothing more than Mr. Higgins, who lives in a onetime farm house near Newhall, Calif., and conducts his end of the business in the garage; his editor-in-chief, poet Emmett Williams, living down in Los Angeles; and a New York sales office, operated jointly with four other small publishers. Printing of its 9 or 10 yearly publications is contracted out.

Mr. Higgins, who also wrote *FOEW & OMBWHNW,* is a little bit of something else himself. The son of a former Communist Party organizer, he spent much of his childhood being dandled on the knees of Weimar Republic intellectuals who visited his family first in England and later in Worcester, Mass. He grew up wanting to be a composer and studied under John Cage for a time before branching out into theater. In 1958 he was one of a small group of artists who, under painter Allan Kaprow, put on the first of those strange quasitheatrical events called happenings.

Later Mr. Higgins created his own happenings, and by 1963 he wanted to gather the scenarios of some into a book. The few publishers who would handle this sort of material seemed too slow or too expensive. Since Mr. Higgins had been working for a book manufacturer, he decided to do it himself.

"I designed the thing, did all the paste-ups, turned it over to a printer, and took an ad in the Village Voice," he says. Only 1,000 copies of the book, *Jefferson's Birthday-Postface,* were printed; the last was sold just a year ago. But the work began Something Else Press.

Future art historians will probably pore over those first Something Else pamphlets and books with the eagerness of Biblical scholars examining Dead Sea scrolls. The Press caught art at a nexus, a point of rapid and crucial change.

Claes Oldenburg, for instance, a participant in early happenings, filled an empty New York shop with found objects, scraps of paper, and papier-mache copies of consumer goods; then he threw it open to the public as a combination happening and art gallery called *The Store*. His drawings and notes and photographs of the event are reproduced in a Something Else book called *Store Days*.

In another direction, a number of poets connected with the so-called Fluxus movement in art were experimenting with concrete poetry. To concrete poets, the physical setting of a poem—whether it is to be recited before an audience or printed upon a poster—is as important as the poem's sound and meaning; they play with a poem's typography and even its printed shape. Something Else introduced this kind of poetry to the United States, and its *Anthology of Concrete Poetry,* edited by Emmett Williams, remains the Press' best seller at 15,000 copies.

Something Else has also explored earlier manifestations of the avant-garde. Mr. Higgins hopes, for instance, to publish all the works of Gertrude Stein, the best-known of all least-read modern novelists. The Press has published Henry Cowell's *New Musical Resources,* an oddly prophetic 1930 work predicting many of the latest innovations in music. Reaching even further back, to 1873, Mr. Higgins has reprinted *Dick's 100 Amusements,* a manual of Nineteenth Century parlor games, which he considers "prehappenings."

From John Cage to the editor of that book of parlor games, all of Something Else's artist-authors have been committed to that which leaves room for improvisation and chance. In John Cage's *Notations,* which shows some of the ways contemporary composers have written scores of their music, statements by the composers were treated as a kind of score, with Mr. Cage selecting at

random the number of words to be quoted from each. In Merce Cunningham's *Changes: Notes on Choreography,* pages from the choreographer's notebook are overlaid with printed commentary that skews off the page, slides around the margin, and generally behaves as wilfully as one of Mr. Cunningham's dancers.

Such books are works of "chance art" in themselves. While some critics suggest that the electronic media have made print obsolete, Mr. Higgins argues that the book is just coming into its own. "Print and the book format were invented before their time," he says. In the hands of Something Else Press, the time has apparently arrived.

—BILL MARVEL

January 1971

That Ham Actor Is You

A FEW minutes before, a dozen of us had been partic-
ipating in a sophisticated form of "let's pretend,"
marching in a circle clapping our hands and shouting
while an actress writhed in feigned agony on the floor.
She was Cassandra and we were the Greeks trying,
under the direction of a second actress, to drive her
mad.

Then the play had become something else. Cassan-
dra's hysteria had suddenly seemed very real, and two
girls from the
audience had
helped her out of
the circle. They
were now kneel-
ing on the floor,
talking to her
softly. Her face
was red and
puffy, and tears
were running
down her cheeks.
Those of us who
had taken part
in the persecu-
tion suddenly

felt very small and conspicuous. I remember edging out
of the circle and back toward the audience.

It had all started as an evening of experimental
theater called *Little Trips,* the first production of a new
company operating in a onetime warehouse in New
York's SoHo (south of Houston Street) area. The Vil-

lage Voice had called *Little Trips* "one of the most adventurous, dangerous attempts at audience involvement you're likely to see." That was endorsement enough for me, since I had come to New York looking for experimental works that might signal the direction of theater in the 1970s.

Seventy Grand Street: Common Ground is the barest sort of theater. There is a cramped waiting room, really no more than a hallway, where we all sat around after our $1 donation had been collected by a young man whose brown hair was swept back into a tiny ponytail. Most of us were young, in our 20s and 30s, our dress modishly casual. A middle-aged gent wore a suit with white shirt and tie. Pretty soon a door opened, and a young woman in leotards invited us into a large room, about half the size of a basketball court, empty except for wooden railings enclosing a circular area in the middle of the polished floor. In the middle of the circle crouched another young girl, also in leotards, her head touching the floor and her arms straight back along her sides.

When we had taken our places behind the barricades, the first girl explained that this was a play about Cassandra, the Trojan woman who foretold the war with Greece but was not believed by her countrymen. After killing all the other Trojans, the Greeks had carried Cassandra back to Greece, where she was eventually murdered. The actress on the floor would be Cassandra. We, the audience, would be the Greeks. During the evening we would try to drive Cassandra mad by progression, performing the same sequence of actions over and over, each time making them more intense. "Please participate," she said. "The more that you give us, the more we can give to you."

She demonstrated: She circled Cassandra, clapping and shouting Cassandra's name. She motioned for us to

join in. Tentatively the clapping began. Cassandra stirred.

The leader explained how Cassandra caught the eye of Apollo, god of the sun, who gave her the power to prophesy. But she rejected him and in retaliation he cursed her so that nobody would believe her prophecies. The leader grasped Cassandra's jaw and spit into her mouth.

The story continued with the actresses enacting how Cassandra killed her baby, how she warned the Trojans against the wooden horse and the slaughter that followed, how Ajax raped her, and finally how she was taken back to Greece. At this point the actress who was playing Cassandra broke away from the leader and threw herself down in the center of the ring.

The leader motioned to us: "Won't you join me?" I joined the circle of fellow former spectators in the arena.

In these situations one soon gets over self-consciousness. There is the desire to be a "good sport." There is the comfort of the group: At least we are making fools out of ourselves together. And there is the fascination of the work itself taking over one's responses. What is going to happen next?

So we found ourselves shouting at Cassandra, taunting her with the story of her baby's death. We huddled together in the belly of an imaginary Trojan horse as Cassandra screamed her warning. The rape scene? Push-ups on the floor. At last we took hold of Cassandra's arms to lead her to Greece; she tore herself away and threw herself down. Before we realized it, the leader had us again marching in a circle and shouting; the second round had begun.

Progression. This time we shouted louder. We walked faster. The nonparticipating audience behind the barricades was almost forgotten, and our actions

took on a life of their own. So did Cassandra's. I noticed, as she was writhing on the floor, that she was digging her fingernails into the back of her neck, leaving deep red scars. Some of them, left over from previous performances, had scabbed up. We re-enacted the death scene of her baby as sweat poured from her face and her eyes rolled.

The action was picking up an alarming momentum, and I found myself wondering for the first time how long this could go on. Then I thought, if this goes on another round, I don't want to be part of it. It is part of the plan of *Little Trips,* however, that there is no time to pause, no time to consider one's acts, to behave on anything but impulse. On impulse, two of the participants had dropped out. The rest of us had burst out of the horse and were running around spearing imaginary Trojans. Cassandra was a quivering lump on the floor.

Unexpectedly, the two girls who had dropped out reappeared and pulled Cassandra from the circle. The action stopped abruptly. She seemed to be sobbing. The guide walked over and quietly said to one of the girls, "Please don't interfere."

"I didn't think this was supposed to be so structured," one girl said.

"I'm trying to create an evening of theater," the guide explained. "I'm trying to show people what's inside them." She held her clenched fists against her stomach as if to show people what's inside them.

Cassandra spoke for the first time: "I'm sorry, Lauren. I don't feel it tonight."

There was an awkward pause. Then our guide, Lauren, said nervously, "Look Fran, we've got all these people here."

Fran, or Cassandra, was still leaning on the two girls, looking very frightened. "Please, Lauren. I can't go on with it."

Lauren flopped down on the floor. "Then I'll be Cassandra," she announced. She motioned for us to resume the clapping, but it was halfhearted. She looked back at Fran impatiently. "Will you lead?"

Cassandra shook her head.

Of course, I wondered if the two girls who had pulled Cassandra out of the circle might not also have been actresses and whether the whole thing had been rigged. But that left the whole evening hanging in the air, unresolved. Meanwhile Lauren got up, dusting herself off. "I'm sorry, you might as well go home," she said to the audience. A few started to drift away. Then, to Fran: "Look at you. You're so freaked out tonight you don't know where you are." She strode to a window sill, where there was a package of cigarets, and furiously lit one.

"Would anyone come join us?" Fran asked softly. Nobody moved, perhaps now wary of being taken in. I wondered again: Were we being manipulated? But something impelled me to step into the circle again. This time there was only a handful of us, including Cassandra and her two rescuers.

"Can we just put our heads together?" Fran asked. We put our heads together. "Will you catch me if I fall?" She slumped this way and that while we supported her. For 20 minutes the five of us stood together, holding hands, supporting Fran, listening to ourselves breathe.

Finally she asked, "How do you feel?" We agreed that we felt curiously peaceful. We talked for a while, then broke up to go our separate ways. Most of the audience had left.

The questions start to pile up about an hour afterwards, after one has "come down" from this extraordinary experience. Questions about the work itself: Is it art? Can it even be called theater? And more questions

about one's own motives for doing what one has done.

Had I really believed that a trained, competent actress could become unstrung during a performance? Did I know I was being maneuvered into making a choice? What was the point in joining the little group at the end? There had come a critical point in the evening when the question of my participation was poised in a delicate balance. Then suddenly I saw it didn't make any difference. The cycle of shouting, clapping, "raping" could not have continued much further in the direction it was headed. Some of us, God forbid, were beginning to feel hostility, for it is amazing how far one will go if one is told something is just a game. The two girls offered a way out. If we could fake hostility, we could fake tenderness too. The choice was as much esthetic as it was moral: The evening had to be resolved, the cycle broken.

Needless to say, this kind of theater can work only once or twice for an individual before he is wise to it. But it does work. Despite its ferocity towards its victim, Cassandra, and its audience, *Little Trips* is really a very humane kind of theater. It allows the members of its audience to work out their own resolution, even salvation.

I asked *Little Trips'* artistic director, Norm Taffel, how often the play ends this way. "Every time," he said, pointing out that Cassandra and the guide are the only two actresses involved. It is really a three-act play, he pointed out. The first act involves the persecution of Cassandra. The second act begins when the audience interferes or when Cassandra herself has had enough.

As weird a piece as it must seem to audiences used to conventional theater, *Little Trips* is only the latest point reached by experimental theater along one of its several lines of development.

Ten years ago, the Living Theater first sent its ac-

tors swarming across the footlights to confront the audience in its seats, to shout at it, to drag it into the play —in short, to destroy the detachment fostered by conventional proscenium-arch stagecraft. But it was merely following in the footsteps of other art forms—happenings, chance music, concrete poetry—in which life was increasingly being allowed to intrude upon art. In a recent article in Art News, happening creator Allan Kaprow states the case for this line of development succinctly: Art, in its traditional relationship to the viewer, is unable to compete with modern life. That is, what does theater have to offer audiences who can turn on the tube and watch a moonshot—or a murder—live and in color?

One answer, then, is to create new relationships between art and audience. And that is what *Little Trips* has done, by placing the creation of the piece in the hands of the audience. Part group therapy, part happening, it is theater in the process of becoming something else, or perhaps theater in the throes of destroying itself.

If it is not a work of art, then it is very like a work of art. Like traditional theater, it depends on an illusion to probe the nature of reality. The crisis between Cassandra and her tormentors is staged. But it reveals something, and the depth of the revelation depends upon the extent of your participation. ("The more that you give us, the more we can give to you.") Taking part, you see how capable you are of blindly following a leader into a situation beyond your control. You learn, once you are in, how hard it is to get out gracefully. When the time comes to choose sides, you see how your motives are never unmixed.

The afternoon before attending *Little Trips*, I was walking along Broadway when I saw an old gent in a wheelchair in the street, waiting beside the curb. I won-

dered as I walked by if he needed somebody to lift his chair onto the sidewalk. I recalled the incident after *Little Trips* and thought how stupid it was to show kindness to an actress who only pretended to need my help, yet to walk by a man who really did need it.

Two of the acts of *Little Trips* are played out in the theater. The third, as Norm Taffel says, "is played out in the audience's head, or life."

—BILL MARVEL

March 1971

The World's a TV Documentary

REMEMBER how you once learned that all the world's a stage and we're merely players on it acting out our appointed roles in a larger drama?

Well, forget it. And while you're at it, forget all that print-oriented, sequential, linear, binary-mode mentality. Instead, try running this through your Sony AV series half-inch Videocorder and see how many video freaks tune in:

The whole world's a TV documentary and you're either on camera or behind one, either the observer or observed, and the best way to see yourself as others see you, the best way to get an accurate fix on reality without the sham and shuck of art, is on video tape. Once you've got that straight, the rest is relatively easy.

Easier, anyway, if you've read the enigmatic, prophetic "probes" of Marshall McLuhan. Or if you're familiar with Harvard linguist Benjamin Whorf's *Language, Thought, and Reality*. Or if you've made your way through 28-year-old Gene Youngblood's brilliant *Expanded Cinema*.

Paradoxically, none of those communications theorists' well-wrought aphorisms or even the pronouncements of the video-tape makers themselves helped very much at "the first comprehensive showing of experimental and nonbroadcast tapes in New York," as Video Festival co-producer Michael Temmer put it. And here's why:

An arpeggio gets your attention. You swing around from the bank of seven TV monitors flickering away along one wall of the Merce Cunningham studio in the West Village and, Shazam, there's Eric Emerson in his

wet-look chaps—just his wet-look chaps—breaking into *Lonesome Cowboys* in a nice, down-home baritone.

But hold on. Wasn't that Eric Emerson you were watching just a minute ago on four of those seven TV screens? And wasn't he singing *Lonesome Cowboys* for John Lennon and Yoko Ono and Andy Warhol down at the Cafe La Mama? As a matter of fact it was, a realization that plucks the string of your space-time continuum and simultaneously sets up a sympathetic wah-wah effect reverberating around in your skull.

The wah-wah effect intensifies as Eric launches into *Darktown Strutters Ball,* replete with spectacular balletic leaps and splits, followed by a plaintive version of *Till There Was You* from *The Music Man.* But again, you've just been watching Eric perform these same songs on video tape, can even swing back around and watch him on that bank of TV monitors because Lora Long from Space Video Arts is rocketing around the studio with Sony Video cameras trailing coaxial umbilical cords, handing them out to the members of the audience. And now they're taping Eric performing the same songs he performed on video tape at the Cafe La Mama, right?

The distinctions by now are beginning to break down between where the video-tape performance began and where the live one ended (if it has), and which is the extension of which? And so from wah-wah to *deja vu* to *presque vu* and back again while the beleaguered synapses in your brain are beginning to crackle and smoke and the Overload sign starts flashing in your head. Heraclitus be damned, you can step into the same river twice.

Which is another way of saying that the tribe from Space Video Arts, which staged this "Video Circus," has succeeded in its objective: a sense of dislocation that forces you to consider the world and all your empirical

evidence of it anew, forces you to reappraise television as a medium capable of much more than the tepid morality plays the commercial networks serve up in neat half-hour and hour packages.

"What we're doing here tonight is really sort of showing the layman how we can use video," explains Maurice McClelland, executive director of something called the Space for Innovative Development, which shelled out the $35,000 for Space Video Arts' cameras and tape decks and continues to sustain them. "We're trying to show the different uses of video, particularly to show video as process rather than as a sophisticated, finished project."

There are perhaps two dozen individual video freaks and video tribes (including the Videofreex) in and around New York who are hard into exploring video as process nowadays and couldn't care less about the sophistication. Mostly made up of people in their 20s, their attitude toward television—that is, watching *Laugh-In* on your 21-inch Motorola down in the den—is understandably ambivalent.

Laugh-In and *Green Acres* or whatever no longer do for them what *Howdy Doody* or the *Cisco Kid* or whatever did when they were children: entertain, inform, and make experiences available to them that were otherwise inaccessible. They changed but television didn't, and now they're out to set aright what they see as television's wrongs with their aim-and-shoot $1,500 Sony Videorover units. Commercial television, it might be added, views all this with about the same degree of guarded interest that the American Medical Association musters up for acupuncture—it's intriguing but suspect. Public broadcasters, however, have aired some underground tapes, as have a few adventurous cable TV operators.

Video as process goes something like this: Since

overground TV (the networks) underloads your sensory apparatus, dulling it and allowing it to atrophy, then underground TV—they call it "video"—can put you in touch with reality only by overloading your sensory apparatus and hoping that some small part of the bombardment gets through. Too, video eschews television's tendency to show you something and then tell you what you saw in favor of showing you everything and letting you decide for yourself. Ironically, in this way video most emulates television at its uncharacteristic best—in its coverage of moon flights, political assassinations, and some athletic events. In other words, real-time coverage of real people taking part in real events.

Declares tape maker Douglas White, "The major impact of half-inch video tape as a communications medium is that it gives us the capability, with a minimum of technological hassle, of presenting reality." You'll note there's no mention of art, which most video freaks distrust as being more interested in making metaphors than in rendering things as they are.

"We're in direct contact with the human condition (through video)," writes Gene Youngblood in *Expanded Cinema*. "There's no longer any need to represent it through art."

And sure enough, there was precious little art to be seen at the Video Festival, nor was there even a minimum level of technical expertise: Images were often shaky and out of focus, sound was generally muddy or downright incomprehensible, and people in the tapes made their entrances and exits with nary a word of identification.

"Most of these video people are technically very unsophisticated," allowed coproducer Michael Temmer. "Most of the complaints we've had from the audience has been about the poor quality of the sound, but it's a lot more than that. What a lot of video people need to do is sit down with a television engineer who's been at

his trade for about 20 years. But I don't know that they could talk to each other."

More than the lack of technical expertise, however, it was the paucity of imagination in subject matter that turned the Video Festival into a long, self-indulgent, and finally cloying home movie. Most tape makers apparently have not progressed past the point of simply turning on their cameras and pointing them at themselves and their friends. The result is a galloping case of what Mr. McLuhan has diagnosed as "Narcissus narcosis." The underground tape maker, McLuhan explains, is so infatuated by his own image on the screen that, his protestations about capturing reality notwithstanding, he never really moves beyond looking at that image of himself mirrored in the TV screen.

It is a problem that some video people recognize, among them Space Video Arts' Lora Long. "Yeh, a lot of what's going on now in video is pretty boring," she says. "You know, people just running around pointing cameras at each other."

Tape maker Richard Rubenstein is an example. An engaging, intense New Yorker in his mid-20s who sports a Zapata-style mustache and wears the usual blue denims, Mr. Rubenstein concedes that "my tapes are subjective off the wall. But I think commercial television only makes a pretense of being objective; for the most part they're just as subjective as I am."

Not quite, judging from the five tapes Mr. Rubenstein showed at the festival. Shot in Spain among his American expatriate friends, they were technically superior to many of the other tapes exhibited but only mildly interesting at best and sleep-inducing at their worst.

"There's no gestation period for tape like there is in film," Mr. Rubenstein says when asked why he prefers to use video to film. "You don't have to send it to the lab and then wait around for a couple of days or weeks to

get it back and see what you got." Moreover, he points out, the new generation of video equipment costs several thousand dollars less than 16-mm. film does, nor is it as cumbersome.

But it was left to tape maker and photographer Cy Griffin to demonstrate how that new generation of equipment can be used to its fullest. His *Peyote Ceremony* was unquestionably many cuts above the self-serving, inchoate offerings of his peers—and, ironically, it was better *because* it was artful and sophisticated. Still, it avoided the glossy patina of commercial television. By turns angry, sentimental, serious, and funny, *Peyote Ceremony* is a fascinating tape of the ritualistic, night-long vigil held by members of the Native American Church, the church that uses peyote as its principal sacrament. On this tape, the vigil was held in a hogan on a Sioux reservation in South Dakota and led by church prophet Leonard Crowdog.

But *Peyote Ceremony* was also something more— an acerbic, affecting history of the white man's duplicity against the Indians told through juxtaposing images from two carousel-slide projectors on a huge screen hung directly behind and above the seven TV monitors, and by a carefully synchronized sound track filled with keening Indian songs and chanting. And as the stunning, full-face slides of Indian men, women, and children were projected on the screen they became the archetypal embodiments of all the Indian men, women, and children seen on tape on the seven, smaller screens below.

"Leonard Crowdog is the heaviest dude in the whole Western Hemisphere," declared David Silver in an epilog to *Peyote Ceremony*. A video visionary of sorts who accompanied Mr. Griffin to South Dakota, Mr. Silver extolled the virtues of peyote for a while, then got off the best line of the festival: "Leonard Crowdog says

the great question of our time is whether to push the button or eat it."

Pushed or eaten, such stuff is surely the most fitting subject for video—intense, personal experience rendered with absolute clarity and without gratuitous comment. Given the amount of lightweight, portable video equipment humming away now and in years to come, some video freak is bound to tape that climactic moment. Then it will take someone else to explain that encapsulating experience does not necessarily illuminate it.

—MICHAEL PUTNEY

August 1971

Curtains for Rifle Gap

L EWIS and Clark sought the Northwest Passage. Orville and Wilbur wondered what would happen if they attached a motor to a great big kite. And Samuel F. B. Morse demonstrated to one and all just what it was that God had wrought.

And now Christo will hang his curtain.

That's the way to think about him. Sure, you've probably read that some crazy artist from Bulgaria with

only one name wants to hang a 250,000-square-foot curtain between a couple of mountains up in Rifle, Colorado. You may even have remembered that this is the same Christo who last year "wrapped" umpteen thousand feet of the Australian coastline. And you may very well have dismissed it all as a publicity stunt.

If so, you're wrong. For Christo is not only on the level, he is a rather modest young man—anything but a

publicity hound—and his plan to suspend an orange veil over State Highway 325, across the span they call Rifle Gap, shapes up as one of those Great American Dreams in the Edison-Morse-Bell-Wright Brothers tradition. The chief difference being that where those bold dreamers aimed at practical results, Christo seeks an esthetic one.

What's that? You're skeptical? Let me persuade you.

For one thing, they take Christo seriously in Rifle. Mosey on down to Mac's Cafe and ask them what they think about the curtain and you'll wait all night for somebody to smirk.

"I don't know," says one hard-bitten cowpoke sitting at the bar. "It seems all right to me. If that fella wants to put it up and is willing to pay to have it done, I guess that's his business." A tough look, and: "Wouldn't you say so, mister?"

A waitress volunteers that "it just might improve the look of the place."

And over at the Rifle Inn, there's a little model of the curtain hung on the mountain mural that covers one wall; it is stretched on a string between two painted peaks, and the man behind the bar assures you that's just how it's going to look when it's finished.

Don't start snickering there, either, because the Morrison-Knudson Co. construction crew that is erecting the curtain puts up at the hotel upstairs, and a lot of the boys take their evening beer in the bar. And they don't take kindly to all those limp-wristed jokes about them being exterior decorators.

Perhaps more important, Christo's Valley Curtain project has the local business community behind it completely. In Rifle, where the Rockies descend to meet the Colorado desert, the area is long on scenery but short on employment. The stark, arid countryside has a

beauty all its own, but it supports only limited ranching. And although the community is sitting on some very rich shale-oil deposits, as yet nobody has made any serious attempts to tap them. The Union Carbide plant outside town is about the only industrial facility of any size in the area, and right now it's not working to capacity.

So, like the rest of the country, Rifle, Colo., has been having its economic troubles. And since things weren't going so well even before the current recession, they are now going a good deal worse than the across-the-nation average.

That is why, when the word got out that Colorado's Gov. John Love didn't think much of Christo's curtain and was moving very slowly on the permit to erect it, local businessmen got to the governor himself on a conference call and told him, in effect, "Listen, we're an economically depressed area out here, and this curtain would bring in money. Therefore we're for it, and you should be, too."

Shortly after that the permit came through. Just how much the construction of the curtain has stimulated the local economy so far is any banker's guess, but when it is completed and hanging it is expected to bring tourists, the merely curious, and even a few art lovers from around the west just to look. That is why Christo, project director Jan van der Marck, and others involved in the planning and execution have the construction crew going 10 hours a day and six days a week.

Just how much "construction" is involved in hanging a curtain, anyway? I mean, you just string it on a rope and let it hang, right?

Wrong.

To do the job right—and remember, the curtain is to be hung above a state highway along which cars will continue to pass day and night—it has to be built along

the lines of a suspension bridge. That is why Christo went to a New York firm of consulting engineers, Lev Zetlin Associates, well known for their work in bridge design, and asked how it could best be done safely and effectively.

The detailed plans that the Zetlin firm worked out from Christo's initial conception and early drawings called for the curtain to be suspended by four thick main cables and an additional pickup cable; there will also be a bottom cable to hold it down. To support all this, seven anchors have been planted in a line across the gap. Seen from ground level they seem substantial enough, each showing a four-foot top plate protruding from the soil, yet they give no real hint of what lies beneath. For the anchors spread down and out and hook into the ground; each of them is weighted down with 70 tons of reinforced concrete, all of it underground. Lateral reinforcement is to be provided by two even more huge 200-ton reinforced concrete block anchors mounted against the sandstone mountain ridges and fastened to them by 59 stressed steel rods that go 40 feet into the sandstone.

All *this* to hold up a curtain? Well, this particular curtain, which was manufactured by J. P. Stevens and Co. out of industrial nylon polyamide, will weigh 8,000 pounds. When raised, it will cover heights varying from 360 to 195 feet between points 1,250 feet apart.

With all this, it may not surprise you to learn that the cost of the entire project will be something on the order of $360,000. That, anyhow, is the amount that its 36 sponsors have come up with. It may surprise you to learn, however, that inasmuch as he was able, Christo has financed it himself. To every donor of $10,000, Christo has pledged $14,300 of his own work: Museums and private donors, for instance, will receive works of his to that amount (admittedly, he will fix his own

prices, but he is, after all, a recognized artist, and his work has a certain negotiable value); a German publisher, for another example, will produce a book on the Valley Curtain project, and Christo will not claim his usual fee.

The reason why he had to do this is clear to Christo. As he points out, "Think about it. No bank in America accepts to finance art. Any other human activity, but not art. It's necessary to have proof you will make money with the money they give you so you can reimburse the bank. But who knows? One day we may have a bank that will help us advance art."

This was the first of a number of disappointments suffered by the project. Another came when they found little interest among American donors, museums, and foundations in the project. True, some did join in—for example, the Frumkin Gallery and Houston's Museum of Fine Arts—but most of the sponsors were found in Europe.

Jan van der Marck, who is the former director of Chicago's Museum of Modern Art, was baffled by the lack of response. He was sure, he said, that the project would appeal to Americans—the idea of an artist working with the environment is exciting enough in itself, but for it to be done in the American West seems especially right. "But maybe," he says, "the myth of the old West is stronger in Europe today than it is in America."

This is offered in a discussion of project pitfalls and setbacks as we sip our early morning coffee before the drive out to Rifle Gap.

Mr. van der Marck cites the trouble with the permit and points out, "A man could get a permit and complete co-operation from banks, highway department, and anyone else if he were going to build a house for himself for the same amount of money. But because this looks

useless to them they become suspicious and ask what our angle is.

"Actually, this is not a useless construction job. First of all, it will bring money into the town, but beyond that it gives people something to think about around here—shakes them up a little, rearranges their preconceptions."

Coffee finished, we stamp out into the dusty court. Christo glances up toward the sun, already bright in the early morning sky, and comments, "It will be so hot again today. The workers do not love that."

He will be riding with me. Jan van der Marck will be following in the project's slightly dilapidated Volvo. I'm glad for the chance to talk with Christo. He has a very open and pleasant way that encourages questioning. Certainly not a poseur, he is simply an enthusiastic young artist who has developed a fondness for working on a colossal scale. He built an "iron curtain" of oil drums across a Paris street, wrapped an entire museum in cloth, and then went on to cover acres of Australia.

How did he come to work on such a large scale? He explains that it probably relates to his early training as an artist in Bulgaria: "A Socialist nation, you see, and the whole conception of art was on the grand scale—as propaganda to inspire workers in the *Kolkhoz* [collective farm] and the factory. In the early 1950s when I was 17 to 19 years old I would be sent perhaps to an electric plant to get up enthusiasm with a display. We try to put up a project in 10 hours. And we find usually the bigger we work the better they like it."

And although he left Eastern Europe as a refugee in 1956 during the Hungarian Revolution, he has retained the conviction that art is essentially propaganda, if not political in intention then invariably social—something to be shared among people.

Christo has also taken with him a deep-seated dis-

like of bureaucrats. "Everywhere it is the same," he says, "in the East, in the West. It makes no difference. In Paris the officials think up the same objections and petty interpretations as in Bulgaria. Here out west in Colorado, though, it is maybe a little better. The people in the town of Rifle I like very much. They are more direct, not complicated."

We had been talking steadily through the 5 or 10 minutes that it took us to drive out from town to the project site. As we rounded a bend, however, Christo broke off and pointed ahead to a point about a mile in the distance. "There," he said, "that is the gap. That is where the curtain will hang."

It was an impressive view. The sculptured effect of the sandstone mountains reminded me of other huge monuments—the Mt. Rushmore presidents, the Christ of the Andes, and the Crazy Horse memorial that Korczak Ziolkowski is blasting from a mountain up in South Dakota.

In a way, Christo's curtain compares with these, for he is an artist working directly on the environment. The surrounding mountains are more than mere setting for the curtain—which, after all, will be just a curtain. No, the mountains themselves are part of the total work.

Halting at the construction site near a stand of heavy equipment, we get out and do a long inspection tour with the din of jackhammers in our ears. Somewhere along the way, I observe to Jan van der Marck, who has joined us, that the curtain will fit here better than one might have supposed.

"Yes," he agrees. "The environmentalists have said to us, 'Why beautify an area that is already beautiful?' They would think it better if Christo hung his curtain over a garbage dump. But naturally the artist wants to work with a beautiful environment."

As things stand now, the curtain will be taken

Saggy Nudes, Giant Heads

COLORFUL paintings of hot rods and motorcycles, huge blow-ups of the human face and figure in which every pore is accounted for, sculpted nudes that look more like specimens of taxidermy than works of art, jars of jelly and boxes of bon-bons spread across yards of canvas. Call it what you will, and there are dozens of names to choose from—superrealism, radical realism, sharp-focus realism, post-pop figuration—the galleries are full of it this season.

This is the sort of art that visitors to the big international *Documenta* exhibit in Germany this summer are likely to see. But what makes it officially certifiable as The Trend right now is a small but important show at the Sidney Janis Gallery in New York, *Sharp-focus Realism*. It is the same kind of mini-survey with which the same gallery helped put Pop on the map back in 1962.

As the title of the Janis show indicates, the new realism has something to do with photography. Most of the new realists work from photos; some of them intend their work to be mistaken for photographs at first glance. Which is not so new after all: Eakins and Courbet, to use but two examples of old realists, also worked from photographs, and Nineteenth Century *trompe l'oeil* painters often included a fake photo in their compositions. Other realists work and think differently; in fact, there is a broad spectrum of realist painters at work these days, ranging from the very traditional to the very *avant-garde*. At times it's impossible to pinpoint just where a particular artist belongs.

The extremes are easy. Chuck Close begins with

photos to create enormous full-face portraits of his friends. Using an airbrush, he transfers "information" from the photo to canvas section-by-section—starting with the eyes, which are sharply in focus, and moving to the ears and shoulders, which are almost shapeless blurs.

Until recently he worked in black and white, using no more than a couple of tablespoons of paint to cover a canvas. Now color has returned to his work, but in a typically roundabout way. Mr. Close has the photographer make color separation prints in red, yellow, and blue, just as they would be made for color reproduction in a book or magazine. Then he copies them, color by color, onto the canvas.

Two or three of these giants brooding over a gallery can be overpowering. First, of course, there is the shock of encountering a face almost nine feet tall. Usually we take in a face at a single glance; here we are forced to look at a nose, then a mouth, then finally at those sharp, piercing eyes. Too, by "freezing" a moment of perception with the aid of the camera, Mr. Close can then reproduce the out-of-focus area at the periphery of one's vision—the blurry ears, for instance—so that it can be looked at directly. Until the invention of photography, this kind of direct gaze was impossible.

Philip Pearlstein, at the other end of the spectrum, works from live models and paints with a brush, creating large nudes whose realism consists mainly in their defiant plainness—plain in the sense of homely. Bellies and breasts sag; hands and feet are too large; knuckles seem swollen. Yet these angular bodies are noble and beautiful in the same old-fashioned way that a house painted by Edward Hopper is noble and beautiful, even though the porch may sag.

Mr. Pearlstein is really a studio painter of monumental nudes, yet he is regularly included with the new

realists. Why? One answer may be his odd way of cropping a figure—cutting off the top of the head, perhaps, or an arm or tip of the foot. This mimics the arbitrary way in which the camera will crop a scene; Mr. Pearstein once worked for Life magazine cropping photographs.

Somewhere in the vast area between Mr. Close and Mr. Pearlstein, positions are taken by dozens of other artists. Some paint with brushes, as God intended; others use the airbrush. Some work from photographs; some paint from life. It's like ecology, with each possibility along the sliding scale of permutations and combinations being occupied by a slightly different organism.

Malcolm Morley, for example, is slightly different from Ralph Goings, no matter how superficially alike their work ends up. Mr. Morley was one of the first realists; as early as the mid-'60s he was marking off post cards into tiny grids and, working upside down, laboriously transferring those grids, square by square, to canvas. He even went so far, in *U.S. Marine at Valley Forge* (taken from a Marine Corps publicity photo), to reproduce the slightly off-register effect of the original color picture.

Close inspection reveals that Mr. Morley's paintings are composed of little daubs of color, essentially abstract; it's almost incidental that they add up to an image. The smallest area in a Ralph Goings work, on the other hand, still looks like something: In *Rose Bowl Parade*, for example, the crowd is made up of literally hundreds of tiny but distinguishable faces. Mr. Goings works from finely detailed color photographs, not crude printed material. He does not grid his source or his canvas, and he obviously pays attention to the content of his picture as he goes along.

Don Eddy uses an airbrush to build up large paint-

ings of automobiles, usually seen behind showroom windows or parked in long rows on dealers' lots. Reflections play over their polished surfaces so that large portions of the paintings almost become abstract exercises in color and form.

To a painter like Don Eddy or Chuck Close, surface is everything. That is, the surface of the picture, where the paint meets the canvas, should disappear, leaving the image to hover in air. But other of the new realists are more "painterly," a word originally used to describe the slash-and-drip school of abstract expressionism. Philip Pearlstein, who once painted in the abstract-expressionist manner, is not at all fastidious about letting his brush strokes show. Malcolm Morley recently has thickened his paint so that his latest works are no longer paintings of pictures but simply paintings. Richard Estes, who paints things almost everybody else wishes would go away—diners, Las Vegas casinos, store display windows—has developed a flair for bravura brush work that reminds one of Hals.

But to see oil paint gorgeously handled, look at the works of Janet Fish. Miss Fish paints bottles and jars. Perhaps you've never looked at a bottle before—I mean really looked. It's clear Miss Fish has, though, long and lovingly.

Miss Fish chooses jars full of jam, honey, or even Windex or some other clear substance that stains light as it pours through. The glint of the jar tops, the printed labels, and the reflections and refractions in the glass itself are recorded with the self-assurance of a Flemish master of still-lifes.

There is a hedonist strain running through much of the new realism, as though painters have rediscovered physical beauty. The same care that Miss Fish lavishes on a bottle of olive oil is spent by a David Parrish or a Tom Blackwell on the welter of chromed and pol-

ished parts in a motorcycle or hot rod. And Claudio Bravo, a young Chilean artist now living in Spain, transforms such ordinary items as light bulbs, tin cans, eggs, and pebbles—and that extraordinary item, the human figure—into objects of almost eerie beauty; a drawing of six small stones is aptly titled *Zen Meditation.*

To the degree that pop artists opened everyone's eyes to the possibilities in banal subject matter, the new realism is a descendant of pop. Certainly the few new realists who make it their aim to copy photographs owe some slight debt to Andy Warhol. As for the rest of the painters, their exact lineage is hard to trace.

But for the two major new-realist sculptors the progenitor is obvious. It was George Segal, who began making plaster casts of real persons—although the resulting works remained rough and sculptural. Duane Hanson and John de Andrea have merely taken the next step: By casting their models in plaster and then making polyester figures from the mold, both have produced figures that are absolutely realistic down to the merest wart and mole. Mr. De Andrea's explicit nudes and Mr. Hanson's tired *Businessman,* slumping in his scarred swivel chair at the Janis exhibit, have more than once given visitors a start.

After 30 years of abstract art, much of it startling in one way or another, it's good to be alarmed by something that looks like a human figure again.

—BILL MARVEL

January 1972

One way or another, the ingathering at Woodstock changed all our lives. "You are not alone," it announced to millions of Americans under 25, and your reaction to that no doubt depended on your own age and your views on the desirability of a nationwide community of the young. But, no longer could anyone deny that the sense of such a community was in the air.

Subsequent events suggested, however, that it was more a sense than an actuality. And it's heartening to discover in Bruce Cook's original Woodstock report that even then, he correctly saw the week end as something less than the "revolution" it was being proclaimed from all quarters.

This section pinpoints some of the landmarks in the youthquake that Woodstock began. One year and a host of failed Woodstocks later, we returned there to inquire what had gone wrong in the interim. Two months later, we sadly wrote of another indication that all was not well in the rock explosion: the sudden death of blues queen Janis Joplin. And shortly after that, Michael Putney discovered during a sad, dirty week in Louisiana that the festival trip had become a real bummer.

To date, however, rock has shown a remarkable ability to bend with the mood of its youthful adherents, and so by early 1971 the raucous blues of Janis Joplin had given way to the freaky theology of *Jesus Christ, Superstar*. We reviewed this still-current phenomenon first as a recording, then as a Broadway play; both reviews are here. And we wind up this section with an affectionate look at B. B. King, one of the great American originals whose music started it all.

It All Began at Woodstock

IT LOOKED like a battlefield.

Not blood and shell, mind you, but all their attendant miseries seemed to be spread out before me as I stood on a hill surveying the devastation of the Woodstock Music and Art Fair in Bethel, N.Y. There were rain-soaked tents in garbage-strewn encampments. Between them were great patches of mud and pools of water, through which the campers slipped and sloshed on their way to answer calls of nature at temporary toilets. Behind me, a little higher on the hill, the kids stood in long lines at the food tents where already—this was just the second day of the three-day "Aquarian Exposition"—supplies were running low.

And there to the left along the road from Highway 17-B flowed a stream of newcomers, many of them mud-spattered and dressed in what looked like hand-me-downs. They carried packs and bedrolls on their backs and, occasionally, children in their arms. They looked like war-weary refugees.

There must have been 250,000 of them then. Before the weekend was out, that number would grow to an estimated 400,000. There have been other music festivals —the Newport Jazz Festival began as early as 1954; 45,000 young people attended the Monterey, Calif., Pop Festival in 1967; and 130,000 showed up earlier this year at the Atlantic City, N.J., Pop Festival. But none of these approached the size of the host that gathered for what is becoming the newest fixture in the style of life of Young America. Its program was conventionally ad-

vertised, of course, but by word of mouth the Woodstock event advertised itself through the young people's grapevine; kids planned for weeks in advance to come. And when it was over, despite the travail, they looked back on it, reminisced about it, with a mystic emotion.

They had come from all over the Eastern United States for what promised to be the biggest week end of rock music ever put together. ("Why did I come?" said Lee Deckelnick of Oakhurst, N.J. "I saw a program that said I could see 28 top groups for $18. That's why.") Janis Joplin; Jefferson Airplane; Canned Heat; Iron Butterfly; Blood, Sweat and Tears; and Indian sitar virtuoso Ravi Shankar were just a few of the attractions that brought them in.

But was it really rock music alone that drew this army of young people to the Woodstock festival? Remember, there were 400,000 of them—this made an upstate New York cow pasture the third-largest city (smaller than New York itself and Buffalo, larger than Rochester) in the state for three days. And that was how the kids thought of it too. Their city. "The only free city in the country," they were calling it. The week-end population was nearly equal to the number of U.S. troops serving in Vietnam; the kids were also aware of that. The affair had been advertised as "three days of peace and music." The accent was on peace. But the appearance of the place was warlike.

This martial impression had grown steadily through the morning, beginning with my first encounter with Max Yasgur, the Catskill dairy farmer on whose 600-acre farm the Woodstock event was being held. Stepping inside his office, I found the air charged with a sort of battle urgency. "Listen," he was rasping into the phone, "I need that skid tank of gas for the ambulances. I want you to meet me with a truck at the

command post." Pause. "I don't care about that. Even if we have to put a hook on it and haul it over with a helicopter, I want that gas." Mr. Yasgur hung up abruptly and turned his red-rimmed eyes to me. He rubbed impatiently at his unshaven cheeks as I explained why I wanted to speak with him, cutting me short in a moment with a wave of his hand. "Maybe later," he said, "I'm sorry to be short with you but I haven't been to bed since Tuesday. That's how busy we are."

Outside I cornered one of Mr. Yasgur's staff who was working closely with the Woodstock people, and I asked him if perhaps something had gone wrong in the planning for the fair. "No," he said, "not unless you call having six to eight times the number you expected show up for it. Water's short. Toilet facilities are overtaxed. The ambulances are having a hard time getting through and are running low on gas. And the 'copters can't fly in the rain. Anything else?"

Leaving the Yasgur office, I joined the long line of marchers moving toward the site of the week-end rock-music festival. Cars were parked tight for miles on either side of Highway 17-B, and inside them sexless tangles of kids still slept, wet and exhausted from the night before. All along the edge of the highway, and far out into the open fields, tents were pitched; you could hear music from some—an alto saxophone running the scale in one, an acoustic guitar thrumming away in another, and innumerable portable radios filling the air with the heavy sound of hard rock.

We marched. The New York state troopers were keeping open a single middle lane through which passed ambulances, official cars, and trucks loaded with supplies. But in two lines on either side of the road went boys and girls, young men and women of every sort, from hard hippies to clean-jim types, from full beards, long hair, and body shirts to crew cuts and college wind-

breakers. They were a strangely silent bunch. Whether too weary from the trek to the music, which for some had begun 10 miles back, or too miserable from the rain, the kids bound for the Woodstock Fair were a silent, almost solemn bunch.

The Woodstock Music and Art Fair had been heavily promoted in the press, above- and underground, and on rock stations up and down the East Coast. Fair producers were thrown into a temporary tizzy earlier when plans to hold the event at Wallkill, N.Y., were overturned by the local Town Council. And although the Bethel, N.Y., authorities had granted a permit for the Woodstock Fair to be held at Max Yasgur's farm, there was plenty of local opposition to it, which took the shape of a boycott of the dairyman's products.

Nevertheless, preparations moved ahead once the farm site was picked. The producers brought a crew three weeks before the opening, and its members worked around the clock building a 100-foot stage at the bottom of a natural bowl of some 80 acres in a pasture adjoining White Lake. By the time the appointed date rolled around, they were ready for an anticipated crowd of 50,000.

Far more than that number had shown up by the hour the fair was to begin. And so many more were on their way that main routes to Bethel were backed up bumper-to-bumper for miles. Halfway to New York City in that vast traffic jam was Sweetwater, the group that was to begin the program. Somehow word was communicated to the fair producers, and the group was airlifted in, instruments and all, by one of the fleet of helicopters that serviced the event. Arriving spectacularly, Sweetwater started the proceedings an hour late.

The night was still young and the program barely under way when the rain began. It came down steadily during Ravi Shankar's recital, and by the time young

Arlo Guthrie had begun his set, it was pelting the crowd. The wind began to blow, the water began to sluice down the hill in rivulets, and before you knew it, the natural bowl had become a natural sink.

But that was one night. I, along with thousands of others, had run for what shelter I could find. Here I was, next morning, marching in as hopefully as the rest, confident that a bad beginning would mean a happy ending.

On the way in, I stopped to talk with officers at a mobile unit from the neighboring Dutchess County sheriff's police. "No problems here," said officer Bill Curtis. "Peace is the theme of the fair, and the kids have really been sticking to it." He explained that his detachment was on loan to Sullivan County to reinforce local police should any trouble develop. But none did.

About the only business these officers had was with young campers who had become separated from their friends. Officer Charles Gesell, who had been exhaustedly sucking on a lime as I talked with his friend, said that the night before a girl six months pregnant had come in lost, chilled from the rain, and faint. She spent the night in the mobile unit and then found her friends. "She brought me back this lime," he said, "just as a sort of a thank you."

Checking with the state police, I got the same story. "The kids in general have been very polite and well mannered," one of them told me. "Of course it's a monumental traffic problem that we've managed to handle pretty well using helicopters. But the kids haven't caused us any trouble. The only problems they're having are problems with themselves."

This last was a discreet reference to the drug problem. The security of the fair site was left up to the Woodstock people. As a result, there were practically no incidents of violence inside the gate. It was easy to see

why. With no police, those in the crowd were totally free to do their own thing, whether this meant walking naked or rolling in the mud.

As a result, too, drugs were taken and marijuana smoked frequently and openly. Marijuana smoke hung over the place like an invisible smog; once you've smelled it, you will never ask why they call it "grass." It is also true there were tragic incidents of drug use during Woodstock's three days. One of the week end's two deaths was apparently caused by an overdose of heroin. And adverse reactions to LSD—"freak-outs," as they call them—were all too common, numbering nearly 100. I saw one pretty brunette wide-eyed and shrieking as her friends tried to calm her, and a blonde wandering blank and disoriented in ankle-deep mud.

A team of specialists in the treatment of psychotic episodes from psychedelic drugs was flown in from New York City. The team set up a treatment center in a special tent not far from the stage. From the loudspeaker came frequent admonitions to "leave the blue caps alone," and "with anything else, try a half tab before you take a whole dose just to be sure it's good stuff."

Such announcements came during between-the-acts intervals of what did indeed turn out to be a grand and glorious program of rock-pop music. Highlights of the week end? Folk-rocker Richie Havens was granted absolute attention and a standing ovation by the audience Friday night. Saturday night stretched on and on, so that when the sun came up Sunday morning Jefferson Airplane was just beginning the final set. The big hits of the evening, however, were San Francisco's Sly and the Family Stone with seven encores (about the only group whose music moved the kids to get up and dance), and The Who, one of a number of English groups on hand, performing a two-hour set that included all their rock opera, *Tommy*. Sunday night? It

was Jimi Hendrix hands down—but by that time the rain had come again, and the exodus had begun. Only the most loyal were on hand to hear.

Yet in a way the music was the least of it. You had the feeling looking around you, as kids wandered in and out of the audience, that for most of them just being there and sharing the same air with so many of their kind was enough. Tom O'Mallia of Youngstown, Ohio, says that the groups were fine, of course, "but I really loved the people. I think what's really great is seeing all those people gathering and getting along. They were really together."

Mere survival became a real problem for some. A few teenyboppers and some hard-core hippies had hitchhiked in with no money at all and no shelter for sleeping. (After all, this was the Age of Aquarius, wasn't it?) Many were outraged at the high prices charged at the concession stands and said they would go hungry rather than pay them. Some of these ate the high-protein gruel dished out by the Hog Farm, a New Mexico commune whose members served as staff and security for the fair.

Those who really saved the day were the residents of Bethel and surrounding Sullivan County. Disgusted by the few who took advantage of the situation and charged exorbitant prices for necessities—$1 a quart was not uncommon for drinking water early in the weekend—citizens donated whole truckloads of food and drink to the stranded rock lovers.

"The greatest people in the world live right here in Sullivan County," said dairyman Max Yasgur when I nailed him down at last. "Many who were dead set against the fair worked hard to feed the kids and take care of them once they got here. When the chips were down, they showed what kind of people they are."

"We were afraid some of these Hell's Angels would

come into town and wreck it," said one man who declined to give his name but said he was commander of the local American Legion post. "When we saw these kids weren't going to be like that, it was okay. They surprised us by being real good."

Once the week end was over, however, many local residents voiced complaints. Mrs. Clarence Townsend says that the kids camped in the Townsends' alfalfa field without permission and ruined it. "They burned fenceposts and everything," she says. "The kids had to go somewhere, but not here. It never should have been held in a town this size." Richard Joyner, who worked in his store in Bethel through the week end, was appalled that "there was no law enforcement. I saw dope being sold right on the corner. It was awful for children to be exposed to this."

That wasn't the only problem for the Woodstock people, who lost a great deal of money on the fair. Although advance ticket sales hit $1,500,000, they made almost nothing at the gate because a lack of security forces—New York's Commissioner Howard Leary withheld the 300 off-duty New York City policemen who were to do the job—made it impossible to hold people at the gate. "Everything was done," says coproducer Mel Lawrence, "for the safety and welfare of the people in the audience.

"What happened was that this show transcended the limits of any festival or entertainment. It was a phenomenon. I've worked on five festivals before, and there was never anything like this. I guess it was a combination of the right circumstances. But whatever it was, the Woodstock Music and Art fair took on a life of its own."

Yes, a phenomenon. But perhaps a phenomenon that has more to do with mass psychology than with music appreciation. This is a point on which men with

strong opinions may indeed differ. Allen Ginsberg, for instance, poet and guru to the young, sees such gatherings as this one and the great San Francisco be-in of 1966 as basically religious in nature. He compares them to the Hindu *Mela* convocations in which the holy men of India—sometimes over a million of them—gather together in one place periodically to trade rituals and enlist disciples.

Elias Canetti, on the other hand, the hermitic philosopher whose *Crowds and Power* is the definitive work on the workings of the mass mind, would be inclined to view the gathering at Bethel as a typical example of an "open crowd," one whose real purpose and urge is simply to *grow*. "In the crowd the individual feels that he is transcending the limits of his own person. He has a sense of relief, for the distances are removed which used to throw him back on himself and shut him in. With the lifting of these burdens of distance he feels free; his freedom is the crossing of these boundaries. He wants what is happening to him to happen to others too; and he expects it to happen to them."

Or, as one of those disembodied voices on the public address system put it to the crowd, "You are all part of the one big revolution." To those of us who were there watching it all, puzzling, and comparing notes, the Woodstock Music and Art Fair seemed a historical occasion, all right, but one in the nature of a mass dropout, a new game for those with time and money to play it. But to the kids there it may well seem a revolution—which is, after all, a war of sorts.

People speak carelessly and often today of revolution, so perhaps it would be best to be specific on a few conclusions carried away from that week end:

✔ The openness with which marijuana was smoked at the Woodstock Fair suggests that it may soon be legalized.

Woodstock Revisited

TWENTY-ONE-year-old Craig Schneckloth of Susanville, Calif., gazes nostalgically across the lush cornfield where it all happened, while Crosby, Stills, and Nash rock along in the background from the *Woodstock* album on his car's stereo tape system.

"You know," he observes to no one in particular, "I can still catch some of those good, year-old vibes."

His friend Gary Avise, 23, who's also from Susanville and who, like Craig, is a senior at Sacramento State College, nods in agreement. So do two high-school seniors from Long Island who actually were at the Woodstock Music Festival and Art Fair almost exactly a year ago.

"We came back to reminisce a bit," explains Rory Dolandis, 17, of Elmhurst, N.Y.

"Yeah, so did we," Gary Avise adds, "even though we weren't here."

No matter. So have thousands of other young people, both those who were and those who were not at that first monumental meeting of the half-million faithful who collectively became known as the Woodstock Nation.

Thousands of members of the Woodstock Nation have made their pilgrimage to this field on Max Yasgur's farm near Bethel, N.Y., where the "Aquarian Exposition, Three days of Music and Peace," occurred one year ago, Aug. 15-17, 1969. And like other pilgrims at other shrines, Woodstock's approach this field with reverence and gratitude, perform their individual oblations, and apparently go away rejuvenated. For those

who cannot make the pilgrimage, relics are available at record stores and movie houses.

The Woodstock record album has been certified by the recording industry as a million-dollar seller—and at the suggested retail price of $14.95 for the three-record set, it is certainly among the most expensive.

Variety reports that the Michael Wadleigh-directed film *Woodstock* has grossed just under $5,000,000 in the 4½ months it has been playing at theaters throughout the country. The film, which cost $1,000,000 to make, is expected to return at least that much to Woodstock Ventures, Inc., and upwards of $35,000,000 to Warner Bros. from rental fees.

In one way or another, the Woodstock Music Festival and Art Fair changed the thinking of millions of Americans, whether they were there or not. The views of two area newspaper editors are not atypical. One, Al Romm of the Middletown (N.Y.) Times Herald-Record, was optimistic before the festival but was quickly turned off by what he witnessed: "Woodstock," he says, "was primarily drugs and sex. The music was incidental." The other editor, Art Sugarman of the Monticello Republican Watchman, took quite a different view of the festival. "In the wake of the largest congregation of its type in the history of the world," he editorialized, "and despite obvious snafus which developed along the way, the Watchman believes that the Aquarian Festival at White Lake has emerged, to paraphrase Neil Armstrong, as 'Man's First Step Toward Bridging the Generation Gap.'" In a less cosmic vein, he adds, "The kids left a lot of garbage behind but they also left a lot of good will."

The Messrs. Romm and Sugarman were just two of the many people I spoke with in the farming and recreational area near the Pennsylvania state line in an attempt to discover how their minds had been altered, if

at all, by the phenomenon of a year ago. Woodstock was just that—a phenomenon. Since its last participant brushed the mud from his poncho and headed for home, there have been many attempts to duplicate Woodstock in communities large and small all over the United States. All have failed—including, most conspicuously and most recently:

✔ The Powder Ridge Pop Festival—An estimated 30,000 people streamed into Middlefield, Conn., despite a court injunction forbidding the festival. Powder Ridge medical director Dr. William Abruzzi, who also served as medical director at Woodstock, reported that he and his staff treated nearly a thousand bad trips. "That's more than we had at Woodstock with 460,000 people," Dr. Abruzzi said. "Instead of the soporific 'pot' experience of Woodstock, we're getting a hostile aggressiveness here. A lot of kids are going to be injured psychologically for a long time." The physician blamed drugs that were "very badly put together."

✔ Strawberry Fields, Mosport, Ontario—After the governor of New Brunswick province banned what had been billed as "three days of love, sun, and sound" to be held at Moncton, festival promoters shifted their locale to Mosport, where the festival was said to be an adjunct of some previously scheduled motorcycle races. Hundreds of young people from the United States heading for Strawberry Fields were turned away at the Canadian border, many of them to be arrested for possession of drugs as they then tried to come back across the border. One youth who had been refused entry into Canada attempted to swim the St. Lawrence River and drowned. Those who survived the hassling and reached the festival site either lost their sense of sharing in the process or never had it in the first place; vendors hawked drugs, cigarets, and food at exorbitant prices, and panhandlers proliferated.

✓ Wadena (Iowa) Rock Festival—"The drugs were flowing like popcorn," commented Fayette County Attorney Walter Saur as some 30,000 young people gathered in a huge hayfield near Wadena. "But there just isn't the manpower to cope with it. Anybody who wants to make a citizen's arrest can be our guest. Anybody who goes into that compound and comes out alive would be lucky." The Wadena Rock Festival was banned by court order but later was legalized when authorities feared there might be a riot if they tried to stop it.

✓ Atlanta International Pop Festival—Georgia Gov. Lester Maddox called the affair "shameful and disgraceful." Many Georgians agreed with him. Anywhere from 250,000 to 500,000 showed up for the festival, held at Byron, Ga., which saw open trafficking in a gamut of narcotics, including what festival medical officials described as "orange sunshine," a combination of LSD and STP, and a pink pill that reportedly contained 90 per cent STP and 10 per cent strychnine.

✓ Altamont, Calif.—The ultimate antithesis of Woodstock although, ironically, promoters of the one-day festival had billed it as "Woodstock West." Pool-cue wielding Hell's Angels, serving as bodyguards for the Rolling Stones, took their responsibility very literally and smashed the skulls of dozens of people who got too close to the stage. The final grim tally from the debacle: one stabbing death, one drowning, two persons killed when they were run over by cars. Lamented the Stones' lead singer, Mick Jagger: "It was supposed to be lovely, not uptight. What happened? What went wrong? If Jesus had been there, He would have been crucified."

A year ago, when the full impact of Woodstock was apparent, social commentators declared something new had been added to the American scene—that Woodstock was only the beginning, and that the rock festival would become an institution. The spate of junior Wood-

stocks seemed to prove them right, but now, with the failures of so many festivals, it appears that the Woodstock era is ending. What made the difference? What really happened at Woodstock to make it work—not work according to everyone's ideals, perhaps, but at least work? The handful of people who were intimately involved in creating Woodstock offer some perceptive insights, among them Mr. and Mrs. Max Yasgur, on whose farm the festival was held.

Fifty-year-old Max Yasgur cannot pinpoint one overriding reason why Woodstock succeeded, but he is grateful for having been a part of it. He is also saddened that the sense of community that Woodstock fostered has been diluted by concern (including his own) over the use of narcotics at rock festivals. Still, Mr. Yasgur speaks with conviction and pique about reports that peace prevailed at Woodstock because of the widespread use of drugs.

"I don't think it was peaceful because the kids were stoned," Mr. Yasgur said. "I think it was peaceful because the kids were peaceful. I sincerely believe that most of the kids simply wanted to have a peaceful festival."

Mr. Yasgur, however, is unequivocally opposed to the use of all illegal drugs, including marijuana. "We were very naive about drugs before Woodstock," he conceded. "And I still wouldn't know pot if I saw it. But I know there's a hell of a difference between changing the law and breaking the law."

With more faith, perhaps, than pragmatism, Mr. Yasgur believes from his conversations with young people in the past year that rock festivals without drugs are possible, and, indeed, are the only kind that can be tolerated: "It would be a terrible thing if festivals deteriorated to the point where festivals and drugs become

synonymous. If they do, they've given the haters more ammunition.

"When I went to the Bethel Town Council and told them I was considering signing the contract for the festival, there was some talk about letting 'those people' come into Sullivan County," Mr. Yasgur says. "My argument is against the phrase 'those people.' This scares hell out of me as an American. We have to provide equal and equitable laws for all segments of society. 'Those people' are our children."

Miriam Yasgur refers to them as "the kids with the shining eyes who come by to say hello to Max." They keep coming because Mr. Yasgur not only listens to them, he understands; and when he talks to them he doesn't pontificate. "I don't see any of them as freaks," he explains. "I just treat each of them as an individual."

A post card Mr. and Mrs. Yasgur received recently is representative, they said, of the more than 10,000 pieces of mail they've received since last August. Addressed to "Max Yasgar (sic), The groovy farmer at the festival, Sullivan County, New York," the message read: "One more thanks for bringing together a beautiful thing—Woodstock. Love and peace, from New York City."

There has been surprisingly little hate mail, Mrs. Yasgur emphasizes. "We only got three scurrilous letters—all unsigned, of course—and one that was intelligent and critical and that was signed."

Despite, or perhaps because of, his abiding interest and concern for young people, particularly those who he believes are being manipulated by extremists of all stripes, Mr. Yasgur refuses to allow another rock festival to be held on his property.

"First, there are the logistics," he says. "This is a rural area, and we just can't handle that number of

people. More important, it would be unfortunate if the good that came out of Woodstock were spoiled by trying to recapture something that can't be recaptured. It can only happen once."

A perceptive Washington, D.C., psychologist, Dr. Ned Gaylin, agrees: "People fell in love with that moment in time. Woodstock was a spontaneous happening and it can't be duplicated. It's like trying to reduplicate a love affair—it can't be done."

Nevertheless, Woodstock Ventures, Inc., of New York, which staged the Aquarian Exposition at Bethel, has plans for an encore. It may never materialize, however, unless the current trend toward crashing—forcefully opening up festivals and making them free—is remedied. So says Joel Rosenman, 27, president of Woodstock Ventures.

"We do have plans pending for some kind of festival, a Woodstock II, that is economically feasible and consonant with the ideas of the Woodstock Nation," Mr. Rosenman says. "But we're in debt and we don't have any assurances that such a festival could succeed financially. In fact, we're almost guaranteed that it wouldn't."

Mr. Rosenman, a lawyer, says he understands and sympathizes with young people who feel exploited by "the Establishment," but criticizes their inconsistency in attempting to right the situation. "There has been a growing feeling since Woodstock," he says, "that cultural expositions of that kind should be free to the members of the generation that produced the culture. But I don't see why festivals should be free and grass still cost $20 per ounce. Why don't these people who crash picket record stores for selling a record at six bucks a copy?"

The solution to the problem is not necessarily stricter security at the sites of rock festivals, especially

when they attract tens of thousands of people. "You just can't have higher and higher fences, German shepherd dogs, and machine guns," Mr. Rosenman says. "That's unthinkable."

"Since Woodstock, this office has served as a kind of clearinghouse for between 10 to 20 festivals, all of which have resulted in the same kind of finale," Mr. Rosenman goes on. "I've never seen a festival since Woodstock that was adequately planned. Every one of them was underfinanced and underplanned."

Even though Woodstock was declared a disaster area by health, medical, and governmental authorities, Mr. Rosenman argues that the festival was "overplanned and overfinanced. Even though we were pressed to the very limit, none of our life-support systems broke despite that fantastic deluge of people." Life-support systems aside, he says, Woodstock gained its particular character because of the sense of community that was engendered: "There were links established; there was a sense of community that, to me, was the most important thing about Woodstock.

"In many ways I think it was an answer to alienation, to anomy. It was a united consciousness, a communication on a level both elementary and sophisticated; it was people talking to people about the basics of life; it was half a million people really pulling together."

There were, of course, scores of people who saw Woodstock with none of the sense of euphoric community that Mr. Rosenman does, among them Al Romm, editor of the Middletown Times Herald-Record. "It was a man-made disaster of the first magnitude, a cross between Sodom and Disneyland," Mr. Romm insists.

Mr. Romm also believes that all the talk about the peace of Woodstock is a hoax: "You hear these people saying things like, 'Well 500,000 adults couldn't have

gotten together and stayed nonviolent.' There was violence in the sense of assaults on people's sensibilities. And in the sense that kids who didn't know much about drugs were turned onto them, in the sense that kids who didn't know about sex were suddenly introduced to it, in that sense Woodstock was neither peaceful or lawful."

Sullivan County Sheriff Louis Ratner, while remembering the many courtesies and kindnesses the "hippie kids" showed his men, remembers even more vividly their flagrant violations of the law. "And there really was nothing we could do about it," he says. "How do you go in there and arrest thousands of people? You can't.

"All of these rock festivals start out small, but they grow to such proportions that they can't be controlled," Sheriff Ratner says. "With all these festivals come all the elements that are looking for trouble."

Then why didn't the troublemakers, who were at Woodstock, disrupt the festival?

"I don't think anyone can explain why we came out of it as well as we did. It was a miracle."

More than being miraculous, Woodstock was a blend of many elements that combined to give it its own pervasive flavor and character. Among those elements:

✔ An isolated setting that enforced a sense of community.

✔ An incredible lack of creature comforts that kept nearly everyone, including the troublemakers, preoccupied.

✔ Use primarily of marijuana instead of the harder, more dangerous drugs.

✔ A sense of moral responsibility on the part of promoters who lowered the fences and continued writing checks.

✔ Inspired music provided by nearly every top rock group in the United States and England.

✔ Several hundred thousand young people, who, as Max Yasgur says, "simply wanted to have a peaceful festival."

Whatever it was, we shall probably never see its like again. Bethel, Sullivan County, and New York State have passed laws in the past year to guarantee that, as have some 27 states. Judging from the violence that has accompanied some recent festivals, the prospect of fewer and fewer in the months to come will sadden the serious, nonviolent members of the Woodstock Nation, but not most of the promoters.

Comments Don Friedman, an organizer of the Randalls Island Festival, after a gamut of politically radical and strong-arm groups had seized control: "The love, peace thing of Woodstock has gone out. It has been replaced by anarchy—complete, total anarchy."

—MICHAEL PUTNEY

August 1970

Janis: 'It's a Rush, Honey'

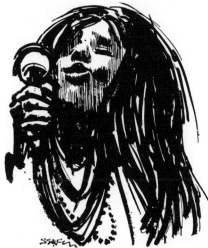

A LITTLE over a month ago she chipped in half on a tombstone for the great blues singer Bessie Smith, who had rested 33 years in a cemetery without one. And now, at the age of 27, the young singer whose rasping voice and frenzied delivery had prompted many to compare her to the late, great Queen of the Blues is herself dead, apparently the victim of an overdose of drugs.

Janis Joplin was found dead in her hotel apartment in Los Angeles, fresh needle marks in her arm. Police reported they later discovered small quantities of heroin and a syringe there.

She was in Los Angeles recording an album for Columbia with her new group, the Full-Tilt Boogie. Things were going well for her. They had just come off the road, and she was proud of her new group. "This band is solid," she said of them recently; "their sound is so heavy you could lean on it, and that means I can go further out, and extend myself."

Extending herself, pushing harder than she should and stretching herself to the limit—it was more than a style with her. It was a way of life. Critics warned her if

she continued with her shouting, bawling, all-stops-open vocal style she would burn her voice out in a few years' time. "People say I'm ruining it," she said of her voice. "Maybe it's getting rough but I still could reach all the notes I ever could. I don't know how long it will last. As long as I do, probably."

And as it turned out, she was right.

Because of the nature of her death, Los Angeles coroner Thomas Noguchi has decided to hold a so-called "psychological autopsy" to "determine the mode of death more specifically." A panel of psychologist and behavioral scientists will investigate her life, its pressures and her response to them, and set about to determine her psychological and emotional health at the time of her death.

What will they find?

They will hear Janis Joplin quoted again and again, proclaiming the good-time, live-for-today philosophy in which she believed. She once told a reporter who asked her what she wanted out of life: "Getting stoned, staying happy, and having a good time. I'm doing just what I want with my life, enjoying it. I don't think you can ask more of life than that." She later mounted this on her wall and referred to it as her credo.

And she lived her life by it. Born in 1943, the eldest child of a Port Arthur, Texas, refinery executive, she grew up feeling lonely in that Texas town and left home at the age of 17 on the first of a long series of excursions into the great world—New York, Los Angeles, San Francisco—but she would return from time to time, register at a college, and try to be the girl her parents wanted her to be. As late as 1965, she had settled down as an education major at La Mar State College of Technology at Beaumont, Texas, was studying hard, and getting good grades. That was when the call came to her from a friend to come to San Francisco and join a group there

calling itself Big Brother and the Holding Company.

That was the beginning of the big time for her. She later remembered her first performance with the band at the Avalon Ballroom, just outside the Haight-Ashbury district: "I couldn't believe it, all that rhythm and power. I got stoned just feeling it like it was the best dope in the world. It was so sensual, so vibrant, loud, crazy. I couldn't stay still; I had never danced when I sang, but there I was moving and jumping. I couldn't hear myself, so I sang louder and louder. By the end I was wild."

And as far as her audience was concerned, the feeling was mutual. Everywhere she sang she astonished her listeners and left them amazed at the power and energy of her performance. That was what happened at the Monterey Pop Festival in 1967. When Janis sang *Ball and Chain* the world suddenly knew who she was.

By fateful coincidence, the Monterey Pop created another big star, the young black guitarist named Jimi Hendrix, who only two weeks ago died in circumstances similar to Janis' in London. After taking an overdose of sleeping pills—perhaps by accident—Hendrix vomited and asphyxiated himself. He, like Janis Joplin, seemingly had everything to live for, but he also subscribed to the same do-it-now philosophy.

There have been other recent deaths in the world of pop music that seem to follow this same reckless pattern of self-destruction. Al Wilson, guitarist with a good heavy rock group known as Canned Heat, died from an overdose of sleeping pills. And Brian Jones, one of the original Rolling Stones, drowned in his swimming pool at his home in England when under the influence of alcohol and drugs.

Why? What is it about the lives of these young singers and musicians that drives them so, that pushes them to drugs and excess in drink?

"The worst thing is loneliness," Janis Joplin told an interviewer last year. "Somehow you lose all the old friends. The travel circumstances pull them away. It's hard to make new ones. When we're not on stage, we rehearse, lay around in bed, check in and out of motels, watch television. It really is lonely."

And how did Janis fight the loneliness? With liquor, she said. When she left Big Brother and the Holding Company and formed her first group, she began carrying styrofoam cups with her everywhere, on stage and off. What's in the cup? reporters would ask her. Southern Comfort, she would say—and she said it so often that the distiller eventually gave her a fur coat for all the free advertising she provided them.

That was why everyone was so surprised when it was drugs—and hard stuff at that—that killed her. Eventually, of course, her drinking would have had the same effect. A doctor warned her as early as 1968 that her liver was dangerously enlarged and that she simply had to cut back on her constant consumption of alcohol or she would shorten her life by many years. She quit going to that doctor.

Not long ago Dr. Donald W. Goodwin, a psychiatrist at Washington University of St. Louis, did a study of F. Scott Fitzgerald, his alcoholism, and its effect on his life and work; his article was published in the Journal of the American Medical Association. In the course of it he pointed out that not only Fitzgerald, but four of America's six Nobel Prize winning writers—Eugene O'Neill, Sinclair Lewis, Ernest Hemingway, and William Faulkner—were alcoholics; a fifth—John Steinbeck—was a very heavy drinker.

Talking with Dr. Goodwin after the death of Janis Joplin, I asked him about her evident mixing of drink with drugs. Wasn't that unusual? "It's not unheard of," he said. "People go to mood-altering and euphoric

drugs—and this includes alcohol—for basically the same reasons. They go with the drug of choice, and choice may be determined simply by availability or cultural preference."

But what are the reasons? Why do they turn to alcohol and other drugs? "The writers I've studied in this regard and singers like Janis Joplin have something in common in that they are all fundamentally performers with the special problems of performers. They are never really sure how good they are, because audiences are so capricious. If they achieve success quickly, they wonder if they can repeat it, because 9 times out of 10, due to the intuitive nature of art, they don't know how they did it in the first place. And they must keep producing, for ultimately, of course, an artist is always judged on his most recent performance. These are very precarious careers—not just financially, but emotionally. Particularly emotionally."

And it's true. They seek drugs, including liquor, as a prop against uncertainty and a bolster against pressure. But such props and bolsters must constantly be reinforced. With some, such as Janis Joplin, Jimi Hendrix—yes, and F. Scott Fitzgerald—you can see the process plainly at work in their lives, moving inexorably on, almost like the ticking of a clock.

"I live for that one hour on stage. It's full of feeling. It's more exciting than you'd expect in a lifetime. It's a rush, honey."

Rush? That's addicts' slang for the initial "hit" of heroin when injected directly into the bloodstream. And that's Janis Joplin talking a year ago.

The clock could have been heard ticking then: In 12 months this superstar will self-destruct. Eleven . . . ten . . . nine . . . eight . . .

—BRUCE COOK

October 1970

McCrea: The Music Died

L IKE the strychnine-laced dope that some pushers
fobbed off on the unsuspecting as "dynamite
stuff," "a good high," the highly touted Celebration of
Life Rock festival in McCrea, La., also turned into a bad
trip. A real bummer.

Legislated against by Pointe Coupee Parish offi-
cials, temporarily enjoined by a state court, reviled by
clergymen, and ridiculed by politicians, the planned
eight-day "living example of an alternative life style"
fell four days and many light years short of its prom-
ises.

Come together (at $28 a head) for brotherhood,
sex, drugs, and rock, the summer's first attempt to re-
live Woodstock found instead enervating heat, choking
dust, bad dope, and mostly mediocre music. Under-
standably, then, many of the 50,000 who found them-
selves at a combination rock show and boot-camp biv-
ouac were quick to scream "Rip off" and point an ac-
cusing finger at promoter Steve Kapelow of New Or-
leans. He in turn blamed hack politicians and high-
priced performers for his problems, while the perform-
ers argued that their years of scrounging around on the
bottom of the bill had to count for something.

The most conspicuous casualty of that self-perpetu-
ating and ever-widening circle of recrimination may
well be the rock festival phenomenon. What happened
more or less spontaneously two summers ago in Max
Yasgur's corn fields at Woodstock refused to be revived
in the broad, shadeless cow pasture at Cypress Point on
the banks of the Atchafalaya River, about 100 miles
northwest of New Orleans. And what was billed as the

exemplary exhibition of the countercultural ethos to celebrate the summer solstice marked instead the end of a community of feeling for many of those who gathered here.

"I'm going to blow this piece of sh—," exclaimed a disgusted 20-year-old girl from Houston on Saturday afternoon as the temperature hovered near the 100-degree mark. "I think this whole thing has had a hex on it from the start with all the hassles they've had. But the promoters still had enough time to get the sound system together and enough toilets and drinking water, but they didn't. I'm cutting out."

Explained an Evansville, Ill., youth hitchhiking out of the 700-acre festival grounds: "I came down here to see what was happening, and it turned out to be just another mob of freaked-out kids trying to make money off their brothers. Man, it's no different from the full-scale capitalism on any Main Street in this country."

Babbitry? And how. It was one of the most difficult but inescapable truths of Celebration, responsible in large part for the anger and frustration voiced by many young people. Price gouging and exploitation is what these young people expect from the Man on the outside, except in lesser degrees from the promoter on the fringes. But from your brothers and sisters? Yet there they were, hawking Boone's Farm Apple Wine at $1.50 a bottle, ice at 25 cents a cup, tepid soft drinks at 35 cents a can. The Man was in their midst.

Ironically, drugs were cheaper and more plentiful by comparison. Wandering through camp sites during the day or picking their way through the throng that gathered in front of the jerry-built stage every night, pushers openly hawked their wares with cries of:

"Ice cold cocaine."

"Organic mescaline, acid, MTH."

"Orange Sunshine, a dollar a hit."

"Jamaican grass here, ten dollars a lid."

"Incense, a dollar a stick and with every stick get a free tab of acid."

"We've had a lot of bummers, a lot of ODs," reported medical director Dr. William Abruzzi, a veteran of a dozen other major festivals including Woodstock. "But we've still had less self-destructive behavior here than, say, we did last summer at Powder Ridge (Conn.). I haven't seen kids popping six kinds of pills in a half hour the way they did there."

Nevertheless, Dr. Abruzzi and his staff were hard-pressed to handle the average 150 bad trips a day, and there was one case of a drug overdose that resulted in death. Additionally, two festivalgoers drowned in the treacherous Atchafalaya River and five others were seriously injured when the stage scaffolding on which they were working collapsed during an intense thunderstorm.

The most serious medical and morale problem at Celebration, however, was not the result of drugs but the brutality of three New Orleans motorcycle clubs that were hired, Dr. Abruzzi said, "for what was euphemistically called security. We treated at least 25 incidents where these bikers beat up long-haired kids for no apparent reason. Kids were walking in here literally with their teeth in their hands.

"Then there were the kids strung out on drugs who came in here screaming, 'The bikers are after me.' That was the biggest cause of paranoia the first day we got inside the festival grounds."

"Our biggest problem has been with these motorcycle groups who think they can take the law into their own hands," agreed Pointe Coupee Parish Sheriff F. A. Smith. "All they are is a bunch of thugs." On Friday afternoon, Sheriff Smith, wielding a submachine gun and assisted by a large contingent of his deputies and Loui-

siana state patrolmen, escorted the bikers out of their encampment.

"After what the [Hell's] Angels did at Altamount, what in the world did the promoters have in mind when they hired the bikers here?" asked Lynn, a pretty girl from Croton-On-Hudson, N.Y.

Hiring the chain- and club-wielding bikers, however, was only one of the errors of judgment of which the promoters were guilty. More serious yet was the grindingly slow pace of the entertainment, caused in large part by the primitive method of transporting performers, their sophisticated equipment, and their entourages onto the stage—a lone forklift that also did double duty carrying lumber and other building materials around the backstage area. Then, too, the stage itself was not completed when Celebration fizzled out early Monday morning, and a closed-circuit television system designed to let the huge crowd get a rare close-up view of the performers only went into operation midway through Sunday night's performance.

"Mellow down, people," an officious hypercool emcee kept advising impatient festivalgoers. "We've been pushed and shoved by the Man at every turn and it's going to take a little more time to get it together."

Shouted back one irate member of the audience, "You've had months to get it together, you m——."

But as bad as the delays were, and the heat, the dust, the stench of the portable toilets and the reeking garbage that lay strewn throughout the festival area, perhaps the worst vibrations were the result of the locals who came to gawk. Windows rolled up, dismay and distaste on their faces, they drove through the Cypress Point grounds with increasing frequency once the gates were thrown open on Saturday. Most bothersome, however, were the curious who manned a flotilla of boats that churned slowly along the shoreline of the Atchafa-

laya. Between sips of beer, the visitors snapped pictures of nude swimmers and sunbathers with everything from box cameras to long-lens Leicas.

"Man, these people are really weird," observed a 19-year-old named Paul from Clearwater Beach, Fla., on Saturday, as still another john-boat filled with women in sunbonnets and men with binoculars slowly cruised by a popular beach. Most young people here, however, greeted the curious with amazing good grace, even to the point of posing nude with one couple in their 40s who showed up Sunday. But the cumulative effect of the gawkers—like the heat, the dust, the inadequate toilet facilities, the lack of showers, the interminable delays in the entertainment—had a wearing effect and soured the whole mood of Celebration.

Young people weren't the only ones who were disappointed. "When the promoters approached me several months ago," confided Dr. Abruzzi, "I was really excited by the idea of a youth fair with artisan booths and all kinds of music and seminars on religion and drugs. It sounded like a very healthy thing in a world where these kids are searching for meaning. But unfortunately it didn't turn out that way, did it?"

—MICHAEL PUTNEY

July 1971

That Incredible 'Superstar'

TWO YOUNG Englishmen named Andrew Lloyd Webber and Tim Rice have written a new rock opera, and its very title is sure to set dentures gnashing. *Jesus Christ, Superstar,* available in a two-record, 87-minute set on Decca, is rather freely based on the events of Passion week. To those who may be ready to take offense, be reassured: It is not nearly as bad as it sounds.

It is, in fact, far better by even the most rigorous standards than anyone could have expected. That, at least, seemed to be the verdict of the audience at the opera's premiere at Manhattan's St. Peter's Lutheran Church. As voices, rock band, and an 85-piece orchestra blared forth on tape, filling the small Lexington Avenue sanctuary, a sound-slide projector shuttled away in visual accompaniment, projecting illustrations to the Greatest Story Ever Told by such as Rembrandt and daVinci on a screen suspended before the pulpit.

The 22-year-old composer of *Jesus Christ, Superstar,* Andrew Lloyd Webber, has shown just how flexible and dramatic the rock medium can be in the hands of an imaginative, bold practitioner. There is variety in the solo writing—tone and mood change properly from the tortured soliloquizing of Judas Iscariot to the indecisive ponderings of an all-too-human Jesus Christ.

But it is the choral portions of the work that set it apart as something quite special. The fickle crowd of Jerusalem, so important an actor in the events of Passion week, is presented in richly textured passages that suggest Mr. Webber has not only a sure grasp of his art but a keen understanding of the psychology of man.

The cast is fine. Murray Head, especially, comes on with a shrieking intensity that seems quite fitting for his role as Christ's betrayer. The augmented English rock group and the chorus perform Mr. Webber's imaginative musical settings with precision, drive, and vitality. The last side of the four builds marvelously through the scourging of Christ—whiplashes against a driving rock guitar—and on to the final vocal movement, "Superstar," which takes the place of a Hallelujah chorus.

No, there are no true hallelujahs sung at the end of *Jesus Christ, Superstar,* for in this nonapostolic version Christ simply dies, a political sacrifice brought to a bad end by his own vanity. And although it smacks somewhat of a recent reading of *The Passover Plot,* this agnostic account of the proceedings does no real damage to the purely historical reality.

But while it is hard to find fault with the music, the performance, or even the argument of *Jesus Christ, Superstar,* anyone with a reasonably sensitive ear should object to the lyrics. Tim Rice has not only failed to rise to the seriousness of the subject, but to the excellence of the music as well. Anachronisms that add nothing are simply tossed in to be cute, and there is such a crude leaden quality to the words in general that at times it seems nothing less than remarkable that the singers have managed to get them out at all.

Yet although he is no equal of Andrew Lloyd Webber artistically, Mr. Rice is a full partner in the enterprise and served as narrator for the work during its presentation at St. Peter's in New York. And afterward, at a nonalcoholic reception in the church basement, he did most of the talking to the press.

Confirming that plans were under way to bring *Jesus Christ, Superstar* into live production, Mr. Rice said, "We—Andy and I—look on this only as step one. While it was great fun doing it on record, we felt when

we were working on it that we were really writing for the stage."

—BRUCE COOK

December 1970

* * * *

A JESUS CHRIST SUPERSTAR by Lenny Bruce out of Lewis Carroll by way of Radio City Music Hall? You'd better believe it.

The Tim Rice and Andrew Lloyd Webber rock opera blew the roof off the rococo old Mark Hellinger Theater in its Broadway premiere. But it blew fewer minds than it might have.

The opera, you will recall, tells of the last seven days in the earthly life of Jesus of Nazareth. In conception it's not a big, "physical" opera; only rarely and briefly does it offer possibilities for traditional spectacle of the carriages-and-spear carriers sort. But that doesn't stop Tom O'Horgan.

With *Superstar* the director of *Lenny* and *Hair* perpetuates the surreal approach that worked so well for *Lenny,* bringing a grotesque fancy to every set, to every costume, to as much movement as he can decently get his claws on. I doubt it's what the authors had in mind.

Central to the production is a wooden curtain that hinges backward with the overture to reveal several of Jesus' followers, scantily garbed, scrambling down it. A moment later they are offering supplications to a huge chalice from within which, in the waxen fashion of a Ziegfeld girl, forthwith rises Jesus of Nazareth. Among those on hand is Judas Iscariot, and before you can blink he is doing pantomimic battle with several "tormenters" in quilted jumpsuits, who will engage him periodically throughout the evening.

Well, enough. It goes on like this all night, and no one could describe it all. Suffice that the performances

are athletic; the sets by Robin Wagner involve all kinds of bizarre totems and platforms descending from above, with or without people on them; and the costumes by Randy Barcelo are distinguished by funny headgear. Herod, most fanciful of all, is done up as a painted drag queen.

Mr. O'Horgan, in other words, can't make up his mind whether to play the opera straight—*his* sort of straight, anyway, which means a kind of stream-of-consciousness symbolism a la Judas' tormenters—or for out-and-out laughs. But unlike *Lenny*, this evening is altogether too thin intellectually to sustain the stream-of-consciousness approach, which must feed off ideas in the text. As for humor, it's there, but in the libretto's flashes of modernity amid the Biblical pageant; you can't lean on it. And you can't make fun of the conception as a whole, which at the end Mr. O'Horgan comes perilously close to doing.

What *Superstar* really needs is not a stage director, but a choreographer; the basic trouble here is that the show shouldn't have been conceived as a piece of Broadway theater in the first place. All Mr. O'Horgan's ministrations notwithstanding, *Superstar* is emotionally lost in the vast reaches of the Mark Hellinger; even the sound, particularly the chorus and the 32-piece orchestra, seems not to cohere. Nor does Mr. O'Horgan's staging, which too often looks designed just to fill up the stage.

But the opera, somewhat miraculously, survives as a notable work of its kind. The music is striking, particularly the choruses and the arias assigned to Mary Magdalene; and the libretto, so bothersome to some, is appealing in the conscious gaucheries that make you sit up and take notice. There are weaknesses, of course: Judas is overdrawn throughout, and the scenes leading up to the Crucifixion are episodic and screechy. And un-

happily, a splashy production tends to underscore them.

Of the principals, Yvonne Elliman's pure-voiced Mary Magdalene (from the original album) comes off best, Ben Vereen is a spirited Judas; and although I didn't much like Jeff Fenholt's rather effete and petulant Jesus, I suspect Mr. O'Horgan hadn't the slightest idea of what He was supposed to be about.

The musical has an advance sale of more than $1,-000,000. That's superstardom, any way you cut it.

—CLIFFORD A. RIDLEY

October 1971

The Story of B.B. and Lucille

T HE BEST most of us can hope for as we grow older
is to lose a few of our bad habits. Bluesman B. B.
King, however, has picked up a few good ones. One in
particular.

It has lately become a kind of custom with him,
when a rare open date appears in his tight schedule, to
send a discreet inquiry to the
local jail or prison, asking if
the authorities might like him
to come by and do a concert for
the inmates. This is how it hap-
pened that he has played to
audiences at Chicago's Cook
County Jail (his first such ven-
ture), Miami's Dade County
Stockade, the Federal Peniten-
tiaries at Leavenworth, Kan.,
and Danbury, Conn., New
York's Riker's Island jail, and
the state prisons of Wisconsin,
Tennessee, and Massachusetts.

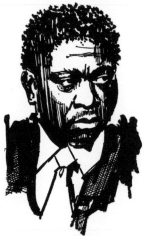

And not long ago, he took his show to Lorton Reforma-
tory near Washington, D.C.

No telling where he'll pop up next—Attica? San
Quentin? It would help plenty if he did, for watching
him perform at Lorton, you could tell his music had a
therapeutic, even healing effect on the men who lis-
tened. As B. B. ad-libbed at one point during the pro-
gram, "If you're sick, the blues will make you well!"

This, along with everything else he said, sang, or
played that afternoon, met with an enthusiastic re-

sponse. He had brought his band along, and together they played a fine show from the middle of the prison's baseball diamond as the men listened from the surrounding grandstand. Beginning, as he always does, with his signature tune, *Every Day I Have the Blues,* B. B. went on to sing all his old favorites—*Sweet Little Angel, Sweet Sixteen, Three O'Clock Blues,* and others —as well as a few of his new tunes, such as Leon Russell's *Hummingbird.* And in between, he joshed and kidded with the inmates like the good showman he is. He presented each member of his eight-piece, jazz-oriented band to the audience and even introduced his guitar, Lucille.

"Oh," he says, "you want to know how Lucille got her name? Well, that was one night in the little town of Twist, Ark., which is located just 79 miles west of Memphis. . . ." Thus he retold that tale, now familiar to his fans, about the two fellows who fell into a fight over a girl in a dance hall about the size of a sardine can. "One of them kicked over a kerosene heater in the middle of the floor, and the place went up in flames. Both those boys died in the fire, and all I got out with was my guitar. I asked who that girl was who caused all that trouble—and they said Lucille. And I thought, 'She must be some girl,' so I named my guitar after her."

B. B. King's history as a performer is crowded with towns like Twist and memories of gigs played in roadhouses and dance halls like that one. Nobody in blues is better established than he, yet none has worked so hard to get where he is. Years and years of one-nighters have taken their toll. In 1956 he set a personal record that few performers would envy, playing 342 one-night stands in a single year. Living on the road broke up a marriage. One auto accident—"You play all night and drive all day"—left him broke; another nearly severed his right arm.

And still he travels today—though now in better style, true. I talked with him before the Lorton gig in his suite at Washington's swank Hotel Madison while his valet-driver readied his wardrobe. Mr. King was in an expansive mood, feeling easy, and I remarked that it must be difficult to relax in odd hours like this.

"Yes," he said, "but it's how you learn to cope with the road—you learn to be yourself. My home is usually a hotel room. My manager is up in New York, and my mother and father are on a farm that I own with them outside Memphis. But me? Well, I don't have a home, really—300 working days this year, and recording dates on top of that. Where would I live?"

But though B. B. King continues to work at just about the same grueling pace as before, the character of his audiences has changed considerably in the last few years. He has been "discovered" by all those young rock fans out there; and now, in addition to clubs, Mr. King plays colleges and universities (100 this year), concerts, and festivals.

How do the audiences differ? "Well, the attention's better at the concerts, of course," he said. "You take your average club-goer, he's got other things on his mind. I'd like them to listen closer, but I don't mind too much because I was brought up with people like that."

As with most blues singers, his audience—at least his black audience—is predominantly female: 70 per cent, by his estimate. "Some people say I don't like women because I'm so hard on them in my songs—but you *know* that isn't true." Punctuated with a wink.

"In fact," he added, "that's the one thing I regret about this concert at Lorton—there won't be any women there. They're a very special audience. You see, there were women at that Cook County Jail concert. They bused them in from the women's jail, though they kept them separated from the male inmates. That was a

good thing to do, because some of these fellows, you know, they have no chance even to *see* women. You should have seen their eyes when the women came in. That's what being a prisoner means. That's part of it."

Why did he begin playing these prison concerts? "Well, I've only been locked up one night in my life, and that was for speeding down in Mississippi, just waiting for the judge. But it was an experience that wasn't lost on me. I know what it's like to be locked up, and that's why I want to get through to these boys in prison. Let them know that the people on the outside haven't forgotten them. They tell me that's the worst of being in jail—feeling forgotten."

At Lorton, he concluded, "I just want you to know there's a lot of us looking forward to seeing you fellows when you get out."

This got some applause, but not as much as B. B. received when he turned back to the band, gave the downbeat, and swung into *The Thrill Is Gone*. He sang it in that powerful, though surprisingly light, baritone of his, and as he stepped back and began his guitar solo, the convicts started clapping time. He is the best of the blues guitarists, the boss of them all. His two choruses took the form of a very subtly accented series of descending runs; it rolled forth to remind anyone who wished to notice that his style is a blend of a variety of influences—from bluesmen like T-Bone Walker to jazzmen like Charlie Christian and the Gypsy virtuoso Django Reinhardt.

That ended the set, but not the visit. B. B. King set Lucille down and walked across the infield to the grandstand. And he spent the rest of the time there among the hard cases, shaking hands and signing autographs, making friends.

—BRUCE COOK

November 1971

Sex. Violence. Rough language. Certainly there has been a real and very audible explosion of these things in the arts over the past several years—pleasing some people, bemusing others, infuriating quite a few. Those of us charged with covering and explaining the arts have experienced all these reactions at one time or another, for the fact is that this Candor Cavalcade lends itself to no easy judgments. And the task is scarcely made easier, as Bruce Cook notes in the essay leading off this section, by the quick-buck operators who cloud the public's perceptions of the real issues involved by passing exploitation off as art.

In collecting material for this section, it was instructive to discover that we really haven't often addressed ourselves to the New Freedoms in broad, abstract terms. This suggests that our preference has been to deal with violence, explicit sex, and so on within the contexts of the works in which these things appear—to look at the whole rather than the part. And so in addition to general comment, this section includes several views of recent works that have particularly fueled or illuminated the controversy over artistic liberty—plus a straight news account (almost the first to appear anywhere) of the motives behind the show that brought the New Freedoms to television.

Pornography as Parasite

THERE WAS a rather puzzling omission when the Commission on Obscenity and Pornography was constituted by President Johnson, one that President Nixon did nothing to set right when he augmented the panel of experts to include one of "his" men. The panel included no one remotely connected with the arts. There were lawyers, clergymen, and sociologists, but there were no writers, movie directors, critics, or even publishers.

Was this simply an oversight? Perhaps not. The two Presidents and their advisers may perhaps have felt that far from being in a position to offer solutions, those involved in the arts—whether as creators or middlemen —are part of the problem.

Looked at from the Establishment's point of view, there is some justice to this attitude. After all, most of the important pornography and obscenity cases of the past 15 years—those that made the new law that is considered by some to be so permissive—have involved bona-fide literary works and films of some artistic quality. The big battles were fought not over some crudely printed collections of photos, nor over some 8mm. stag film seized at a smoker, but rather over *Lady Chatterley's Lover, Tropic of Cancer,* Allen Ginsberg's poem *Howl,* and Louis Malle's film *The Lovers.*

Yet in all these trials, expert testimony on what does and does not constitute a work of art has played an important role; most of them were decided, at least in part, on the question of the artistic quality of the works concerned. So it seems wrong to have set up a panel for such a study—a group that is supposedly representa-

tive of those segments of society particularly interested in the problems posed by pornography—without having included at least a few people professionally involved in the arts.

And it is probably a bad thing, too, for the community of the arts, because the nation badly needs a study of pornography and its relation to art. Such a study might contain a surprise or two; it might suggest, for instance, that pornography—the real stuff—offers something of a threat to art these days.

Stay with me. You will be spared the usual view-with-alarm tirade against all that sex on the best-seller list and those quick flashes of nudity in the R-rated movies.

There is a distinction to make, both useful and legitimate, between merely sexy matter and what is instantly recognizable as pornography. It has to do with the play of imagination permitted the reader or viewer. There is nothing essentially pornographic about the nude male or female body, for when we look upon it, the full potential of the imagination is still strong: We are free to think whatever thoughts we will. Have male or female strike an explicit pose, however, or present us with a close-up of their private parts, and attention has been focused and our imagination thus impaired. Now throw that nude male body together with the female and put them through the usual routine, and imagination has gone right out the window.

Art, of course, can only operate within the province of the imagination—and that ought to be room enough. Great erotic art achieves its effect through suggestion rather than direct statement, and that effect is often genuinely sexy in a way that pornography never can be.

It is all so much more explicit with pornography. Attention is fixed precisely. There is no room for fantasy; indeed, an active imagination is likely to be an im-

pediment to the pornographic connoisseur. Thus theo-
retically, at least, if an individual immerses himself in
the stuff, he is likely to render himself unable to appre-
ciate anything else.

There is some evidence that something like this is
actually happening. I don't know how it is in your city,
but in mine the downtown theaters are changing over
one by one from the usual first-run Hollywood fare to
X-rated sex films—and worse. Far, far worse. And these
houses wouldn't be showing *The Seducers, He and She,*
and *Kama Sutra,* choosing a few at random, if they
weren't attracting patrons. The conclusion is inescap-
able: The audience for sex and pornographic movies is
growing as the general film audience shrinks.

There's no doubt about it: Movies of the usual kind,
in which actors speak lines instead of merely grunting
and moaning, are in real trouble. Blame it on the econ-
omy, if you will, but even the most successful producers
and directors are finding it hard to line up financing for
projects that would have seemed modest undertakings a
few years ago.

Producers of sex films and plain pornography are
having no such difficulties. One reason is that such
movies are cheaper to make. Porno king Alex deRenzy
made his first film a couple of years ago for $80. They
cost more now, but not much more. And they offer a
higher percentage return on each dollar invested.

These are facts that major Hollywood producers—
first, last, and almost always businessmen—understand
quite well, and at least a few of them intend to get into
the act. Twentieth Century-Fox retained sex-movie
maker Russ Meyer (*Vixen, Mud Honey, The Immoral
Mr. Teas*) to do a feature. He gave them *Beyond the
Valley of the Dolls,* easily the worst film ever to bear the
Fox imprint. The studio people were so delighted with
it, after they read the box-office receipts, that they have

given him another to do, Irving Wallace's *Seven Minutes.*

Pornography's relationship to art is essentially parasitic. Like kitsch, it is *imitation* art and can justify itself only insofar as it comes close to the real thing—and that, in fact, is what the law now requires. And so, in a way that nobody quite intended, the question of whether this movie, that book, or even that series of photographs should be considered obscene has become essentially an esthetic question.

As a result, the very crudest pornographer, though he may barely be aware of the meaning of the phrases he mouths, will now brazenly invoke the freedom of the artist in his own defense. And it is impossible to listen to him recite the little piece he learned from his lawyer without becoming aware of the threat he poses both to art and to society. He debases art by claiming its prerogatives: like any other parasite, he has neither respect nor pity for his host.

—BRUCE COOK

December 1970

The Truths of Lenny Bruce

I FIRST heard of Lenny Bruce on an old Shelley Berman album, when the mention of his name was enough to draw a laugh.

It was easy to chuckle knowingly about a scatological comic making over $300,000 a year. But later on, after repeated busts for obscenity had reduced his income to $6,000 and falling, the laughs came harder. Eventually, after he died in a Los Angeles bathroom in 1966 at the age of 40, they stopped coming altogether.

Lenny Bruce was one of the first casualties of the counterculture or the new morality or whatever you want to call it. Today, barely more than a decade since he hit the big time and less than five years since he died, plays and movies and even magazines and newspapers are sprinkled with the words that got him arrested again and again. Burghers of the highest respectability echo his ideas on race, drugs, sex, obscenity, and justice as if they had just thought of them. If ever there was a man ahead of his time, it was Lenny Bruce.

Unfortunately, his time rewarded him by almost literally hounding him to death for opening his mouth. And while he might be gratified today by the widespread acceptance of much that he fought for, I suspect

he would probably wag an admonishing finger to re-
mind us that our freedoms hang by a diaphanous
thread indeed.

Because he was not a publicity-seeker—although
God knows publicity sought *him*—he would probably
also be at least bemused by, at most scornful of, the cult
that has formed about him since his death. His auto-
biography, *How to Talk Dirty and Influence People*
(Pocket Books) and selections from his monologs, *The
Essential Lenny Bruce* (Ballantine), are paperback best
sellers. A magnificent play and a mediocre movie about
him have just opened, with more movies on the way and
another play closed down over a copyright dispute. And
his records continue to sell briskly to an audience that
wasn't old enough to see him perform.

There are, then, many avenues to Lenny Bruce
these days. But Lenny Bruce, they tell me—for I never
saw him work either—is tough to pin down because you
had to see and hear his gigs in context. Simply reading
his stuff was a start, but only that; so was simply hear-
ing his records. He didn't tell jokes, although he could
be outrageously funny. After a while he didn't really
even try to be comic. He just stood up there talking
about things, hallucinating, twisting reality into mad
hyperbole; and if the reality was ridiculous enough it
came out funny; and if it wasn't it didn't.

The famous niggerniggernigger bit, for instance.
The point was that if we could just strip the word "nig-
ger" of its pejorative sense, then "you'd never make any
4-year-old nigger cry when he came home from school."

The thread ran through everything he did. Just as
he assumed that we might shake the habit of derogat-
ing black people if we had no bad words to lay on them,
so he assumed in another bit that if we had no bad
words for breasts, say, we might shake the idea that sex
and bodies are unclean—or at least get it out in the

open. Naive, you say? Perhaps so, but the years since his death have produced a fair body of evidence to suggest he was right. Besides, most of our great moralists have inclined to the naive, and Lenny Bruce was nothing if not a moralist.

"All my humor is based on destruction and despair," he said. "If the whole world were tranquil, without disease and violence, I'd be standing on the breadline right in back of J. Edgar Hoover and Dr. Jonas Salk."

Lenny, the play by Julian Barry that opened at the Brooks Atkinson Theater in New York, understands all this. To be blunt about it, it is a helluva play, the most exciting new work I've seen since *Indians.* It is everything the theater ought to be and so seldom is. It crackles with vitality, with ideas, and with the sense of life that time and again leaps the gulf between artifice and "reality" to insist, as they said of Willy Loman, "Attention must be paid to such a person! Attention must be paid!"

The staging by Tom O'Horgan (who directed *Hair*) is not superimposed on the material but derives directly from it, a whirling and throbbing collage of surreal backdrops, of totemic tribal rites, manic fantasy, black farce, countless streams of consciousness in countless smoky night clubs, and an occasional snatch of raunchy melody. Intercut with all this, the story line takes Lenny from his strip-show origins to his death. And although the narrative is the least convincing thing about the evening ("Meaningless jokes—that's what my life's all about," grouses Lenny back in his stand-up days), it is fortuitously overwhelmed by everything else. Overwhelmed, that is, by the hammering force of Lenny Bruce, affirming life as it is really lived even while his own life is being sapped from him.

Like *Indians*, this show never underlines either its contemporary "relevance" or the tragedy that lurks just behind its abundant store of laughs, save at one electric moment when Lenny prostrates himself before the audience and cries "You're the ones who arrested me!" It doesn't have to; as Lenny, Cliff Gorman carries his relevance and tragedy about with him like the suit on his back. This is a supercharged performance for all seasons, a brilliant portrait of a nice Jewish boy, wanting nothing more than to speak his mind, driven to bitterness and despair when the social order locks up his words.

It is also an incredible *tour de force*. At one moment Lenny is Count Dracula, at the next a dummy Nixon opposite a ventriloquist Ike, at another the Lone Ranger acquiring Tonto "to perform an unnatural act." He floats high across the stage in a giant blimp (well, more or less); he defies gravity to scramble atop a 12-foot courtroom bench; he unerringly mimics the sound of a tape-recorder rewinding.

And above all he grabs a hand mike, shakes it at the audience like a priest dispensing holy water, and instead dispenses monolog after monolog, bit after bit, of what Lenny Bruce saw as the whole truth and nothing but. ("When I'm interested in a truth, it's really a *truth* truth, 100 per cent. And that's a terrible kind of truth to be interested in.") Way over half of the material in *Lenny* is derived word for word from *The Essential Lenny Bruce*. And if Mr. Gorman has not attempted to duplicate the timbre of his character, he has the style nailed down—the rapid-fire delivery, the fragmentary syntax, the casual way with the wholesale asides and Yiddishisms, the easy transitions from comment to dialog. Not all of it works, of course; some *shticks* fall flat. That was a 100 per cent truth-truth too.

For all his problems, Lenny Bruce stuck it out in the country that rejected him. (So did some other countries.) "The capitalist system is the best," he once said, " 'cause we can barter, we can go somewhere else. Communism is one big phony company." But finally he died in that bathroom of an apparent drug overdose. He had been busted several times on narcotics charges, but he always said it was a frame. Perhaps we will someday know for sure about that, but right now it doesn't seem to matter. We have his art, and that is enough. Except that we don't have him.

—CLIFFORD A. RIDLEY

May 1971

Zap! 'McCabe' and 'Macbeth'

RATHER THAN WRITE this review of *McCabe & Mrs. Miller,* I would much rather go back and see the movie again. And again, and again, and again, and again.

It is that kind of movie, the rare sort in which you can lose yourself in exactly the same way you can immerse yourself in a rich, dense, grand-dimensioned novel. Like that kind of novel, it creates its own world, with its own resonances, its own people and places. You feel that it is all real, that you are seeing a part of the action but that other things are happening at the same time, that those in the town of Presbyterian Church, Wash., have lives of their own—pasts that precede the few months sometime in the 1890s whose events you witness, and for all but a few of them, futures as well.

The world-maker is Robert Altman. He directed the film and collaborated with Brian McKay on the screenplay, adapted from a novel by Edmund Naughton. More important, Mr. Altman saw and heard, even smelled and felt the reality he had to communicate, and then managed to convey his vision of it all as nearly perfectly as anyone has in an American film.

None of this is to deprecate a single performance; as this is a director's film, it is just as surely and just as rightly an actor's film. It should remind you that when artists (that's right, *artists*) like Warren Beatty and Julie Christie appear on the screen in a work of real quality, they more than portray roles. They fill the screen with the special sense of their own reality. They add dimensions that could only be suggested, say, on the stage. What they do together in *McCabe & Mrs.*

Miller exemplifies the very essence of screen acting.

(Have I gone too solemn here? I hope not, for this one is, among other things, a very funny film—in a raw, vulgar, masculine way. Its dialog is the truest in this regard, and its situations the most authentic of any yet.)

McCabe (Mr. Beatty, of course), a gambler with an ill-deserved reputation as a tough customer, shows up in Presbyterian Church, a grim mining town named after its most prominent structure. Before long, he has grand plans for gambling and prostitution. He will run the town. He builds McCabe's House of Chance, then journeys off to the next town, buys three chippies, brings them back to Presbyterian Church, and installs them in tents, ready for business.

Enter Mrs. Miller (Julie Christie). "Mr. McCabe," she tells him in purest East End cockney, "I'm a 'ore, and I know a lot about 'ore 'ouses." She is and she does. She takes over the bordello operation for him, running it on a percentage, importing her own girls from Seattle.

They succeed perhaps a little too well, for these two little fish attract the attention of a very big fish. The mining company that owns and operates just about everything in that part of the country sends up a couple of representatives, who take a look around and offer to buy out McCabe lock, stock, and barrelhouse. He turns them down, perhaps giddy from Mrs. Miller's constant urging to "Think big, McCabe."

But McCabe is a very little man, as you soon see when the company's gunmen turn up. A small-timer? Sure. But with his back against the wall he will fight. And he does—like the nasty little ferret he is at heart.

What this is all about, of course, is how the West was *really* won. In this sense it stands in some relation to a few more realistic Westerns, the best being *Will Penny* and the most recent being *The Wild Rovers*. Yet

simply in being what it is, *McCabe & Mrs. Miller* seems qualitatively different from any Western ever made. It doesn't seem like a Western at all, for it simply does not deal in the usual myths, not even to debunk them. It is a story in the deepest sense—personal history, motley bits from the patchwork of human experience.

In a film as nearly perfect as this, the only jarring notes come from the Leonard Cohen songs that provide the film with its only musical background. They are pretentious and terribly literary ("some Joseph looking for a manger"—come *on!*), everything that the rest of the movie is not. Even so, I don't expect to see a better movie this year, or next year, or for some time to come.

—BRUCE COOK

July 1971

* * * *

"WHAT BLOODY man is that?" asks King Duncan in the 11th line of *Macbeth,* and in Roman Polanski's version of the Shakespeare tragedy, the sergeant who tells the king of Macbeth's bravery in his behalf is a bloody man indeed. He is smeared and caked in gore, still bleeding from half a dozen wounds, yet he offers his report with the pride and ebullience of a man who truly loves a fight.

If this offends you, leave the movie forthwith, for it is but a taste of what Mr. Polanski has in store. This is probably the goriest reading of Shakespeare ever committed to the screen; it is also one of the best. Mr. Polanski, whose obsession with terror and cruelty has been cataloged in such previous films as *Repulsion* and *Rosemary's Baby* (and reinforced by the ghastly murder of his wife, Sharon Tate), properly sees *Macbeth* as a litany of horrors in a crude, superstitious, and violent society.

Thus his witches, far from being the quaint old biddies of popular conception, are primitive, repulsive outcasts whose very repulsiveness lends them a kind of credibility—as if their sorcery must be genuine because they are clearly good for nothing else. Mr. Polanski makes their predictions truly chilling (even though he belabors his effect with a prophetic montage the second time around), and at the end he brings the play full-circle with an audacious return to the old hags that nails down the play's roots in superstition. As much as anyone can, he has made Macbeth's behavior credible, and that is no small achievement in itself.

But there is much more. As noted, Mr. Polanski has understood the world of this play as a place of blunt and casual cruelties—early on, a soldier whips a dying man for no reason whatever—where murder, or at least the idea of murder, is a commonplace. Thus Macbeth's thug can run his sword through Macduff's little boy without a trace of pity; thus, at the end, Macduff's decapitating the dead Macbeth seems as natural as a sneeze.

But not everyone in this world is suited to its easy violence, and it is to Mr. Polanski's credit that he actually elicits a measure of sympathy for Macbeth and his lady as people in over their heads, as failures in an enterprise that another couple might well bring off without a blink. When he gives you Duncan's murder in living color and fulsome detail, then, it is not just to shock. It is also to demonstrate Macbeth's indecision to the very last, to suggest what Lady Macbeth will see when she smears the fatal daggers on the king's guardians, to make Macbeth's "I have done the deed" less a boast than a moment of resignation. He knows, right then, where it all must end.

We know, too, of course, yet Mr. Polanski has directed the tragedy as if we didn't. And in so doing he whips up a remarkable amount of suspense, perhaps

hinging less on the outcome of events than on the manner of them: What new horror can he show us now? Yet for all his ups and downs, he doesn't neglect the inevitability of the tale; at the end, when Macbeth addresses his "loyal friends" and the Polanski camera pans across a handful of sycophants and dead-enders, the effect is both just and touching.

More just than I am, perhaps, in ignoring until this point the superb and almost totally unknown cast that Mr. Polanski has assembled. His leads are much younger than we are used to—the Macbeth, Jon Finch, is 29; his lady, Francesca Annis, is 25—and they work at their natural ages, a decision that reinforces the notion of two innocents playing at adult games. They are both marvelous; if Miss Annis is so gorgeous that her plea to "Unsex me here" must inevitably go unanswered, that is doubtless intentional, part of the intimation of vulnerability that lurks behind her facade of resolve, so that her tastefully nude sleepwalking scene becomes entirely credible. As for Macbeth, Mr. Polanski has chosen to do the soliloquies largely as voice-overs and occasionally to break them up, and Mr. Finch rises to the challenge with readings that are almost flawless.

The "look" of the film, finally, is crude and spartan, as befits the events of it. The Scottish landscape is bleak and windswept; Macbeth's castle is a dirty barn of a place where dogs and geese run wild in the courtyards; the costumery, even for the nobles, is frequently ratty. Mr. Polanski uses all this, but he doesn't dwell on it. *Macbeth* is a wordy play; but in showing us its rough, destructive underpinnings, Mr. Polanski has exposed the words for the bluster they are. He has created, quite literally, a bloody masterpiece.

—CLIFFORD A. RIDLEY

January 1972

Groovy Gore: Enough, Already

IN "STRAW DOGS", the beleaguered hero defends his home by pouring hot lye on one attacker and beating another one to death with a poker, clubbing this last chap again and again after he is clearly unconscious. And a predominantly youthful audience claps, whistles, and cheers him on.

In *El Topo,* perhaps the goriest movie ever made, a sadistic Lesbian whips another woman and then licks the wounds; a legless man borne by an armless man are shot apart, and you are afforded a good look at their wriggling to death; at the end the hero immolates himself. Youthful hordes turn the film into a cult object, and the underground press proclaims it a classic.

In *A Clockwork Orange,* the young leader of a gang of British toughs sometime in the near future cheerily yodels *Singin' in the Rain* as he kicks the kinky husband of a terrified rape victim again and again; earlier in the same fictional evening, he and his boys have brutally beaten an old man. The New York Film Critics have just voted *A Clockwork Orange* the best movie of 1971.

I think it is time to insist that the emperor is nekkid.

Yes, this is the same fellow who just recently was branding Roman Polanski's *Macbeth*—certainly the bloodiest Shakespeare ever committed to the screen—as a masterpiece. And who nominated both *The French Connection* and *McCabe & Mrs. Miller* for Ten Best laurels. Clearly there must be a difference.

There is. In *Macbeth,* in *Connection,* in *McCabe,* in all violent movies that succeed as art, the violence is not

the desired end of the movie but only the means of getting there. At base, both *Macbeth* and *McCabe*—and the parallels between them are striking when you think about it—are studies of little people out of their league; and both of their leagues, medieval Scotland and the American West, were places where the weak were dispatched by force. *The French Connection?* It, too, has to do with a society obsessed with force—our own—but it flips the focus: It sees matters from behind the guy on top. And shows you the human cost of his remaining there.

In each of these films, that is, the subject is not violence per se, but men and women, who are met with violence in their lives and must deal with it with whatever emotional and spiritual and intellectual resources they have managed to accumulate. It is the uses to which they attempt to put those resources that make their movies interesting. No matter how gory, the violence is secondary.

As indeed it ought to be, for violence in itself is a dull subject for art. Whether you happen to believe that the condition derives from Cain or from some long-forgotten ape, I think most folk agree by this time that we are indeed a violent species, that violence lurks in the emotional recesses of each of us. But if you do accept violence as a sort of primal urge, as a matter to which we will all come sooner or later not by choice but by a kind of inevitability, then you destroy it as an artistic subject. For art, as I take it, is rooted in the exercise of choice.

That is why I can't accept the argument that I should respond to *Straw Dogs* as high art because, in detailing how Dustin Hoffman suffers all sorts of indignities from a pack of Cornwall bullies but draws the line at the violation of his home, the film demonstrates how we all will draw a line somewhere. Even if it does, so

what? By director Sam Peckinpah's *Territorial Imperative* lights, there's no choice involved in Hoffman's act; it's a purely animal response. And that, I admit, is a subject best left to the psychologists and sociologists; the artist ought to have more subtle matters on his mind.

But *Straw Dogs* doesn't even succeed on these simplistic terms because you can't accept the situation. No man alive would endure the degradation to which Mr. Hoffman is subjected by his wife (what does she have against him, anyway?) and the village roughnecks without either seeking redress or cutting and running. The oddest thing about the movie, however, is that after he somehow withstands all that clumsily underscored menace, Mr. Hoffman's eventual reaction to the siege on his house sounds less like a territorial imperative, which it's obviously meant to be, than a matter of principle.

"I will not allow violence against this house," he says, as near as I can recall it, and I fear I got me the giggles. All I could think of was a gubernatorial election in my state a few years back, in which the majority-party candidate ran on the slogan "Your home is your castle" and thousands of us tiptoed across party lines to elect his opponent. Whose name was Spiro Agnew, and I wonder what he'd do now in Dustin Hoffman's place— and whether the kids would groove on his bloodshed, if he went that route, the way they're grooving on Dusty's.

Ah, irony. Stanley Kubrick likes irony; the irony in his *Clockwork Orange* is that our worship of free will— which Mr. Kubrick apparently shares—must not only permit the freedom to choose evil, but must in fact produce a society in which evil is the majority choice. "Aha!" you exclaim. "Just what the kid said wouldn't happen—a film about violence that's not inevitable but *chosen!*" But no, for the film's subject in such a cir-

cumstance wouldn't be the violence, but the act of choice. Anyway, that's not what *A Clockwork Orange* is about, for Mr. Kubrick never offers an alternative to the evil he postulates; his "good" people are as rotten as his villains.

Mr. Kubrick takes Sam Peckinpah one further; where Mr. Peckinpah's hero is violent only when pushed, Mr. Kubrick has said that his Alex "symbolizes man in his natural state"; the lad isn't anything *but* violent. Well, I don't buy that, but I'd be willing to hear his argument if he cared to offer one. He doesn't, however; evil is a *given* in *A Clockwork Orange*, just as hardship is a given in *McCabe & Mrs. Miller* or power-lust is a condition of life in *Macbeth*. Well, all right for them, because we know they're accurate; history says so. But the trouble with all futuristic narratives is that you must take the conditions in them on faith, and it's awfully easy for a creator to stack the deck.

In a way, Mr. Kubrick tries to appear even-handed by suggesting that the life-style of his futuristic England is simply an extension of what we have now, but the things he chooses to extend—from Pop art to the drug culture—often seem things that are already on the wane. (Some say this film has "the look of the future," ignoring the fact that it was largely shot on locations existing—and already looking a little decadent—in the present.) I think Mr. Kubrick has indeed stacked the deck. We're supposed to come around to *liking* Alex, according to Mr. Kubrick, because we're essentially mean; but if he really believes that, why not test us honestly by having the punk rape and pillage some decent people whom our "civilized" selves might identify with? Uh-uh. Like Sam Peckinpah, Stanley Kubrick is playing it safe. And the kids can have their violence and deplore it too.

They sure have it in *El Topo*. And while Mr. Peckin-

pah is saying man *can* be mean and Mr. Kubrick is saying he's mean all the time, Alexander Jodorowsky is here suggesting that God isn't such pacific shakes either. I know the protagonist is God, incidentally, because he says so; it's one of his few lucid pronouncements. Played by Mr. Jodorowsky himself, he's a wandering avenger who slaughters a host of villains, falls from grace and kills a quartet of holy men, is himself almost killed, recovers years later to lead a colony of incestuous dwarfs to freedom and their own slaughter, and eventually martyrs himself out of despair. It's a rotten world.

That's what the movie boils down to, all right—after 2½ hours, lots of surrealist nonsense, and a host of little ten-Zent riddles that pass for profundity. One critic calls Mr. Jodorowsky an "instinctual thinker for whom ideas are sensuous entities," and he may be, but the notion is pure rubbish.

At base, in their simplistic stories and their Pop-art characterizations, these movies are cartoons; and you would think audiences shouldn't become as involved with them as they would with a clearly "realistic" movie. But I fear that precisely because they don't seem to matter, these films generate a mindless absorption quite different from the attention paid a movie that brings you up short now and then with a recognizable human emotion, a character you can care about. These movies aren't interested in persuading you of a premise; they *present* you with one, and if you don't accept it, the movie makes no sense. So since you've paid your money, you accept the premise, and then there's nothing interesting to do but sit back and groove on the violence. As Mr. Jodorowsky might have it, even God says it's okay.

—CLIFFORD A. RIDLEY

January 1972

The People Behind a Bigot

ARCHIE Bunker, the central figure in one of those television situation comedies, is watching professional football reruns on his TV set.

He does a double-take. He turns to his family and says:

"Willya look at that spook run? You gotta hand it to 'em, moving like that. It's in their blood. . . . It's like inherited—from the time his forefathers was in the jungle . . . running barefoot through all them thorns and thickets with a tiger on his butt."

Spooks. Polacks. Hebes. Coons. Dagos.

Such language, and on commercial television too.

Archie Bunker, played by actor Carroll O'Connor, is television's newest "hero," the star of a CBS show called *All in the Family*. Nothing like it has ever been shown on American television before and—if critics have their way—will ever be shown again. It's a phenomenon.

Archie Bunker is blustering, seething, lower middle-class, bigoted all the way from his beer belly to his flat, florid face. He has his own view of life.

"What's in a name anyway?" he asked in a recent show. "When I was a kid we didn't have no race trouble —an' you know why? Nobody called themselves Chicanos, or Mexican-Americans, or Afro-Americans. We was *all* Americans." Then he pauses. "Then after that if a guy was a spic or a jig it was his own business."

The structure of the show is simple. First is Archie, the head of the family. Then there's his wife, Edith, usually called "dingbat" by her husband. Living with Archie and Edith are their daughter, Gloria, a pert but empty-headed blonde, and her husband, Mike Stivic,

who is long-haired and concerned, about Archie and about war, the environment, race relations, and just about everything else. Archie calls Mike a "Polack," but the ethnic background of Archie himself is not clearly

stated. He and his wife presumably are WASPs in the New York City area.

The show is the creation of Norman Lear, a writer-producer who turns funniest when he tightens the screw. "The harder you can make people laugh," he says, "the more you can make them swallow." But even he wonders if the public will swallow what he is dishing up.

The Columbia Broadcasting System is obviously wondering too. Before the show begins, CBS apologizes in advance, explaining that *All in the Family* is an attempt to get viewers laughing and talking about their problems. That way, the network suggests, people will come to understand some of society's problems. The statement is, in fact, a kind of disclaimer.

That CBS should be producing the show at all is something of a wonder. This, after all, is the network that built its ratings with such pap as *The Lucy Show, The Beverly Hillbillies,* and *The Munsters.* CBS decided to go with *All in the Family* after the American Broadcasting Co. (ABC) declined the honor.

"It could be an important breakthrough for television," says Mr. Lear. "Our show could mean that television might be getting away from its super-consciousness that overprotects the public from anything that might offend or irritate. If we make it, artists like Martin Ritt, John Frankenheimer, and Paddy Chayevsky might look at television again."

If the show's popularity, or share of the audience, keeps growing, it could become the year's biggest hit. The first week's show had a Nielsen rating of 25, the second 29—and it must compete with ever-popular motion pictures on the other two networks. "We simply want to convince CBS that we should be back next fall right now," says the show's director, John Rich. "That means we probably need a Nielsen rating of 33 or so."

Carroll O'Connor's performance as Archie dictates how the show fares. His role—that of the ignorant bigot —demands great subtlety and control, so that when he flares into florid-faced vehemence he doesn't become merely another bitter, angry old man.

"I see Archie as a true American stereotype, a man so ignorant of his world that he's absurd," says Mr. O'Connor. "He truly believes that he is right, and if he ever learned otherwise his world would end right then.

"But he is a good man who has simply never thought through his prejudices and feelings. He doesn't mind a black youngster like Lionel [a friend of the family] coming into his home, but he'd never consider a daughter of his marrying him."

The cast enjoys the production, and after taping only six episodes—it's television's only "live-on-tape" show—they already have a rapport unusual for television.

"Norman and Bud [Yorkin, of the Yorkin-Lear Tandem Production team] and our director, John Rich, are great to work for," says 23-year-old Sally Struthers, the blonde who plays the daughter. "They even listen to suggestions from us young 'uns."

In a recently taped episode, she is expecting a baby, only to suffer a miscarriage. "John worked with me for hours developing my emotional recall so I could feel the pain," she says. It must have helped—for her performance brought the studio audience from full laughter to sudden silence, and tears from many of the women.

"The show is an excellent opportunity for an actor," says Rob Reiner, the mustachioed son-in-law who off stage is the son of actor Carl Reiner. "I wasn't interested in the part because the show might be innovative and break new ground in television, but because the show's situation is real and the script is good. It is natural for me, the son-in-law, to live with my wife's

parents because she has a strong attachment to them and because I'm still in school."

Archie's wife, Edith, is played by Jean Stapleton, who has appeared in many movies and Broadway shows such as *Damn Yankees* and *Funny Girl*. She is exceptional, playing to perfection the harried, devoted, fussy, bustling wife who always manages to deliver delightful non sequiturs.

When Archie berates Mike of having written President Nixon—"You, Michael Stivic, meathead, wrote the commander-in-chief, our very President, about a rash" —Edith adds hopefully: "Maybe he knows a good skin man."

Some of the show's best moments come when the family gets away from the earthy ethnic slang of Archie and the lovey-dovey scenes of Mike and Gloria to hilarious routines at the dinner table or while playing Monopoly. Or when Lionel, the young black friend of the family, pops in.

Michael Evers, who had been attending Los Angeles City College and only heard of the part from a man who picked him up when he was hitchhiking to class, portrays Lionel. He slips into the round-eyed, guileful role of the stereotyped Negro in love with pork chops and watermelon when confronting Archie.

"Mike has that inborn instinct before an audience," says Mr. Lear. "But much of the credit for Mike's—the entire cast's—success belongs to John Rich. He works well with the actors in developing the script. His taste is good, and his instincts are excellent."

Mr. Lear adapted *All in the Family* from a similar series shown by the British Broadcasting Company (BBC), *Till Death Do Us Part*. "We made our first pilot production of *All in the Family* for ABC 2½ years ago," he says. "Carroll O'Connor and Jean Stapleton were in the starring roles then too."

He made a second pilot show a year later, but again ABC allowed its option to expire. "I had really given up on it," he recalls, "when Bud Yorkin and I were talking with CBS' president, Bob Wood, about a special we were doing for them. We showed him the *All in the Family* pilot and here we are."

Mr. Lear contends that he is not attempting to make the show into a personal statement about social and political issues. "I simply think that most of our bigotry, our prejudices, are based purely on ignorance," he says. "They are really silly, which I think the show points out."

The show is based to some degree on Mr. Lear's personal background. "My father used to tell my mother to stifle herself just as Archie does Edith," he says. "I had a letter from my mother last week telling me that my father also called her a 'pip' when he 'liked' her. And the poem Mike read Archie and Edith on their wedding anniversary, in the first show, I wrote that when I was 13 for my parents."

He had worried, right along with the CBS executives, about how the viewing public would receive the show. He says now that the letters indicate people are beginning to identify with his characters, and that the mail is running nine to one in favor of the show.

Mr. Lear's comedy has always been laced with serious comment. His motion picture, *Divorce American Style,* which he wrote in 1963, dramatized the plight of a poverty-stricken husband after his divorce. Another of his movies, *Cold Turkey,* also deals with contemporary problems, first smoking and then pollution.

Author Irving Wallace says that he has never seen a writer more serious when he's attempting to be funny, nor one more funny when he's attempting to be serious. In *All in the Family* Mr. Lear intends to keep his viewers laughing at themselves and their neighbors. "We as

Americans praise and romanticize our ability to laugh at ourselves," he says, "but too often we don't seize upon the chance when it is there. I'm not the greatest fan of Vice President Agnew, but, for example, he deserved more credit than he received for seeing the humor in the Mickey Mouse-type watch of himself."

The show has been relying heavily on the shock value of Archie's liberal use of insulting ethnic slang. There is a real question as to whether people do in fact exercise bigotry by bandying it about and laughing at it, and whether Mr. Lear's treatment of attitudes on such issues as homosexuality, sexual mores, racism, anti-Semitism, and more is, in fact, cathartic.

The show's value could probably best be measured after a run of some length on television, but the nature of television dictates immediate acceptance by the viewing public.

"We're certainly hoping for the chance to see what we can do with the show if it can run as long as the average successful situation comedy," says Mr. Lear. That would be about four years.

—JOHN PETERSON

February 1971

In Defense of Archie

IN HER RECENT two-part New Yorker series on the making of what may be The Great American Movie, *Citizen Kane,* Pauline Kael makes a persuasive case for *Kane* as the culmination of "that sustained feat of careless magic we call 'thirties comedy'." Along the way, she pays more than passing tribute to the writers of those often perishable but ineffably brash and joyous pictures:

"Though their style was often flippant and their attitude toward form casual to the point of contempt," she says, "they brought movies the subversive gift of sanity. They changed movies by raking the moralistic muck with derision. . . . They entertained you without trying to change your life, yet didn't congratulate you for being a slobbering bag of mush, either. . . . They may have failed their own gifts and the dreams of their youth, but the work they turned out had human dimensions."

I absorbed these words, and a good many others that are just as perceptive, in between pondering on the new CBS television series called *All in the Family*. And it struck me that what is so very good about *All in the Family*—and the thesis here is that it is at least the brightest new thing on commercial TV since the early *Laugh-In*—is precisely what was so very good about those 1930s comedies. Weighted down with codes and conventions and formulae, commercial television has been "moralistic muck" to the teeth, yet *All in the Family* manages to take its measure through a combination of qualities rare to the home screen: humanity, satire, and common sense. In the creation of these things,

formlessness and flippancy may be not so much results as causes, for perhaps it is only in the rarefied atmosphere of no-holds-barred, free-form invention that the barnacles of years of mental stagnation can be hacked away.

On the surface, of course, *All in the Family* is an unlikely candidate for the betterment of anything. Its protagonist is Archie Bunker, a paunchy elevator starter who dislikes, in no particular order, Negroes, Jews, "ethnics," intellectuals, liberals, hippies, kids, homosexuals, and anyone who disagrees with him. Since he is profligate with ill-formed opinions, that last class encompasses just about everybody; and among those who occasionally venture to dispute him are his marvelously patient wife, Edith; and his daughter and her student husband, who live in the Bunker home. And since Archie is prone to discuss the population in such epithets as "spade" and "spic," he is clearly not your everyday hero. In fact, he is not a hero at all.

That should be understood. Archie Bunker is clearly a caricature—but a caricature not of traits that don't matter, in the fashion of the tube, but of those that do. Being a caricature is what makes him not only tolerable but harmless; although there are those who fear he will make prejudice respectable among latent bigots awaiting a spokesman, I think they underestimate the public's understanding of the satiric conventions. And the familiarity of his peeves is just what may make him useful, for although Archie is a boor, he is at base a decent enough man who has merely absorbed every easy answer that every oversimplifier has ever set before him. In other words, he is *pure* bigot, far too unsubtle for anyone to emulate, yet hopefully not quite so absurd that no one can recognize a bit of himself in him from time to time.

It is odd that those who worry about Archie-as-ex-

emplar are not put off by the simple fact that, week in and week out, he always loses. And why does he lose? Not because he's a misfit or a bumbler or a dumbbell—not, in other words, because of the kind of patronizing characterization that is foist upon so many situation-comedy males. No, there is evidence that he is none of these things. He loses, rather, simply because he is *wrong*. At base we are asked to laugh not at the man but at his ideas—and if that isn't a subversive notion in TV programing, I never heard one.

The aim, of course, is to eschew condescension, to forsake the easy target—and, not so incidentally, to head off the chap who might otherwise conclude that yes, Archie is laughable, but his ideas are okay. And what of the rest of us? How do we overcome our instinctive and immediate annoyance at the man's incessant pigheadedness and address it instead as satire? For the simple reason that Archie not only loses, but that we know from the outset that he is *going* to lose.

It is an odd fact that television, probably the most convention-ridden medium in history, has never really used its conventions in any particularly helpful way. *All in the Family,* by playing on the audience's awareness that Archie is always proven wrong—and it's important that the proof be clear to *him* as well as to the viewer—does exploit its conventions. By freeing the audience from the nagging fear that Archie will not meet with retribution for his sins, it releases us to laugh at what is going on around him.

And "around him" is the literal truth, for the fact is that Archie himself is only a fraction of the fun on *All in the Family*—and that fraction always of his own doing, for he is forever backing himself into ideological corners from which there is no escape. He inquires fearfully, for instance, whether Jews are moving into his block and is visibly relieved to be told the new people are

Baptists. (They are also black, which he will discover later.)

Larger-than-life Archie surely is, but he is also a genuine human being, and so are Edith and the rest. That, of course, is a considerable tribute to those who write the show—so far, mostly Norman Lear—and it is offered with thanks. In the best sense, *All in the Family* sounds written by a bunch of mentally double-jointed hacks having themselves a good time; and while this poses problems, it offers compensating rewards.

Almost everything in it, for instance, runs on too long by any standard of "craftsmanship," and yet it is in this very looseness that *All in the Family* differs so winningly from the garden-variety sitcom, in which un-funny lines thud one upon the next with the depressing regularity of golf balls at a driving range. At times the show sounds almost spontaneous—an impression that is reinforced by its infrequency of set changes—and these are generally the times when it's best.

Accept, if you will, that the funniest matter is the truest; and accept, then, that truth requires time to develop. By supplying this necessary time, by not hurrying everything for the sake of a "gag," *All in the Family* has given us such moments as Edith's interminable and totally pointless story about having the same blood as Katharine Hepburn, or Archie's and Edith's arguing unto death over whether Archie prefers link or patty sausages with his pancakes. These are the moments that make *All in the Family* much more than chic shock, for they are as true for you and me as they are for Archie and Edith.

They are true in huge part, of course, because of the actors creating them. As Archie, Carroll O'Connor's cherubic, overgrown-choir-boy mien and deportment are precisely right, and as Edith, Jean Stapleton . . . well, let me say a word about Edith. She is a marvel of

convoluted reasoning, dreadful malapropisms, and shamelessly borrowed grandiloquent diction. (She once confused room spray for hair spray, and "all day long I reminded myself of the Great Outdoors.") When she thinks, everything pauses in awe of the creaky gears in her brain, and yet she invariably comes up with the right answer. Last week she did jury duty, and when she explained that "in all my life this is the first time anyone asked my opinion about anything that really mattered," it was a fine moment. Miss Stapleton, I love you.

I don't love *All in the Family,* exactly, but I respect it a good deal for what it is: a piece of mass entertainment that rather consistently manages to deal with recognizable people talking of things that might concern them, rather than Pop-art plaster casts speaking in balloons. I will even accept as part of the game its rather unabashed pilfering from other sources; there was a gin-rummy bit in an early episode that was straight out of *Born Yesterday*. It must be said that occasionally the series does confuse brashness with bad taste—a reference to "that Jewish dentist in South Africa" is funny until you suddenly realize he had a name and he's dead —and there's the inevitable question of how long they can keep it up. Well, good luck.

—CLIFFORD A. RIDLEY

March 1971

The pieces in this section, which are otherwise about as diverse as any nine articles could be, are joined by at least one thread: They all deal with creations of almost no "artistic" pretensions whatever.

This is not to say that their subjects are without value. The head-comic artist R. Crumb is a draftsman of considerable skill, with a social conscience to match. The old radio comedies collected by David Goldin could teach a thing or two about style and wit to the sitcoms of today. Howard Cosell, beneath his put-on public mien, is a reporter of rare honesty. And Venturi and Rauch, the architectural firm that finds its models in tract houses and hamburger stands, is clearly onto something about the function of building design.

The point, rather, is simply that if Art is produced by these people, it is produced by accident, for their basic aim is not "artistic" but social. They are concerned not with esthetics but with group dynamics—with the ways in which we interact as people, whether in our politics or our games. As for the rest of the phenomena here, they represent Escapism in some of its broadest forms—comic books, mindless children's TV programing, instant art, ersatz emotion. (Is it unfair to include Erich Segal among those with no artistic aims? His protestations to the contrary, one doubts it is.)

Social interaction and the filling of our leisure time, of course, are at the very heart of how we live our lives from day to day. Which is, of course, where Art is supposed to be as well. And so it is just possible that in their own ways and despite their modest ambitions, the subjects of this section are artists in the truest sense of all.

Boning Up on Batman

A MONG the scholarly resources in the concrete, six-story library of Bowling Green State University in Ohio are two famous calendars, which feature the late Marilyn Monroe wearing nothing but Chanel No. 5. They were real acquisitions, and Dr. Ray Browne is extremely proud of them. But he'd rather talk about some of the more significant items in the library: the stacks of Playboy, the bound volumes of True Confessions Magazine, the collection of underground newspapers, and pamphlets published by offbeat religious sects.

It's all grist for the scholars' mill. The calendars, the magazines, and religious tracts are part—and a small part at that—of the collection gathered in less than a year by Dr. Browne's Center for the Study of Popular Culture, a unique institution dedicated to broadening a college curriculum that Dr. Browne believes has become too narrow.

Dr. Browne seems mild enough for a revolutionary. He wears striped ties and conservative brown suits, and phrases like "golly" and "gee whiz" creep into his conversation. He is an unabashed enthusiast, not the kind who collects bubble-gum cards and original manuscripts with equal relish, but of that discriminating sort with an eye for the significant and sometimes beautiful cultural potsherd.

Dr. Browne is not the only one. A number of scholars lately are turning their attention to overlooked aspects of a chrome and plastic civilization. They have formed a professional society, the Popular Culture Association. They publish the scholarly Journal of Popular Culture, which takes up such esoteric matters as the

problems of textual criticism of Beatles' lyrics and the comic strip *Peanuts* as an American pastoral. There are college courses on popular fiction, the occult, the history of dress, and rock music. And in the middle of all this is Dr. Browne and the Center for Popular Culture.

The center has been criticized by the University of Michigan's Dr. Russell Kirk, among others, for being anti-intellectual and for debasing culture. Such criticism, its defenders say, misses the whole point of the popular-culture-studies movement.

"Our aim is completely different from that of English studies," says Carlos Drake, a folklore specialist who teaches at Bowling Green. "The end of English studies is mainly appreciation. The end here is secondarily appreciation. But basically, it's to understand."

"Most of the teachers who embark upon popular arts courses," says Dr. John Cawelti of the University of Chicago, "share with their students a fascinated discovery of a richness and variety of material which reveal a whole new range of insights into our culture." One of the founders of the Popular Culture Association, Dr. Cawelti has made studies of the self-made man as a popular American figure and, more recently, of the Western as a popular art form. Such studies, he believes, must be based upon solid training in history and the arts, if they are to mean anything.

When subjected to the scholars' traditional skills of cultural and esthetic analysis, many popular works turn out to be "of serious artistic intent," according to Dr. Cawelti. "The best Western films are an example, the movies of John Ford."

At the same time, he warns, "as our field develops, we will increasingly face the problem of trivialization—it doesn't take too long a look to see how much this has happened in the field of English literature even with its concentration on a limited number of excellent works."

Dr. Cawelti's concern is shared by almost everyone in the movement.

"The danger," says Dr. Carl Bode of the University of Maryland, "is in being quaint about the whole thing." One of the pioneers in popular-culture studies, Dr. Bode has written a study of popular culture before the Civil War. His special interests these days include "cheap popular fiction, what you might call very bad books," and lithographs by Currier and Ives.

Dr. Bode traces the humanities scholars' new interest in popular culture partly to the social scientists' interest in the effects of mass communications. Another factor, he says, has been the work of cultural anthropologists, such as Margaret Mead, who make it a point to study all the aspects of a culture, no matter how seemingly trivial. "But their problem was that they were frightened by the American culture," Dr. Bode suggests. "It was so darn big that it was too big for them. So they went off to the South Seas or to the Aleutians where the culture was much more manageable."

The most immediate ancestor of popular culture studies, however, was the American studies movement that began shortly after the end of World War II. American studies fused literature, history, and economics into a multidisciplinary approach to a question none of these disciplines could adequately answer by itself: What is the American character? "American studies' two main roots were the drive to study America for its own sake and the revolt against specialization in studies," says Dr. Bode, who formerly directed Maryland's American studies program.

Dr. Browne, who received his doctorate in American studies from the University of California at Los Angeles (UCLA), believes popular-culture studies is as much a reaction to American studies as a development from it, "American studies people are old men," he com-

plains. "They tend to stress 'high' culture. We're inter-
ested in what they would call American nonculture. I
consider them elitist."

Elitist is a dirty word in Dr. Browne's vocabulary,
as it is to almost anyone involved in the movement. An
elitist is any scholar who believes that dime novels, tele-
vision, magazines, and other artifacts of popular mass
culture are beneath his notice. At their extreme, elitists
believe mass culture destroys real culture by turning it
into a marketable commodity.

One of the early elitists was the Spanish philoso-
pher Jose Ortega y Gasset, who warned that the rise of
the common man would mean the fall of culture. In a
1932 essay, *The Coming of the Masses,* he accurately
traced the rise of mass culture to the Industrial Revolu-
tion, which provided faster and cheaper means of
spreading culture and at the same time disinherited the
landowning class of aristocrats who had been the arbi-
ters and patrons of high culture.

Ortega y Gasset was especially perturbed to find
the masses taking up theater seats, which, he believed,
could only lead to the vulgarization of the theater. "The
mass crushes beneath it everything that is excellent, in-
dividual, qualified, and select," he lamented.

The next elitist came from the Left. Starting in the
1940s, essayist Dwight Macdonald turned his attention
to mass culture in a series of essays that have come, in
the mind of popular-culture advocates, to epitomize the
elitist position. A Marxist at the time (he now describes
himself as an anarchist), Mr. Macdonald described
mass culture as the embodiment of Gresham's Law, in
which the bad product drives out the good.

Mr. Macdonald was the first writer on popular cul-
ture to distinguish a middle ground lying between the
heights of Beethoven and Shakespeare and the swamps
of rock 'n roll and Edna Ferber. He dubbed this Mid-

cult and cited, as typical examples, such works as Hemingway's *Old Man and the Sea* and Thornton Wilder's *Our Town*. The trouble with Midcult, Mr. Macdonald wrote, is that despite elegant trappings it's really lowbrow.

Caught between the rock of Masscult and the hard place of Midcult, Mr. Macdonald concluded, real culture was in danger of being crushed. "A considerable portion of our population," he wrote, "is chronically confronted with a choice between looking at television or old masters, between reading Tolstoy or a detective story."

Dwight Macdonald's apocalyptic vision of the end of culture and his either-or distinctions are out of date, students of popular culture say. But he was the first to take a hard look at the phenomenon of mass culture and thus he is, in a way, one of them. "He exerted a strong influence on critical studies of popular culture for the next 15 years," says Dr. Russel B. Nye, professor of English at Michigan State University and president of the Popular Culture Association.

"Until the '60s, it all seemed very clear that there were three kinds of culture, high, middle, and low, and that they were split along educational and class lines," Dr. Nye says. "Elite was good, mass was bad."

But it has become apparent, Dr. Nye continues, that the class politics of the '50s had heavily influenced the views of Dwight Macdonald and other elitist writers. Other writers, free from a political bias, have taken a new look at mass culture and seen something quite different. The chief seer, of course, has been Marshall McLuhan.

"He said, quite shatteringly, 'Hey, the content of culture isn't all that important. It's the medium that's important,'" Dr. Nye says. "Macdonald had said that content was either good or bad. All the studies from Macdonald down to McLuhan had said nothing about

the media. They never asked: What is the function of a
B movie?"

People in the '60s, Dr. Nye points out, refused to
fall into the either-or patterns proposed by Mr. Macdon-
ald. Musicologists and intellectuals suddenly were pay-
ing serious attention to the music and life-style of the
Beatles. Serious art appropriated some of the most
banal images from American mass culture: truck-stop
food, comic-strip heroes, Brillo boxes, soup cans. Even
Hollywood, that synonym for Philistinism, became re-
spectable as the films of Bogart, Bette Davis, and Busby
Berkeley were trotted out for festivals.

On the surface, it seemed sometimes like a gentle
put-on; but underneath, a new sensibility was at work:
Intellectuals had, for the first time, begun to savor all
of American culture. There were unsuspected beauties
there.

One needn't look far to uncover examples. The
films of John Ford had been mentioned. John Lennon's
lyrics are filled with as playful and poignant an im-
agery as that in the poetry of T. S. Eliot. And *Ode to
Billy Joe,* by Bobbie Gentry, is as well-crafted a narra-
tive poem as any antique ballad in English literature.

Perhaps the best statement of this new sensibility
to date, and one treasured by popular-culture scholars,
was made by critic Susan Sontag. Miss Sontag, who in-
vestigates science-fiction films with the same tone of
level seriousness with which she discusses the work of
French New Wave director Alain Renais, argues that
art in our technological society is primarily concerned
with "a programing of sensations" towards new forms
of beauty (even Miss Sontag's vocabulary is borrowed
from the new technology).

The new art is cool, sensual rather than moral, em-
phasizing form over content, she says. Under these cir-
cumstances, it makes little sense to split up culture into

that which is edifying, uplifting, and that which is not. "The feelings (or sensations) given off by a Robert Rauschenberg painting," Miss Sontag declared in her essay, *One Culture and the New Sensibility,* "might be like that of a song by the Supremes. . . . They are experienced without condescension."

Popular culture's emphasis upon form has been relentlessly chronicled by essayist Tom Wolfe, whose classic study of the custom-car subculture, *The Kandy Kolored Tangerine Flake Streamline Baby,* is the first of a kind, a popular statement of the popular-culture movement. Mr. Wolfe is fascinated by form. When he calls the neon and felt tangle of Las Vegas the only completely realized Western city since Versailles, he is really paying tribute to both as extreme statements of formalism, examples in which a single, shaping style triumphs absolutely.

A former teacher of Mr. Wolfe (when he was at Washington and Lee University) is Dr. Marshall Fishwick, now professor of English at Philadelphia's predominantly black Lincoln University. Dr. Fishwick calls popular, mass culture "the first true international style since the Gothic." A rock group in Birmingham, England, Dr. Fishwick points out, is virtually indistinguishable from a rock group in Birmingham, Alabama. Both stem from the same source, American Negro music as it has been disseminated over the world by the mass media in the form of blues and jazz.

Though white himself, Dr. Fishwick is a serious student of black culture, which he believes to be "a powerful, maybe an overwhelming influence" on the formation of much of American popular culture. Likewise, the black-studies movement has been a major factor in bringing about the popular-studies movement, Dr. Fishwick believes. Black culture is by definition a popular (non-elite) culture, and one reason its contri-

butions have been recognized, he says, is that it does not lend itself easily to the heavy, Germanic kind of traditional scholarship.

Bowling Green's Dr. Browne and Maryland's Dr. Bode agree in viewing black-culture studies as a part of, and even a forerunner to, the popular-studies movement. Among the practical benefits of popular-culture studies, Dr. Browne believes, are the democratization of the college curriculum. It deals with the culture students know from their daily lives. By extending the tools of humanistic study into an area with which students are familiar, he points out, popular-culture studies can also serve as a useful introduction to the academic world.

Maryland's Dr. Bode is pessimistic about any immediate revolution in the college curriculum because of popular-culture studies. "The people who frame the curriculum are the most conservative people on a college campus," he says. The only hope is for its influence to be felt, through established American studies programs, upon future professors of English and history.

Nonetheless there is evidence that the college curriculum has already begun to bend a bit under the impact of popular-culture studies. According to a survey made for the Popular Studies Association by Chicago's Dr. Cawelti, over half of American colleges and universities now offer courses in popular culture. These are liberal-arts courses for the most part, emphasizing cultural and esthetic issues. Dr. Cawelti's survey did not include professional courses in journalism, television, film, or other mass media.

At Bowling Green, one popular course is "Problems in Utopianism." Utopianism is the popular movement that has led groups of Americans to drop out of society to set up their own "ideal" communities from time to time. Hippie communes are a modern example, but the

impulse is at least as old as the founding of Massachusetts Bay Colony. Part of America began as a Utopian experiment. The course is being team-taught by members of 10 departments, an approach that Dr. Browne hopes to use in other popular-culture courses, expanding the interdisciplinary approach pioneered in American studies.

To support such courses, Bowling Green's Center for the Study of Popular Culture is collecting material.

William Schurk, who is in charge of the collection, haunts junk shops and used book stores in the area with a shopping list that includes phonograph records, religious tracts, self-help books, sheet music, comics, back-issue magazines, best sellers, post cards, and catalogs. The center's modest budget stretches far because sometimes he can buy such material by the pound.

The collection is so big that nobody has cataloged it all yet. The phonograph records alone, some dating back to the gramophone days and presented to Bowling Green by a Cleveland disc jockey, would be the envy of any collector. Mr. Schurk frequently gets letters from collectors offering, even demanding, to buy this or that item out of the collection. "We want to dispose of the idea this is a museum," he says. "We are a repository for popular-culture items for research."

"Our goal," adds Dr. Browne, "is for scholars to come from all over to use this collection. We want to become one of the finest libraries in the world. We're not interested in trivia. We collect comic books, but there are many things more important.

"This movement is really too big and too broad to be a passing fad," he concludes. "I'm not worried. It's really the dawning of a new age. It comes down to giving education a broader base and greater richness."

—BILL MARVEL

July 1970

Comics for the Underground

CONSIDER the lowly comic book—crudely drawn, cheaply printed purveyor of banality and violence. Everyone under 30 remembers that apocalyptic day when his parents put a collective foot down: The stack of comics in the closet—lovingly accumulated, traded for, hoarded—were to be thrown out immediately. And good riddance.

Dr. Fredric Wertham, a psychiatrist, had just written *Seduction of the Innocent,* a book revealing how young minds are led to sadism and worse through the influence of comics. Publishers of the magazines began a hurried housecleaning. The grosser comics were swept from the newsstands like autumn leaves, while others underwent a laundering and reemerged bearing comic-book-code seals of approval on their covers.

Today comic books are enjoying their revenge upon middle-class sensibilities. They have become the latest weapon in a cultural arsenal that includes rock lyrics, drugs, and underground newspapers. And nobody wields that weapon more effectively than a skinny, bespectacled, 27-year-old genius who lives on a farm near the California lumber community of Potter Valley.

Robert Crumb draws comic books like no other comic books ever seen. They are chock full of violence and raunchy sex, at least three times causing authorities to seize them as pornography. They are also very funny and, more to the point, full of some of the most perceptive observation and penetrating criticism of our society to appear in print. The late Janis Joplin was a Robert Crumb fan; so are poet Allen Ginsberg and novelist Terry Southern. Even Establishment art critic

John Canaday finds him "raw and sophisticated, impulsive and perceptive." Mr. Crumb's comics have been exhibited in the Whitney Museum of American Art and sold in the bookshop at San Francisco's Museum of Art.

Comic books in an art museum? Yes, and who knows? By now they may have infiltrated seminaries and psychiatrists' offices, for alienation, depersonalization, and the search for God are just a few of the heavy subjects transmogrified by Mr. Crumb ("A cartoon for all occasions") into . . . into something else. Something resembling Soren Kierkegaard as written by Lenny Bruce and drawn by the creator of *Snuffy Smith*.

One typical R. Crumb character sits in front of his TV, a question mark floating in a comic-strip bubble above his head. He goes to work, buries his nose in books, is nagged by his wife, harangued by street-corner salvationists, but the question mark continues to percolate. He drops out, sleeps on sidewalks, shoots up dope, until a swarming cloud of question marks threatens to overwhelm him and blot him out. He stumbles over a cliff and falls into the sea; he is washed ashore and crawls through the sand until nothing is left of him but rags and bones. Then, in the last panel, it happens: The question mark disappears, replaced by an exclamation point. Analogies to Voltaire's *Candide* and the Buddha's Enlightenment suggest themselves, but they are only analogies. The strip is pure R. Crumb.

That character's quest bears at least a passing resemblance to Robert Crumb's own life. He is the latest example of an old phenomenon: the artist as drop-out.

Born in Philadelphia into a Roman Catholic family (his father was a career Marine), young Robert became a child prodigy by collaborating on his first comic book with his brother, Charlie, at the age of 5. Mr. Crumb has saved many of his early comics, mostly funny animals

in a *Looney Tunes* mold, drawn on tablet paper with pencil and crayon.

Like most boys, the Crumb brothers collected comics, prowling through Salvation Army stores to find the old, good ones. "You could tell comic books were already declining by then," he says. Charlie Crumb gave up drawing comics when he was 18, Robert says. "He swallowed that stuff about comic books being a lesser art. Now he's a writer."

Robert Crumb began a "fanzine," devoted to the doings of comic-book animals. Fanzines were small amateur magazines, usually mimeographed, that were passed back and forth between comic-book fans. After high school he "just hung around home for a year," then went to Cleveland to draw for the American Greeting Card Co.

The company had "roomsful of artists," he recalls. The work was uninspiring, the pay just fair. Mr. Crumb sank into the doldrums. He married, went to New York City and Europe, drew a series of strips called *Fritz the Cat,* and returned to the greeting-card factory. Although he was now drawing for the company's sophisticated Hi Brow line, things were scarcely better. "One night I met two guys in a bar who were going to California. I asked if they had room for me and they did, so I took off. I didn't even tell my wife."

In California Mr. Crumb became part of the San Francisco underground scene. A friend had a printing press. Joined now by his wife, the cartoonist assembled another set of strips into Zap Comix No. 1 and with his wife began hawking it on street corners in Haight-Ashbury. Even the flower children didn't understand his stuff at first; then it began to catch on. Berkeley's Print Mint, which had made itself a mint riding the crest of the psychedelic poster craze, saw in Zap Comix the possible successor to the poster.

The Print Mint's distributing apparatus placed Zap Comix in head shops (stores specializing in posters, pot-smoking apparatus, and other hippie paraphernalia) everywhere. It was magic. Other cartoonists who had been working in the same direction as Robert Crumb suddenly began falling out of the trees and crawling out from under the cultural rocks. While Mr. Crumb carried on with more Zaps and the classic Despair, two Chicago artists began Bijou Funnies. From Detroit came Motor City Comics. Others included God Nose, Hydrogen Bomb and Biological Warfare Funnies, Heavy Tragi-Comics.

Today there must be dozens of these half-mad, freaked-out souls turning out anything from crude motorcycle sagas to intricate acid-head visions. But Robert Crumb remains, by common assent, the best of them and probably the only one to make a living at it.

His style underwent a metamorphosis several years ago, when he was introduced to LSD. His drawing became more intricate, busier. Often he abandoned the straight story line of the *Fritz the Cat* strips for mind-boggling jumps in time and space.

A typical strip might begin with a character staring into space. The next frame shows his eyes in close-up. Moving in like a zoom lens, subsequent panels show a building reflected in his eyes, somebody doing something in the window of the building, and so on until somehow you return to the original character staring into space. In other strips, logical sequence is broken up and destroyed. Things happen with rhyme but without reason. Characters utter jive talk and change into swastikas.

On the other hand Mr. Crumb can plunge into the heaviest psychological stuff. Despair comics is an almost oppressive examination of modern *angst*; it opens with a page in which R. Crumb, self-caricatured, con-

fesses a morbid sense of humor. Watching a child fall under the wheels of a bus, an electrocution, and various other forms of mayhem, he says: "I find the strangest things amusing. . . . I seem to derive pleasure from the suffering of others. . . . Even now, as an adult and an eminently respected American cartoonist, I still sometimes find myself fascinated by . . . by . . . psychological sadism with you, the reader, as victim."

This reveals the psychological underpinnings of humor, so much of which is based upon the misfortunes, or at least discomfort, of others. As "an eminently respected American cartoonist," R. Crumb caters to a need to laugh by delivering pratfalls. But not without also putting his reader on the grill for a moment, by pointing out the basis of that humor, by stripping away the pretension.

At the same time he probes to the causes of the disease. In a strip in Motor City Comics, for instance, automobiles take on human characteristics while humans become progressively more machinelike. Jimmy the smiling Jeep runs down "Gonsa Magilla, the famous humanitarian," in the street while a robot snickers at a TV program that asks "Are human beings becoming irrelevant?"

All of this cosmic stuff, which suggests the raw material of an Ingmar Bergman film, is conveyed in a funky style that leans heavily on all the comicbook conventions. Characters' hats fly off in surprise; men shed huge drops of sweat; their eyeballs bulge. Mr. Crumb seems to have studied and absorbed every other comic cartoonist; acknowledged and attributed influences include Rube Goldberg, Mad's Basil Wolverton, Billy De-Beck (creator of *Barney Google*), and Elzie Segar (*Popeye*). Just 14 when Mad put in its first appearance, he found it irresistible. He also fills his strips with outdated

slang: "Hey there, Kemo Sabe," "Nice going, Ace," "Har-de-Har-Har."

Perhaps Robert Crumb's greatest genius is in exploiting the very "lowness" of the comic book form to create a counterpoint between banality of treatment and importance of theme.

He dismisses all attempts to analyze his work as "bull." He has become a folk hero to the underground, but he finds his increasing popularity makes it difficult to work: "You become self-conscious." Commissions from Establishment magazines such as Playboy (which has offered him $500 a page) and Esquire leave him practically paralyzed and unable to create.

So he has moved his wife and child from San Francisco to the small farm in Potter Valley. The couple raises corn, pumpkins, tomatoes, and goats. His wife has learned how to can vegetables from an elderly neighbor. In the living room of their tiny frame house, Mr. Crumb works at a drawing board amid a clutter of wind-up toys, old comic books, posters, a jar of marbles—the kind of detritus that parents make their children throw away.

Although he fears censorship more than anything else, Mr. Crumb has had minor problems of a different sort. Some of his original drawings have strayed from the mails to end up, the cartoonist suspects, taped to the wall in the pads of an occasional long-haired Post Office employe. One arrived at the publisher's in an envelope obviously torn open and stuck back together. Inside was a note: "This is groovy stuff."

—BILL MARVEL

January 1971

It's Howdy Doody Time!

THE FACE is jowlier, the stomach bulges a bit, and there is as much gray as brown in the wavy hair. But there's no mistaking Buffalo Bob Smith as he bursts on stage at New Orleans' Tulane University in his mustard-yellow cowboy suit.

Pandemonium: Balloons and bubble gum, distributed for the occasion, are popping everywhere; short-haired and long-haired students, young mothers with their children, are all on their feet. Buffalo Bob! Then they hush, 1,600 strong, for the inevitable question they've come to hear. Buffalo Bob obliges.

"Say, kids," he booms, "WHAT TIME IS IT?"

The answer thunders back, ricocheting off the walls: "IT'S HOWDY DOODY TIME!"

It's not the first time. From 1947 to 1960 it was Howdy Doody Time on NBC for Buffalo Bob, his troupe of a half-dozen or so puppets, and the other characters who enjoyed unprecedented TV popularity then. And since early 1970, some of the millions of young people who settled down in front of their Zeniths and Carlsons and Philcos every afternoon during those 13 years have been wild to reminisce about the good old days. Consequently Buffalo Bob, now 53, is the hottest thing on the college entertainment circuit.

"Everywhere it's the same," says Buffalo Bob, who is almost never called Mr. Smith. (He likes to refer to himself as Buff or The Buffalo.) "Everywhere I go, whether it's Boulder or San Diego or Hartford, it's always the same. The kids may be a little skeptical at first, but they're great kids, and they remember everything about the *Howdy Doody* show. I've never had so much fun in my 35 years in show business."

Tulane sophomore Richard Katzoff, 19, chairman of the committee that booked Buffalo Bob at Tulane, admitted to some hesitation. "When I first thought about getting Buffalo Bob here after my mother suggested it—she saw a newspaper article about him—I went to some people in the administration and they couldn't believe it. They all started laughing." But when the laughter stopped, both administrators and students gave Mr. Katzoff the go-ahead and, for $1,500, Buffalo Bob came.

In terms of those who preceded him to the Tulane campus in the same series, he's in fast company: Edmund Muskie, Dick Gregory, Joseph Heller, and poets Lawrence Ferlinghetti and Allen Ginsburg. Only Mr. Gregory, as it turned out, outdrew Buffalo Bob.

The Buffalo Bob Howdy Doody Revue is sheer nostalgia, and the Tulane students indulged in it with unself-conscious gusto. Before Buffalo Bob's tumultuous appearance on stage, a kinescope of the 10th anniversary *Howdy Doody* show—Dec. 28, 1957—is played to set the mood. Using a this-is-your-life-Howdy-Doody format, the show is complete even to the commercials for Wonder Bread, building strong bodies 12 ways, and Hostess Cupcakes. The commercials elicited as many cheers and boos as each member of the *Howdy Doody* cast, including the irascible Phineas T. Bluster, Flub-a-Dub, Chief Thunderthud, the Inspector, and (as Buffalo Bob says) all the Doodyville Gang.

The students found one *Howdy Doody* routine particularly campy—the *Howdy Doody* most-winning-smile contest, in which the 10 young finalists paraded on stage for an interview with Buffalo Bob. There were oooohs in response to one contestant's two-year-long perfect attendance record at Sunday school, and some gamier comments when one 7-year-old, settling herself on a stool, flounced her crinoline up to her waist.

But it was Buffalo Bob, not the kinescope, they came to see, and the second half of *The Buffalo Bob Howdy Doody Revue* is pure Buffalo Bob: A strange amalgam of second-rate Victor Borge, jokes you might hear in the lounge of one of the Las Vegas casinos (though not as racy), and sheer corn. Buffalo Bob jumps back and forth between his piano and a stand-up microphone, now singing one of those sprightly, un-memorable *Howdy Doody* songs, now exchanging arcane trivia about the show in a question-and-answer session.

In the process there are some inevitable raspberries and even unkinder comments, but Buffalo Bob skilfully parries them. In response to prolonged and irrational giggling here from one student, he quipped, "Whatever it is, pass it around before you stamp it out."

But this oblique reference to marijuana was about the only topical moment in a studiously apolitical per-formance. "I've gotten maybe one or two questions about drugs and the war and things like that," Buffalo Bob says. "But that's not what the kids come to hear or ask about. They come to relive the happy, carefree childhood days when everything was beautiful and they used to watch the *Howdy Doody* show—the days when we didn't know about burning draft cards or wars."

On the Tulane campus, there have been demonstra-tions against the war in Indochina. Last spring, one night after a speaking appearance by Rennie Davis, the Tulane ROTC building was burned.

"I think many of the kids who led and took part in the demonstration last spring enjoyed the show to-night," observed Mr. Katzoff.

Added a bearded 21-year-old Tulane senior, Steve Armbruster, "I think everybody should be a kid in some ways as long as they live. Everybody should be able to play. There are very few things you can do with the abandon that you can watch Buffalo Bob with."

After his scheduled appearance at Tulane, Buffalo Bob staged an impromptu performance later for some 50 students who didn't want to leave the Howdy Doody world. He signed headbands, books, and draft cards while two teary-eyed coeds clung to his shoulders.

Eventually he swept off to prepare for another college, blowing kisses as he went and saying, "Good night, sweet kids. I love you."

—MICHAEL PUTNEY

March 1971

Reviving Radio's Heyday

FIBBER McGEE is alive and well—on an eight-track stereo cartridge in suburban Westchester County. And so are Amos 'n' Andy, Senator Claghorn, Ma Perkins, and all those other wonderful folks from radioland.

They live in what surely is the nation's largest private library of radio shows, the recorded cream of radio's golden age, which ended abruptly in the early 1950s when television arrived.

And they're all for sale. J. David Goldin, 29, who quit his job as an engineer with NBC in New York City five years ago when his radio library outgrew the limits of a hobby, is making a handsome living selling copies of his recordings from his home in Croton-on-Hudson, N.Y. He sends them out in reels, cartridges, and cassettes of magnetic tape to customers in every state. One obviously happy lady in Florida has already ordered $11,000 worth of old-time radio shows. The tapes, usually including even the commercials, sell for $10 for an hour's recording.

"She hasn't even scratched the surface of what we've got," says Mr. Goldin, as he riffles through the clutch of morning mail. "For that matter, neither have we. We're way behind on cataloging all the stuff we have."

Radio libraries are new, and they're a fad in the nostalgia boom. The Goldin collection is the largest, but it isn't the only one. Mr. Goldin counts 32 competitors, and most got their basic library from him.

"There's nothing I could do about it, if I wanted to," he says, shrugging. "You can buy a tape from me

for $10 and make dozens of copies, and if you can sell them, you're in business. The quality won't be any good, unless you spend a lot of money on equipment, if you can find it. But you can make the copies, all right."

To the astonishment of most radio buffs, the networks didn't always keep recordings of their shows. Most of the early shows were not recorded because they were performed "on the air," and union contracts stipulated that no recorded sound—not even background music—could be used. To avoid disputes, the programs often were not even recorded for the network or station library.

Later, most of the programs were put on 16-inch 78-r.p.m. records, now brittle with age. Not all were saved. CBS won't talk about what it has, or where its library is. NBC zealously guards its vaults on West 53rd Street in New York City. "I made such a pest of myself at NBC trying to get to their radio archives, that I came close to getting fired," Mr. Goldin recalls.

Several universities have established modest collections. The University of California at Los Angeles has many of Jack Benny's old radio shows. NBC gave a small collection to the University of Wisconsin, and Northwestern University got 30,000 radio transcriptions from WMAQ, the NBC affiliate in Chicago, which discovered them in the basement of its building in 1960.

But these recordings, under the terms of the bequests, can't be shared with collectors. Mr. Goldin's recordings can, and he occasionally fills a request from one of the networks.

Though many of the tapes are purchased from Mr. Goldin because of nostalgia, many orders are sent from college dormitory addresses. Occasionally he gets orders from actors or writers, who are astonished and delighted to learn that someone still has their voices filed away.

The content of the old shows ranges from very camp to very good. Camp, of course, is part of the charm to the buffs who collect the sounds of the old days. Mr. Goldin's customers never are quite satisfied with the occasional shows with missing commercials.

Younger customers, who know the radio days only by word of mouth, often are surprised by the origins of familiar expressions and characters of legend. Those who grew up on radio are enchanted with the topicality, even if the lines aren't as funny the second time.

Consider the exchange from Allen's Alley (Nov. 21, 1945) between Fred Allen and Senator Claghorn—the character who became the caricature of the unreconstructed Southern congressman:

Allen: You know, since gasoline rationing has ended, traffic congestion in large cities has become one of the greatest problems of the day. Let's go down in Allen's Alley and see how the traffic dilemma is affecting the people who live there.

Portland Hoffa [Allen's wife and lady side-kick]: Shall we go?

Allen: As the two sticks said when they saw the tom-tom, "Let's beat it!"

(Allen raps smartly on the first door in the alley.)

Senator Claghorn: Somebody, ah I say, somebody thumped on mah doah.

Allen: Yes, Senator Claghorn, I've . . .

Claghorn: Ah represents the solid South. I loaned Mason and Dixon the chalk the day they drew the line.

Allen: Well, I, ah . . .

Claghorn: Speak up, son. Out with it. Speak up. UP, that is. You'll never get anywhere staying silent. Don't try to be another Calvin Coolidge, son.

Allen: Look, Senator, tell me, how are traffic conditions in Washington?

Claghorn: We're investigatin'. Congressman Coffee

is boiling. Hah, hah. Coffee is boiling. That's a *joke,* son.

Allen: Yeah, well . . .

Claghorn: Pay attention, son. Be on your toes.

Allen: Well, I'm doing it . . .

Claghorn: Yeah, you keep *missin'* em, son.

Allen: Senator, look, the streets are filled with cars. What is the solution to the nation's traffic problems?

Claghorn: One, ah, I say, one-way traffic. Monday, all the traffic moves only to the east. Tuesday, all the traffic moves only to the west. Wednesdays east, Thursdays west.

Allen: Ah, ah—what about the north and south?

Claghorn: Son, that was settled by the Civil Wah.

The loquacious senator was only one of several tenants on Allen's Alley, and they all kidded various ethnic groups unmercifully. Titus Moody, who now sells Pepperidge Farm bread and dinner rolls in a new radio-commercial incarnation, played the parsimonious Yankee. Mrs. Nussbaum, who lived in the Bronx, was the quintessential Jewish mother. She doctored with chicken soup, and when her nephew became quite sick she sent him to a famous clinic. "The Meyer brothers," she called it.

The most famous ethnic kidders of all were *Amos 'n' Andy,* of course, and more people order *Amos 'n' Andy* tapes than any other show's. Fred Allen and Jack Benny are almost as popular.

Amos 'n' Andy went off radio in the mid-1950s, under a withering hail of criticism from Negroes, who said the humor demeaned them. But a replay of some of the old Freeman Gosden and Charles Correll tapes shows that some of their humor is back.

Radio buffs who remember Madame Queen, Andy's tough and very liberated girl friend, easily recognize her new incarnation as Flip Wilson's friend Geraldine.

Consider this Nov. 16, 1952, re-creation of an ex-

change between Madame Queen and Algonquin J. Calhoun, Andy's loudmouthed lawyer, during the famous *Madame Queen v. Andrew H. Brown* breach-of-promise suit. Madame Queen has completed her testimony, devastating Andy as a devious philanderer who took advantage of the emotions of a helpless girl.

Algonquin J. Calhoun rises to the occasion.

"Andy" he tells his client in an aside, "watch me wrap this ol' gal around my finger." And then, shouting: "Now, Madame Queen, I'd like to ask you a few questions . . ."

Madame Queen: Wait a minute, shrimp. Whose face does you think you is shaking your finger in?

Calhoun: Well, I . . . I . . . I . . .

Madame: Ain't you ever learned no manners at all?

Calhoun: Yes, ma'am . . .

Madame: Where was you brung up, in a ree-form school?

Calhoun: No, ma'am . . .

Madame: What does you mean, shaking your finger in my face? Is you looking for trouble?

Calhoun: Your Honor?

Judge: Yes, counselor?

Calhoun: If the witness is through with me—she can get down off the stand.

To most listeners, *Amos 'n' Andy* seems as funny today as it did years ago—and a great deal wittier than most of television's fare. And many who buy the tapes are surprised to find the racial humor not nearly as racist as they remembered it. Andy, the Kingfish, and a few of their pals were rogues indeed—but Amos and most of the others were square and middle-class suburban straight.

"I thought we might catch a little flak about the *Amos 'n' Andy* stuff," Mr. Goldin says, "but many of our

customers are blacks, and they buy *Amos 'n' Andy* too. A lot of radio humor was ethnic, and I guess people aren't as sensitive now as they used to be."

Another big comedy seller is *Lum 'N Abne*r, the two hillbilly rubes from the Jot-em-Down Store in Pine Ridge, Ark., whose 15-minute nightly show was once one of the most popular on radio. In fact, *Lum 'N Abner* recordings are back on the radio—on one station, in Arkansas.

Dave Goldin got into the radio-recording business almost by accident. He started collecting occasional 78-r.p.m. snippets of old-time radio in college, and he got going in earnest in 1963, when he went to work as a disc jockey at radio station KSEW in Sitka, Alaska. It was cold during the long nights and there wasn't much for a boy from New York City's Lower East Side to do.

Rummaging through the station's record library one day, he found a few old recordings of *Tarzan* and *Clyde Beatty* shows. They were 16-inch records that only a radio station could play—though not all stations today can play them, because the big turntables are no longer standard equipment.

"When I got back to New York in 1964," he recalls, "I met other people who had recordings—actors, writers, engineers. I started swapping. Pretty soon I had about 200 recordings. I even picked up a few at a Salvation Army store, though God knows why they had them.

"Then one day someone told me they wanted a few of my recordings, but they didn't have anything to trade. So I agreed to sell tapes of what I had. That's how it got started."

Since then, his collection has grown to 10,000 recordings. Nine employes, including his wife, make the tape copies on a bank of machines that can clean up the fuzz and some of the noise of scratches and static on old recordings.

He has hundreds of recordings still uncataloged, including Sir Winston Churchill's wartime speeches to the British House of Commons, Hitler's harangues to the German public, and every Presidential speech since Harry S Truman took office. He got the overseas broadcasts from a British Broadcasting Co. collection of old 78-r.p.m. records.

Mr. Goldin also collects pulp magazines from the 1930s, comic books from the 1940s (one of his poodles is Shazam, named for the Egyptian sorceress who changed Billy Batson to Captain Marvel when Billy called her name), and old radios by the dozens.

His kitchen radio is a 1935 Zenith. The bedroom radio is a 1928 Atwater-Kent. The baby's room has an old Philco. The living-room radio is a floor-model 1922 Atwater-Kent Model 10. The vacuum tubes, which are no longer manufactured, are purchased from radio-tube collectors, who put out a catalog too.

"There's a story about the living-room radio," he says, running a loving hand over the newly varnished surface grain. "I was working then in New York City, and working on this radio when I'd get home at 2 o'clock in the morning. I'd worked on it for months, and my wife had helped. One night, I worked until about 4 a.m. and then turned it on. The light on the dial glowed, it hummed to life—and out came *Amos 'n' Andy*.

"My throat went dry. Man, it was spooky. I ran in and waked up my wife, and she came out, and sure enough, it was *Amos 'n' Andy*, all right. I ran into the den to get a tape recorder—I knew nobody would believe it.

"And then the announcer comes on. It was a station out in West Virginia, playing one of my records."

—WESLEY PRUDEN JR.

January 1972

Football With a Flair

OKAY, sports fans, listen up. Get out your Howard Cosell Outrageous Coup Score Card and chalk up another one: the Vice President of the United States.

Yes, right there at the great man's shoulder (at Howard's shoulder, that is) sits Spiro T. Agnew, an immaculately groomed, hermetically sealed island of calm in the pregame frenzy roiling around him in the ABC-TV broadcasting booth at Baltimore's Memorial Stadium. Howard has persuaded the Vice President to open tonight's show with him, but right now they're trading arcane trivia about the great Baltimore Colts' teams of the late '40s and early '50s.

". . . then there was Jack Del Bello, Howard; do you remember him? Or how about Racehorse Davis?"

"Indeed I do, Mr. Vice President, indeed I do," asserts Howard, and pulls some obscure facts and figures out to prove it.

"Agnew? Here?" booms Dandy Don Meredith as he bursts into the booth, resplendent in yellow blazer, red tie, boots, and his beloved Bailey U-Rollit rough-out suede cowboy hat.

"Hello, Spiro, sir," says Dandy Don, shaking the Vice President's hand. "I luv ya but I didn't vote for ya. But here's someone who luvs ya and probably did. Frank Gifford. Do you know Frank?"

If Howard is Mr. Agnew's host, the former Dallas Cowboys quarterback is his tour guide, explaining this row of dials and switches, that bank of TV monitors, those headsets and earphones. "And then Frank sits over there on the left to do the play-by-play, I'm over here on this side, and Howard's right there in the mid-

dle directing traffic." Only Dandy Don pronounces it Haw'rd.

Mr. Agnew carefully takes it all in and then, with the deliberately casual air of a man who's no slouch at turning a phrase himself now and then, pronounces his benediction: "A veritable plethora of talent."

"Whooooooooeeeee," whoops Meredith, "A veritable plethora of talent. How 'bout that, Haw'rd?"

"Indeed, Dandy Don, indeed," barks Howard in his very best parody of Howard Cosell, "A veritable plethora of talent."

Frank Gifford, deferentially standing off to one side, shakes his head and mutters to no one in particular, "Fantastic, just fantastic."

At the ABC corporate offices in New York on the Avenue of the Americas, that's also the word a lot of executives are using these days to describe *ABC Monday Night Football*. Well they might, because the Nielsen ratings report it is the ninth most popular program on television, probably the first time that a regularly scheduled sports program has ever pushed its way into the top 10. It means that every Monday night an audience numbering about 35,000,000 switches on ABC to watch the football game. Or something.

"I don't think there's any question about it," says Chet Forte, producer and director of the weekly broadcasts. "I think the people tune in the show basically to hear what Howard and Don have to say."

Credit for putting the Messrs. Cosell, Meredith, and Gifford together goes to 41-year-old Roone Arledge, the president of ABC Sports and, by all accounts, some kind of genius. It was Arledge who also had the imagination and clout to schedule professional football in prime evening time, the 3½ hours between 7:30 and 11 p.m. (EST) when on any given night TV sets in 36,000,000 American homes are switched on. Trouble was, most of

them used to be switched to anything but what ABC was showing.

But no longer, thanks largely to what Cosell calls "the happy triumvirate" in the broadcasting booth. Meredith, Cosell, and Gifford seize on every play with the ardor of a Bubba Smith wrapping his six-foot, eight-inch, 270-pound frame around an opposing quar-

terback. They describe, analyze, and evaluate this guard's trap block, that tight end's fly pattern, or why the Baltimore linebackers don't blitz as often as they used to.

More important, the happy triumvirate also points out the shoddy play, the poor coaching, the occasional faulty missed calls by the referees. In short, Cosell, Gifford, and Meredith are honest; they don't gloss over the inevitable mistakes that are unreported by other sports broadcasters. Best of all, they do all this with a zany sense of humor, most of it provided by the badinage between Cosell and Meredith, with Cosell playing Falstaff to Dandy Don's Prince Hal.

"Howard especially will criticize a team or a player in ways that most jocks-turned-announcers won't," observes producer-director Forte, himself a former All-American basketball player at Columbia. "Everything he says is usually the truth, but it's so often things that just aren't said. I mean like the time he pointed out that Lenny Dawson's pass completion record is so high because Dawson throws so many short passes. Who else did you ever hear say that?"

Cosell is an original. He somehow combines the philosophies of both Janis Joplin and Zero Mostel: Get it while you can, and when you've got it, flaunt it. Spending more than five minutes with him is like being force-fed a couple of pounds of baklava and being asked to wash it down with a quart of Grand Marnier. His life style, like his broadcasting style, is grand baroque.

Here he comes now, a tall, slope-shouldered figure with a Ramon Novarro hairpiece, blue blazer, and paisley tie, striding through the bar at the Baltimore Hilton with the crowd, like the Red Sea, parting before him.

"What an extraordinary moment this must be for you, young man," he announces solemnly, sticking out a thin well-manicured hand as I meet him for the first

time. Does decorum dictate that I should kiss his ring?

Cosell, of course, can talk like any moderately intelligent human being except that he sort of pictures himself as an intellectual giant in a profession of intellectual Lilliputians. To ensure that no one confuses him with them, he has developed a speaking style with a penchant for the polysyllabic and alliterative. It is structured on the principle of accretion: He builds his sentences as a good lawyer (which, by training, he is) builds his closing argument before a jury, piling up more and more evidence until the conclusion seems irrefutable. Never mind that some of his sentences don't make complete sense; they always parse, and sometimes they even scan. The final embellishment is, of course, his biting, Brooklyn accent, nasal and falling-inflectioned.

"Dandy Don Meredith? He has personality, he has flair, he has a style, and most important he has an irreverence that this game badly needs," Howard says. "He does, of course, have a guttural illiteracy, but he doesn't treat every play as if it were a coronation. I view Don as the best act I've had since Muhammad Ali," with whom he has long-standing rapport.

As if by cosmic stage direction, Dandy Don suddenly materializes in the gloom. He's wearing jeans, tennis shoes, Izod sport shirt, and a blue ski parka. Just back from a set of tennis (which he lost) and a sauna, he slumps into a chair looking on the verge of total collapse and explains that he's fighting off a bad cold. Howard, solicitous, orders up "a tall tomato juice for Dandy Don"—more, you suspect, for the alliterative possibilities than the fact that Dandy Don will drink it.

"Would you believe it?" Howard begins, now ignoring Meredith. "After more than two decades of wedded bliss with my bride, Emi, I have a whole new marital problem. She's in love with Meredith. And my

younger daughter, on the verge of her marriage, has canceled her engagement—she's in love with Meredith too."

He shakes his head in wonderment at his plight, then spreads his arms heavenward in supplication: "The whole foundation of my life is being swept out from under me."

"Funny thing, Haw'rd," says Don from his death bed, "I just can't see calling you 'pops.' "

He reaches for a slug of Howard's vodka Martini, revives a little, and begins to explain his doing-what-comes-naturally approach to sports broadcasting. "I'm not a comedian and I don't try to be one. I don't have any gags planned before I get up there. I just say primarily what I feel. Football was awful good to me, but it's just a game that's supposed to be enjoyed by the people who play it and the people who watch it. Sure, there's a lot of money involved, and when that comes up the talk gets a little serious. Of course the media of television has . . ."

"Medium," corrects Howard. "The word is medium, Don."

"Of course, the medium of television has had a tremendous influence. . ."

"Did you know that they're going to rename Dandy Don's alma mater," Howard interrupts. "The news just came out today. They're going to call it Southern Meredith University."

Cosell delivers the line straight-faced, then unable to contain himself any longer, breaks into a cross between a giggle and a cackle, shoots his cuffs, and taps an imaginary ash off his cigar.

"Haw'rd, you're beautiful," says Don. "Just beautiful. I luv ya."

"Frank keeps us abreast of the game and gives us his incisive insights," Howard says, plunging into his

explanation of what he thinks the trio's roles are. "Dandy handles the instant replay with the experience and insights he gleaned from his years in the NFL. And I try to put the game into perspective and humanize the athletes. Occasionally I try to break a news story, like the time last year Matt Snell authorized me to break his retirement on the air. About a week later the New York sportswriters had it plastered all over the papers—but, of course, there wasn't any mention at all when I reported it.

"But the game is still the thing," he continues. "The swiftness, the grace, the violence, the sense of the gladiator to it. What we do differently is in the presentation of the game. Am I right, Dandy?"

"Haw'rd," Dandy Don replies in mock resignation, "I was going to say exactly what you said if you wouldn't have said it."

"I love him, I really do," says Cosell, draping a well-tailored arm over Dandy's shoulder. "And all those things that those $120-a-week, bread-and-butter sportswriters have said about us—you know, one of 'em even had us in a fistfight—well, all that is so . . ." Even Howard gropes for the right word to justify the stupidity of it all, and finally settles, a little lamely, on ". . . petty." He shoots his cuffs again in disgust.

"You're fantastic, Haw'rd," drawls Dandy Don. "Just too much."

"Some people are endowed with good looks, others with brains and talent," Howard explains. "I was fortunate enough to be included in the latter category."

"Yeh," allows Don, "but you've still managed to handle the role of sex symbol of Monday night football pretty well."

It's Frank Gifford, obviously, who has been cast (albeit involuntarily) as the sex symbol of *ABC Monday Night Football*. Roone Arledge this year replaced Keith

Jackson, a competent, crisp, play-by-play man, with Gifford, apparently on the belief that in a matriarchal society it's Mom who decides what the family will watch. And Mom will watch a lot of pro football to see a little of Gifford. Once again, Arledge has been proved right.

At 41, Gifford is close to his playing weight with the New York Giants, where, for 12 years, he was—in the kind of superlative-filled phrase that he applies a little indiscriminately to others—one of the truly great football players of all time. Earnest and intense, Gifford is not humorless, but he has been hard pressed to make his own voice heard between Cosell's pronunciamentos and Meredith's japes. Resultantly, Gifford has talked a little too much, although he's finally settling into an accommodation with his colleagues on that score.

"Howard is a real journey, a real charger," Gifford says in his well-modulated, announcer's voice. "That's the side that most people see, but when he comes down he is one of the most interesting people I've ever known, even if I am a jockstrap. You know that Howard really does have a resentment of athletes who think they can go right from the field up to the broadcasting booth. I made that transition myself, but I've been in this business for 11 years now, and I don't think he resents me.

"As for Don, he's a very, very, close friend and one of the most charismatic people I've ever known. He's flamboyant, fun, and fair. When he tells you something, you believe it. With Howard, when he tells you something you'd better believe it." It is a nice distinction, and an accurate one.

On the Monday of the game, each of the three men generally follows a schedule that reflects his style, self-confidence, and to some extent his ego. Gifford closets himself in his hotel room studying game films and team rosters for a last time, although he has already memo-

rized them thoroughly days earlier. Cosell usually runs through an onslaught of interviews, may make a speaking appearance at a civic-club luncheon, and in the late afternoon tapes the staccato commentary that accompanies the half-time films of highlights of the previous day's football games. Meredith might study team rosters or statistics on individual players, but he's more likely to play tennis, read, or whatever.

"If Don showed up tonight at the stadium and knew everybody's number I'd know we were really in trouble," says producer-director Forte. At that very moment Howard Cosell wanders into the Baltimore Hilton's coffee shop, where Forte is having lunch, and announces in a stage whisper that penetrates the farthest corner of the restaurant: "Let me tell you one more thing about Chet Forte. No man in the total chronicle of college basketball ever dumped more games than Chet Forte." Cosell then turns on his heel and moves off.

"What a piece of work is Howard," Forte says with some wonder in his voice. "What a piece of work."

Back in the broadcasting booth it's five minutes to game time, and the Vice President chooses this moment to make his contribution toward more trenchant sportscasting.

"The next time a player is complaining to a referee about a call, why don't you say that he's keening?" suggests Mr. Agnew.

"I'll tell you what," drawls Don, "if you tell me what it means I'll use it."

"This way, Mr. Vice President," says Howard, pointing Mr. Agnew toward an outside porch where the interview will take place. "You've got to climb over a little fence here but you'll maneuver it easily. You have magnificent physical grace."

A minute later the red light on the television camera flashes on, and the Vice President and Cosell are reminiscing how Mr. Agnew bought his first season ticket to the Colts games back in 1947, fresh out of the service.

"For you, sir, we wish a Colts victory here tonight," Howard concludes. "As for us in the booth, absolute objectivity."

Well, not exactly, but does it really matter?

—MICHAEL PUTNEY

November 1971

A One-Man Art Factory

A GENUINE van Gogh fetches more than $1,000,000 on the auction block. An original Morris Katz sells for $6 wholesale. But Vincent van Gogh, as everyone knows, died broke while Morris Katz is making a profit. The difference is merchandising.

The indefatigable Mr. Katz promotes his works over television, at shopping-center openings, and in conventions and trade exhibits such as the Lamp and Shade Show in New York City. Come summer he plans to buy a GMC van and take his studio to the Catskills, where most of his customers spend their week ends. If van Gogh had peddled his pictures along the Riviera, who knows how far he would have gone?

Of course there is a difference in relative quality between the two artists' work. But Mr. Katz's customers are not overly fussy. Mainly they want to be able to say they own original oil paintings—and all of Mr. Katz's paintings, 18,000 of them so far, are that if nothing else. As his sales brochure points out, "If it's a Morris Katz it has to be Original."

Mr. Katz is the king of the so-called shlock artists, superefficient painters turning out hundreds of thousands of slick and forgettable landscapes, seascapes, still lifes, and even a few abstracts every year to hang in hotel rooms, offices, living rooms—anyplace where they don't clash with the drapes.

New York City may be the greatest purveyor of this kind of art in the world. Until recently the city's largest concentration of shlock emporiums, a half-dozen or so, was found along Third Avenue between 42d and 55th Streets, most of them holding perpetual going-out-of-business sales. Several actually did go out of business, a

completely unexpected turn of events, but there are still enough elsewhere in the city to provide several days of casual browsing for the most determined art lover.

Come, then, to Di Salvo Galleries, located on Third Avenue at 50th Street. It's noon, and the place is flooded with girls from the steno pool and tourists dangling cameras. "You take 50 per cent off all marked prices," the banner in the window proclaims, and marked prices are already bargain-basement. Paintings are hung cheek by jowl, floor to ceiling, or stacked in bins. The place has the air of a busy surplus store.

Among the floral paintings, the Paris street scenes, and the pictures of kittens with enormous soggy eyes, one work catches my attention, one lonely abstract filled with shaggy patches of color. From the perspective of several dozen yards and a couple of martinis, it might be taken for a painting by Clyfford Still, but it is signed by P. Wolff. Taking 50 per cent off the marked tag brings its price down to $100.

"That's a nice little number," the cigar-smoking salesman told me. "It has form; it means something." He mentioned that P. Wolff is a Swedish artist, then went on to single out some of the work's salient qualities. "You don't find frames like this very often," he said, indicating the stainless-steel strip that edged the canvas. "Very expensive frame."

I asked about the investment promise of works by P. Wolff. "There's no painting that won't go up in value, whether it's $5 or $10 or $200," the salesman replied. "I've got an article from the New York Times I could show you that says impressionism, which this is [it isn't], is very popular now. If you went up to Madison Avenue, this kind of thing would cost $300-$400."

If you went up to Marlborough-Gerson Galleries on 57th Street, this kind of thing, painted by Clyfford Still, would cost perhaps $10,000.

"If it hits you, buy it" seems the ultimate sales pitch of shlock-art salesmen hot on the trail of a customer. I heard the phrase a dozen times during my pilgrimage through New York's painting stores. In fact, the Arts International Ltd. "Galleries of Discovery" hand out little leaflets that contain helpful advice to potential buyers: "Question: How can I tell if a painting is good? Answer: If you like it—buy it. Art is an emotional experience. A painting is good only if it appeals to YOU. . . . Your own sense of color, line and composition must be satisfied in order for you to really like a painting."

By taking the mystery out of the complicated matter of appreciating and buying art, and thus collapsing 200 years of art criticism, Arts International has become the General Motors of shlock. Each of its 20-odd Galleries of Discovery keeps some 700 paintings in stock all the time—$5 to $75, none higher—and with 400 artists daubing away in studio and loft under exclusive contracts, Arts International has filled up a lot of empty walls.

But what Arts International makes up for in quantity, it more than lacks in variety. During my stop at the New York outlet, located on Fifth Avenue not far from Central Park, a young secretary obviously on her lunch break hurried in and glanced anxiously around the walls. "Where's the painting of the red boat you had last week?" she asked the salesgirl.

The salesgirl shook her head. "We sold everything we had on the walls then. Look around, maybe there's another boat picture you'll like."

If red boat pictures were selling big at Arts International last week, there'll be plenty more of them around this week. In fact, chances are that one of the artists in the company's stable specializes in red boat paintings, producing whole fleets of them. Each of those artists

has one or two specialties. Hector Salas does nothing but sunny forest clearings. Abeita paints gauzy peach-and-plum-colored nudes. M. Katz, not to be confused with Morris Katz of Lamp and Shade Show fame, dashes off bearded prophets.

Arts International has artists who paint Venetian canal scenes after the manner of Canaletto, still lifes of brass pots and peeled lemons after the manner of Chardin, and vines, blossoms, and birds painted with a flick of the brush after the Chinese manner.

The company passes out a mimeographed sheet with each painting, giving a brief biography and photograph of the artist. The faces are young, attractive, art-school eager. No scruffy beards here. "Some of the artists represented in our collection," according to the question-and-answer leaflet, "are talents on their way up, some are fairly well known, others are artists who have 'arrived' in their own country but are unknown in the U.S.A."

They are also, from the looks of their work, one-man art factories turning out perhaps dozens of paintings a week, most of them as alike as toothpicks.

Despite images of struggling young artists bent over their easels, most shlock is produced under what resembles sweat-shop or assembly-line conditions. Crates of the stuff are shipped from painting mills in Hong Kong, Formosa, Holland, and Italy, a fact that has Morris Katz fuming. In the time-hallowed tradition of native craftsmen everywhere, Mr. Katz favors a high protective tariff on all imported works of art.

While he has a point, painters everywhere could as well petition their governments for protection from Mr. Katz. He has tossed off those estimated 18,000 works so far, and now that he has painting down to a system, he could theoretically bury his competitors up to their chins in a few months' output. He demonstrated his sys-

tem during a visit I made to his Greenwich Village studio.

"Time me," he insisted as he placed a blank canvas board on his easel and squeezed fresh oils onto a nearby palette. I glanced at my watch. Then he was off and painting, using nothing but a palette knife and a wad of toilet tissue.

Swish, swish. His vorpal blade went snicker-snack across the top of the canvas board. Sky done. Band of cadmium yellow and raw sienna next, slick as frosting a cake. The knife was wiped clean, dipped into the black, and several quivery vertical lines were sketched in— tree trunks, I realized. Limbs were added.

Suddenly Mr. Katz paused. "No fair, time out," he protested. "I'm out of white." He fumbled for a tube, squeezed out some pigment, and resumed his work, adding highlights to the trunks and branches.

"Next comes the interesting part," he said. "This I invented myself." Dipping the wad of tissue into orange paint, he began daubing autumn leaves onto the branches "I discovered this one day when I dropped a cleaning rag onto the studio floor," he explained.

Including the time taken to replenish the white paint supply, the finished work had taken 3 minutes and 14 seconds, surely less time than da Vinci needed to mix the paints for his *Mona Lisa* and by all odds a record of some sort. After the demonstration, Mr. Katz brewed tea and laid out a sack of cookies while he talked about his work.

Selling paintings takes more time than painting them, it turns out. "Most men are afraid to buy anything without their wives' consent," he complained, referring to a customer who had rummaged through the studio for an hour that morning and had left without buying anything. Still, he insists, "I can make a sale in five minutes."

For a mere $200,000, Mr. Katz says he could be franchised all over the country with galleries and art schools to teach his exclusive palette-knife system. Until then, it looks as if it's the Lamp and Shade Show and the Catskills. But Mr. Katz has managed a more modest kind of fame without benefit of franchising.

The artist also turns out work in what he calls the "Old Masters style"—that is, painted with a brush. These take more time, of course, and they cost a lot more. But mainly they are "good for show, not for sell," he confesses. The triumph of his Old Masters style—Morris Katz's Sistine Chapel, so to speak—is a portrait of Pope Paul VI painted before the pontiff's 1965 visit to the United States. A New York printing company ran off thousands of copies and sold them as souvenirs. And so while an original Morris Katz may never make the auction block at Parke-Bernet for $1,000,000, a slightly less than original Katz made it to parlors and hallways of New York City at a quarter a copy.

—BILL MARVEL

June 1970

Let's Hear It for Vegas!

LET'S PLAY a little game. Think of an ugly building, some pimple on the landscape that only the architect's mother could love, and I'll make up my mind to like it. Okay? Start:

Kennedy Center.

I . . . uh . . . I like it.

Almost any Holiday Inn.

I can like that.

A McDonald's. You have to like the golden arches too.

Easy. I love them.

One of those crackerbox tract houses in Levittown.

Beautiful.

With a plaster footman holding a brass lamp on the front lawn?

Gorgeous. Almost perfect.

Most respectable architects, of course, would have dropped out of the game somewhere between the Kennedy Center and the Holiday Inns. A few esthetes with a taste for pop might have survived the golden arches of McDonald's. But long after most people would have given up, stomachs churning at the thought of some new plastic-and-chrome horror, Mr. and Mrs. Robert Venturi would be plunging on, finding redeeming merit in the strangest places.

The Venturis invented the game, in fact; they often play it together as a means of sharpening their professional talents. Mr. Venturi is an architect; his wife, whose professional name is Denise Scott Brown, is an urban planner. Together with their Philadelphia firm, Venturi and Rauch, they have become famous—noto-

rious?—as advocates of "ugly and ordinary" architecture.

As critic Ada Louise Huxtable says, the profession "is split right down the middle" over the Venturis—"90 per cent against."

About the only real voice raised on Mr. Venturi's behalf is Yale art historian Vincent Scully, who calls Mr. Venturi's *Complexity and Contradiction in Architecture* "probably the most important writing on the making of architecture since Le Corbusier's *Vers une Architecture* of 1923."

"I think his major strength" says Mr. Scully, "is to deal with the American reality, with the way Americans actually live, what they do, the tools they use, what they believe in." The American reality, in part, is tenements and suburban sprawl and the neon and asphalt wasteland of the commercial strip. What most of his critics cannot forgive is that Mr. Venturi and his firm don't just deal with these realities; in an odd sort of way they promote them. The reaction—and the word is not too strong—is hatred.

"This is no more than happened to Le Corbusier," says Mr. Scully, returning to the man who seems to function as a sort of touchstone for all modern architecture. "They called him a Communist and a Fascist in the '20s. A lot of Venturi's critics have labeled him a Nixonian architect, an Eisenhower architect."

Complexity and Contradiction should have vindicated Robert Venturi as an enemy of Establishment architecture in any form, left or right. It calls for an architecture full of accommodation and compromise, expediency, inconsistency, surprise—all those qualities denied by the steel-and-glass-box school that has dominated modern design.

For inspiration, Mr. Venturi turns to the Italian townscape, where 2,000 years of architecture find a

sometimes easy, sometimes tension-filled coexistence. Renovation piles on renovation, shoe shops and bakeries lean against ancient temples, naked children splash in public fountains. What the Venturis see here, and what is absent from so much contemporary architecture and urban planning, is life, vitality.

"Walk by Penn Center," says Miss Brown. "Then walk by Market Street. Market Street is a mess, but it's a vital mess." Penn Center is a gleaming office and shopping complex in downtown Philadelphia. Market used to be one of the city's main business thoroughfares, but now it's just a string of B-movie houses, coffee shops, and adult book stores.

But for all its seedy mercantilism, the Venturis believe that Market Street has something to teach architects and planners. Le Corbusier and the early moderns learned from the architecture of factories, grain elevators, steamships—the vernacular (as opposed to "high") architecture of their day. But the exposed I-beams, the concrete curtain walls repeated in high rise after high rise have become a cliche, Mr. Venturi believes. When the vitality has gone out of a style, he says, it's time to look around for another vernacular to draw from.

"We're learning from the everyday architecture of the commercial strip," Mr. Venturi says. "The architecture that is effective today is ordinary architecture, the decorated shed. Architecture is the decoration of structure, but modern architecture froze out decoration. Our idea is in the mainstream of architecture. Chartres is like a billboard. A person living at the time it was being built could read it. It was a piece of religious propaganda."

In somewhat the same way, the signs along Market Street, and sometimes the very shape of the buildings themselves, can be "read" by a passer-by. A neon cock-

tail glass invites him in for a drink; a marquee titillates him with the prospect of a movie. "Modern" buildings, on the other hand, tend to be abstract. They don't say what they contain. What signs they carry are tastefully recessed and indirectly lighted.

Market Street is an old strip. To see the new strip, you have to go to the suburbs. "McDonald's takes parabolic arches and makes a symbol out of them," Mr. Venturi says. "The thing has to be read from a highway at 70 miles an hour."

This is just the kind of thing urban planners deplore, this "reading" buildings from the freeway at 70 per, no doubt while slurping a milk shake and tuning in a top-40 station. To the Venturis it is just one more step in the evolution of large, public spaces. They said as much three years ago in an article for an architectural magazine.

The scorned shopping center with its vast parking lot, the article insisted, is really a latter-day Versailles. The painted lines control the flow of traffic much as the paving patterns and shaped greenery directed the strolling aristocracy. Instead of urns and statues to mark off intervals, there are lampposts. At the shopping mall one enters another kind of strip, the medieval street where goods are displayed in shop windows and everything is scaled to be read by the man on foot.

The ultimate commercial strip, of course, is the Strip at Las Vegas, where many neon Chartreses offer their messages of renewal and uplift. A few years ago Mr. Venturi, then a Yale professor, and Miss Brown took 13 Yale architecture students to Vegas on what must certainly have been one of the strangest field trips ever.

Out of it has come a book coauthored by the Venturis: *Learning from Las Vegas*. Besides its obvious lessons in decoration, symbolism, and the monumental use

of space, the book draws a subtler message from the Venturis' Las Vegas experience.

"We were recently approached by a group of low-income ghetto residents who wanted our help fighting an expressway," says Miss Brown. "They respected our views of the Strip. They said, in effect, 'If you can like Las Vegas, we trust you not to try and neaten up South Street at the expense of its residents.'"

The remark could stand as a statement of policy. Venturi and Rauch designs are all low-key affairs, never grand or heroic gestures at the expense of their residents. The Guild House in Philadelphia is a solid-looking, eight-story brick structure that looks like what it is: a home for the elderly. Fire Station No. 4 in Columbus, Ind., is the essential suburban firehouse: big sign, siren tower, wide doors for the trucks. At first one would scarcely notice either building, which is fine with the architects. "We're trying to produce second-glance architecture," says Miss Brown.

Second-glance architecture does leave room for art, and Yale's Vincent Scully sees a vein of irony in Venturi and Rauch designs. Two elegant little vacation bungalows are similar to thousands of wooden cottages up and down the New England seaboard—except that the windows are huge, all out of scale with the houses but fine for watching the sea. Scully compares them to the big Ben Day dots in a Roy Lichtenstein painting. And before the wind blew it down, a fake TV antenna sprouted from the roof of Guild House because, according to Mr. Venturi, "The elderly spend a lot of time watching television."

Mr. Venturi speaks of someday designing a government building with a sign on the front that proclaims, "THIS IS A MONUMENT." His firm came very close in a projected city hall for a small town in Ohio: The building was designed with a false front.

The firm recently put together an exhibit for New York's Whitney Museum of American Art. Typically, it was in the form of a big plastic billboard (green and purple, naturally) covered with slogans, pictures of some of the office's projects, and some of what just about everybody but the Venturis would regard as ugly design.

There were the houses of Levittown, the shopping centers, the Strip.

Nearby was the motto: "Learn from what you don't like."

—BILL MARVEL

February 1972

The Great 'Love Story' Con

IT'S CALLED "novelization," and it's a homely little literary cottage industry that works very simply. A paperback publisher arranges a deal with a film company, gets the original screenplay of a new movie, and hires a writer who has done a novel or two himself to adapt the script to fiction form, or "novelize" it. This usually entails inserting some "he saids," a bit of mood and description, some interior monolog, and a dab of straight narrative. The important thing for the writer is to deliver the manuscript on time so it can be gotten out on a "movie tie-in"—that is, published at the time the movie is released. Thus the movie gets publicity from the book and the book gets publicity from the movie; the publisher makes money; and even the author of the "novelization" makes a little.

But that little is evidently too much to suit Erich Segal, the author of the screenplay of Ali MacGraw's new movie *Love Story*, to be released late this year. He has eliminated the middle man and written his own novelization. What's more he has conned a hardback publisher into putting it out and calling it a novel, and now he is on an old-fashioned whirlwind publicity tour —financed, significantly, by Paramount and not by the publisher—to drum up enthusiasm for the hardback edition.

So here he is, dashing in from a television interview, long-haired, suede-booted, looking even younger

than his 32 years. He apologizes effusively for being late and claps a hand to his forehead. "What a schedule! All these interviews in all these cities—and it's just beginning! Let me tell you, I wouldn't put up with it, except that when I read the reviews of my book, I know it's worth it. Here, have you seen them?"

He thrusts forward a sheet of mimeographed foolscap filled with laudatory two- and three-line quotes from various sources. "I mean, if I were pushing last year's encyclopedia I wouldn't bother—but for this book, my book, anything!"

Mr. Segal collapses into an easy chair near a window of his Mayflower Hotel suite in Washington, D.C., loosens his tie, and lets out a deep sigh. "I'll be glad when it's over, though. I want to reorbit. Yes, I feel I have to get back into the university orbit."

That's right: university. Erich Segal is not only a full-time screenwriter, he is also a full-time associate professor in the classics department at Yale.

Somehow, between an off-Broadway musical, *Sing, Muse!,* and the screenplays for three other movies—the Beatles' *Yellow Submarine, The Games,* and *RPM*—he has managed to squeeze in a Ph.D. in classics from Harvard, five years of teaching at Yale, a book of Plautus translations, and a book of scholarly criticism on the Roman theater.

How does he do it? "Well, partly by making use of the classics—not in a ruthless way, but I've robbed from Aristophanes. I'll admit it. Who hasn't?

"But I also think the classics have made me more analytical in my approach to writing. For instance, with *Love Story* I kept asking myself basic, term-paper questions like, 'Is this statement consistent with the view and limits of the narrator?' You see, I wrote the book in a kind of *faux naif* style, kind of phony naive"—Mr.

Segal translates helpfully—"and if you think it's easy to write as simply as that, well, you're wrong.

"But little did I know that I was creating a whole style that's *perfect* for the Seventies. Let's face it. Movies are the big thing now, and this is the style that's right for the age of—as McLuhan called it—electronic literature. Writing should be shorthand, understated, no wasting time describing things. I had no idea that I was solving the whole problem of style this way. But I like it. I'm going to keep it for all my other novels."

So much for style. As for content, Mr. Segal has written a pretty little sad story about a Harvard WASP who meets and falls in love with a poor Italian-American Radcliffe girl and marries her in defiance of his millionaire father. There are interesting complications. Boy meets girl and gets her in the first 50 pages or so, but loses father (is disinherited) in the bargain. But then in the last 50, boy loses girl (by leukemia) and gets back father. While the moral of all this is slightly elusive, the wisecracking, put-down dialog Mr. Segal has written for Ali MacGraw as the Italian girl is all too familiar. You may well find yourself wondering if *Love Story* were not written expressly as a sort of *Addio, Colombo* follow-up to her last film.

And how does Mr. Segal feel about his story? "Well, let's be frank," he says. "It's a very romantic novel. But I think that's where we're going. I think of *Love Story* as heralding a whole renaissance of the romantic. I think we're chucking cynicism. *All You Need Is Love*—that's what the Beatles say, and the kids believe them. Yes, I think it's really going to come."

Erich Segal, a very impressive young man. Sammy Glick with a Ph.D.

—BRUCE COOK

February 1970

* * * *

WITH *Love Story,* movies enter the age of the computer. No, don't look for some exercise in random composition after the manner of John Cage. Anything but. Think, rather, of market research. Remember the precision with which its practitioners determine the profile of the potential consumer so that a manufacturer can then produce an item designed to perfectly satisfy that Mr. Average. They do that with computers.

And that, surely, is how they did *Love Story.* After the usual samplings and surveys, they must have programmed some statistical image of the moviegoer, then fed it into the proper machine. This is what came out: Ali MacGraw, a young, Italian-American Radcliffe girl, meets and falls in love with a super-WASP Harvard boy, attractively played by newcomer Ryan O'Neal. They marry over his rich parents' objections, and he is cut off without a cent. Undaunted, the plucky couple presses on. She puts him through Harvard Law, from which he graduates near the top of his class. And when he accepts a position with a Manhattan law firm, and they are about to reap their just rewards for their sacrifices, it turns out that Ali has leukemia. She dies.

That's it. That's the movie. And if that seems a bit short on plot, then you must be the only kid on the block who hasn't yet read Erich Segal's novelization of his own screenplay, which has been at the top of the best-seller list for nearly a year. On the other hand, if you have read the book, then you know that the story doesn't really depend on complications or the subtle interplay of characters; it is really no more than a series of vignettes glorifying young love. That, too, is essentially what the film attempts—although the lyrical quality that director Arthur Hiller was obviously seeking is dissipated somewhat by the fact that the movie was shot in the dead of the New England winter. And everybody looks so damned cold!

Altogether, it is awful. Terribly cute and self-conscious, whoring flagrantly after youth, mawkish and sentimental, crudely dishonest about death—yes, *Love Story* is all these. Yet it will probably pack them in anyway, for this is precisely what market research said would sell. And who will argue with computer technology? Not H. L. Mencken, for one. A long time ago he observed, "Nobody ever went broke by underestimating the intelligence of the American public." And that, unfortunately, is still true.

—BRUCE COOK

December 1970

DEMIPOP

One of the few verities in contemporary American culture is that the mass audience, as we once knew it, is breaking up. Only in television does a mass audience still exist. Elsewhere, the once-mass art forms (notably movies) are fragmenting into a series of subforms, each with its own audience; and the always-elite forms (theater, serious music, the plastic arts) are growing more elite than ever.

This section deals with some of those few artists who have managed to buck the trend, from Ross Macdonald to Neil Simon to Leonard Bernstein to Andrew Wyeth. Each of them has managed to create popular works in a medium where popularity is a rarity. For some, we have applause; for others, we have doubts. For all, we have a measure of awe.

There are more reviews in this section than anywhere else in the book, and for good reason. With these phenomena, after all, the question to be answered is not so much "What?" (most people, by this time, know of Neil Simon or Leonard Bernstein) as "Why?" Why do these folk succeed where hundreds before them have failed? Herewith, seven attempts at an answer.

Popular — and Art Too

CONTROVERSY, all too rare in the world of books these days, blazed briefly not long ago in the usually quite uncontroversial literary pages of Time magazine and the New York Times. The disagreement centered on the work of mystery writer Ross Macdonald—or, perhaps, not so much the work itself as the weight given to it by a front-page review in the New York Times Book Review of his latest Lew Archer detective novel, *The Goodbye Look*. The honor implicit in the awarding of such a space was made quite explicit in the

review itself, by novelist William Goldman (*Boys and Girls Together*), who said: "It's too soon to assess Ross Macdonald. All I know is I've been reading him for 20 years and he has yet to disappoint. Classify him how you will, he is one of the best American novelists now operating, and all he does is keep on getting better."

Time took violent exception. Citing the Goldman review as chapter and verse, the magazine's anonymous reviewer took off after Mr. Macdonald's latest as "overlong for its specious plot . . . about lost opportunities." Concluding in that tone of stern authority that seems to reside only in the larynx of a Time reviewer, the critic said, "As Macdonald used to know, and now seems to

forget, the order of imperatives in mystery writing is plot first, red herrings second, and philosophizing last, if at all."

Without falling into further discussion of *The Goodbye Look*—which was, after all, favorably reviewed in The National Observer around the time of its publication—it is instructive to examine the fundamental points of view counterposed in the Time and New York Times reviews. What Mr. Goldman is saying, basically, is that a piece of fiction written in a form usually taken as entertainment can nevertheless be taken seriously as art and judged by the same standards used to judge all fiction. The anonymous Time reviewer, on the other hand, is saying that such genre fiction cannot be art and that those who write it had darned well better remember that, rather than cluttering up their entertainments with a lot of pretentious superfluities.

The weight of serious critical opinion is all on the side of Time. For instance, in an essay on the detective novel, the fierce English critic Brigid Brophy treated detective fiction as "the modern myth of violence." She defines it as a kind of fiction, like some others, that "is popular in that it makes small intellectual or imaginative demands on its readers, though its readers in some cases are, unlike pulp-readers, capable of responding to such demands when they are made by a different sort of book." These are "deeply addicted readers," and the fictions that satisfy them, she says, "are our latter-day myths." She implies that literary quality is quite beside the point here, that the real appeal of detective fiction lies in its direct communication with the reader's fantasies.

This is not quite an out-of-hand dismissal. Presumably Miss Brophy has a fantasy life of her own, for she has praised the work of Georges Simenon and Patricia Highsmith, both fine crime writers. Yet remarks she

makes in passing, in an essay on Miss Highsmith, go a long way toward resolving ambiguities: "Indeed, safely beneath the notice of intellectual pretentiousness, the crime genre evolved immense technical flexibility. I suspect more fertile experiment has been made in B-feature writing than in all the *avant-garde* schools. The narrative strategy of Dashiell Hammett, the witty narrative tactics of Chandler, and now the quite brilliant narrative surface of Mr. Ross Macdonald, their successor and, perhaps, culmination, constitute a superb repertory of technical expertise applied, like Hitchcock's mastery of cinematic technique, to (a quite precise critical term, which I use in full consciousness of ingratitude for the stunning entertainment I've had) highclass hokum. It's all, on an unbelievably polished plane, so much play-therapy."

Which backhand slap, delivered with true Brophic dispatch, suggests the categorizing passion of the Time reviewer: There are serious novels, and then there are the entertainment forms—science fiction, historical fiction, mystery and suspense fiction.

Yet Miss Brophy's mention of Alfred Hitchcock—and by coincidence William Goldman cites him, too, in praising Ross Macdonald—prompts a counterstatement of some sort. For the critic who argues against genre fiction by analogy to the film does so at his own risk. The movie makers have done so well lately with what would heretofore have been considered genre films—that is, films in the old entertainment categories of mystery, suspense, Western, etc.—that they have called the validity of such classifications to question. Take such movies as *Bonnie and Clyde, Rosemary's Baby, 2001, Bullitt,* and *The Wild Bunch.* It is no good pretending that these are good films in spite of the stuff from which they were made, for their common virtue lies in having perfectly realized their material—vio-

lence, horror, and the marvelous. Not an *Anna Karenina* in the lot. But these same films have done more to raise the medium to the level of real art than all the pious screen adaptations of literary classics of the past 50 years combined.

What are the implications of this for written literature? First and plainest put, it would seem that Mr. Goldman is right: The fact that fiction is written in the form of popular entertainment should not exclude it from consideration as serious literature.

But that is a bit anemic, isn't it? For after all, while that may be Mr. Goldman's fundamental position, he used that foundation to build a mighty monument to Mr. Macdonald. Can his enthusiasm be matched in some generalized way?

Yes. An honest reader will admit that most so-called genre or entertainment fiction—and within this you can include any specialized sort you like, from Westerns through science fiction—is better than most of the straight stuff. How better? Better in the simplest, most basic sort of way—better because it is more interesting. Entertainment fiction can be interesting in a hundred different ways—a mystery may present a particularly ingenious puzzle, a science-fiction novel may project an intellectually challenging vision of the future, a suspense novel may absorb the reader completely in its narrative rush. But interesting such stuff must be, or it will probably never see print.

Ezra Pound used to say that poetry should be at least as well written as prose. By the same token it seems reasonable to expect that so-called serious fiction be at least as well written as so-called entertainment fiction. But is it? Can you be reasonably certain, that is, that the next novel you pick up will not be written by a creative-writing teacher at a Midwestern state university about his—or for that matter, her—last summer's

adultery? Or will it be a first novel by a solemn-faced young man or woman, as evidenced by a lovely photo on the dust jacket, detailing each painful moment of a Catholic-Jewish-Negro-or-Other Minority Group childhood? And whether one or the other, will the novel be written in that embarrassingly naked style that proclaims Honesty! Truth! and all those other writer's workshop virtues? Chances are that unless touched by true genius, as such works are from time to time, this hypothetical work of fiction will be crushingly and agonizingly dull.

And what virtue has entertainment fiction to offer against all this sweaty sincerity? Intelligence, usually. Sometimes only that, sometimes more. It may be the ingenious intelligence of the seasoned professional writer who knows that whatever else he does, he cannot bore the reader. Kingsley Amis, who is Miss Brophy's nemesis and at least as well qualified to an opinion as she, has given it out that he considers John D. MacDonald, the tremendously prolific writer of thrillers, to be America's best writer—period.

Or it may be the playful intelligence of the man who is alive with ideas and interested in spinning them out in fiction just to see where they will lead. He will very likely choose some form of entertainment fiction because of its more elastic limits and because, as a rule, playfulness is frowned upon in serious fiction. When John Kenneth Galbraith wanted to satirize the inadequacies of Johnson-era foreign policy for instance, he did so in a suspense novel, *The Triumph*. Much science fiction of the better sort is the product of this sort of impulse too. Remember that Kurt Vonnegut Jr., the most playful, the most outrageous, and perhaps the most extravagantly gifted writer in American fiction, "graduated" from science fiction without ever really altering his approach. He was simply accepted in the larger world.

The most consistently interesting serious novelists today have all played with the popular forms—at least to the extent of parody. Vladimir Nabokov, that great parodist, had a good deal of fun with the psychological suspense story *a la* Simenon in *Despair,* and his minor spoof *The Waltz Invention* is basically science fiction. Nor can William S. Burroughs leave science fiction alone; he will surely go on chronicling the escapades of the gang on the planet Nova as long as he continues to write. Among English novelists, Nicholas Mosley writes most often in the thriller format; William Golding deals in science fiction; and Anthony Burgess has done two straight science-fiction novels and a spy story.

"At the root of our esthetic troubles, in America and Great Britain, lies Europe; and in Europe, the Nineteenth Century. The Europe from which our conventional and fashionable notions of culture derive is no more. The new culture is American, even in Europe; and its art is so offensive to those of traditional European culture orientation—and they dominate the cultural Establishment everywhere—that it is dismissed as 'uncultured,' 'commercial,' and 'popular.' "

Henry Pleasants wrote that in the most important book on art—any sort of art—published in some time, *Serious Music—And All That Jazz!* The fact that he was talking about music, for the most part, makes his generalizations no less valid for literature. He argues for American music—jazz, rock, pop—as the new serious music, and he maintains that it would be recognized as such if the inflated notions of the Nineteenth Century were not so widely accepted today. Art is a mystery, and the great artist is a genius passionately inspired to truth-telling and blood wisdom—these are the going assumptions in literary as well as musical criticism.

What is art, then? What is the artist? Again quoting Mr. Pleasants: "Art is no more a profession,

than excellence is a profession, or mediocrity. It is a distinction, the name we give to a superior craft of communication—music, painting, theater, literature, etc.; and the artist is, or should be, the master craftsman."

It is usually those who care least about art who talk most about it and are determined to uphold its standards. They frown a lot and act displeased: they are very rarely entertained. Why is this? Why can't they just read, look, or listen, like or not like, and let art take care of itself? As eventually, of course, it always does.

—BRUCE COOK

September 1969

Mr. Bogdanovich's Throwback

IN THE OPENING moments of *The Last Picture Show*, you discover the young protagonist at the movies. The feature is Vincente Minnelli's *Father of the Bride*, that funny Spencer Tracy comedy, while a poster outside the theater announces John Ford's *Wagonmaster* as the next attraction. Toward the end of the film— of *The Last Picture Show*, that is—the young man flicks out again, this time to see John Wayne in Howard Hawks' Western classic, *Red River*.

I mention all this because it suggests (but only suggests) some of the themes (but only some) in this extraordinary new movie. *The Last Picture Show* is about love, real and illusory; about the American West, real and mythical; and most particularly about the movies, the collective mythmaker to a generation of American young. It is among the most impressive American movies of the past decade. It is a film you can admire, and it is also a film you can love: The two are not always synonymous.

I said it is "about" movies, but it isn't about them in a narrative sense—so let me explain. Peter Bogdanovich, who directed the film and wrote the screenplay with Larry McMurtry from the McMurtry novel, is a 31-year-old film scholar whose subjects have included, among others, John Ford and Howard Hawks. In *The Last Picture Show*, in effect, he has made a Ford-Hawks movie about the people who used to watch Ford-Hawks movies, borrowing the means of myth to destroy the myths themselves—hoisting us, as it were, with our own petard.

"Us." A reviewer's first-person, yes, but a very personal first-person as well. *The Last Picture Show* is about a bunch of kids who graduate from a small-town high school in 1952, and I happened to graduate from a small-town high school in 1952. To be sure, mine was in Westport, Conn., and the movie's is in Anarene, Texas, but *The Last Picture Show* leaves you no doubt that kids in those days were pretty much the same all over. White kids, anyway, and at that time did we think about any others?

Yes, things have changed—and that, too, is what *The Last Picture Show* is all about. Some of the changes are implicit; some of them are right there in the film. The kids are leaving Anarene; the last of the old-time Westerners are dying off; sociability is giving way to remaining at home with *Strike It Rich* and *Your Show of Shows*. "Nobody wants to come to shows no more," laments the old lady who has inherited the town's only movie theater, and one of the boys replies, "Won't be much to do in town when the picture show closes." But did most people really care?

Perhaps nobody really cared about much of anything in those days; perhaps a lot of small towns had to die so that a lot of people could start living. A harsh suggestion, no doubt, yet the casual cruelties that proliferate in *The Last Picture Show* leave little room for keening over the demise of this particular era and way of life. Boy friends and girl friends are summarily discarded for more alluring prospects; an idiot boy is coupled with a cheap, fat hooker for the sake of a few laughs; a young man is struck in the eye with a bottle in a senseless fight over a sexpot who doesn't deserve him.

But am I making *The Last Picture Show* sound altogether grim? I hope not. For one thing, it is often funny—not in any preconceived sense, but in the way

life itself tends to teeter at the brink of absurdity. And for another, there are people of real dignity and substance in it. Sam the Lion, for one: Owner of the picture show, the pool hall, and the cafe, he embodies what was decent and noble in the Old West, the part of the myth that's the first to go. Or Ruth Popper: The lonely wife of the high-school football coach, she takes one of his stalwarts into her bed—and you will just have to see for yourself how gentle, how heartbreaking, and ultimately how understanding this potentially sentimental situation can be.

Ben Johnson and Cloris Leachman give the performances of their lives as Sam and Ruth; and if you want to know what screen acting is all about, I commend two moments to you. The first is just a phrase, Sam's casual reference to the time "after my wife had lost her mind and my boys were dead." It invites pathos, but there is not a shred of that. The other is Miss Leachman's outburst when her young man, Sonny, returns to her after tossing her over for the town cutie. It is a blinding revelation of a human soul in all its battered pride, and it is magnificent. And so is what it gives way to, a brilliant collaboration between Miss Leachman and her director.

For all this, of course, the kids are at the heart of *The Last Picture Show.* Timothy Bottoms as Sonny, Jeff Bridges as his best friend, and Cybill Shepherd as the sexpot are the kinds of kids whom you once knew, if you are older than I, or whom you once were, if you're from around my time. (And let me not forget Ellen Burstyn as Miss Shepherd's mother, another fine evocation of latent dignity.) Yes, *The Last Picture Show* is a "coming of age" movie, among other things, but it bears no resemblance to such purious forebears as *Summer of '42* and *Red Sky at Morning;* these young people are for real.

Finally, there is the matter of authenticity, of detail. The picture is in black and white, to begin with, an inspired stroke that not only lends it the proper drabness of mood, but also reinforces its role of saboteur from within, of using myth to demolish itself. The "score" is composed entirely of period pop tunes emanating from jukeboxes and car radios: *Hey, Good Lookin; Cold, Cold Heart; Mister Sun; Blue Velvet,* and dozens more. The rest of the film is equally proper: People read Collier's and *I, the Jury;* marching bands play *The Washington Post March* and alma maters derived from Cornell's; girls wear halters and lockets; boys drive old Hudsons and spiffy Ford convertibles.

Nostalgia? Don't you believe it. "Antinostalgia" is closer to the mark, for it all looks pretty silly from our present perspective. You greet all those tunes and objects with pleased recognition, all right, but there is nothing of "the good old days" in them, no warmth or promise in their existence. They are like archeological artifacts, useless today.

In his one previous feature film—*Targets,* which starred Boris Karloff as a retired impersonator of movie monsters who gets involved in a real-life mass killing—Peter Bogdanovich also explored this matter of movies and reality, of the obsolescence of myths. There he was working something of a Hitchcock mine; here he is closer to Ford and Hawks in the traditional, ungimmicky, deliberate (but not "slow") way his picture has been shot and put together. *The Last Picture Show* is fine entertainment, a real *movie* movie; just incidentally, it also happens to be a splendid work of art.

—CLIFFORD A. RIDLEY

October 1971

Neil Simon, Boffmeister

A S *The Prisoner of Second Avenue* begins to unfold, it's clear that Mel Edison (Peter Falk) is your prototypical middle-class New Yorker. A 46-year-old account executive who has lived six years in his 14th floor apartment at Second Avenue and 88th Street, he is beset by all the existential woes of the urban condition.

It's 89 degrees outside, but it's an air-conditioned 72 in his living room. The stewardesses next door play *Raindrops Keep Fallin' on My Head* at 3 in the morning. All his food is artificial, and health food makes him sick. Dogs bay in the streets; garbage piles up in the courtyard. "In three years," he says, "this apartment is going to be on the second floor."

Mel Edison, in brief, is quite literally losing his sanity; and in establishing this condition, Neil Simon has done his best work to date. If his new "comedy" is not a wholly successful play, it is a wholly admirable one.

In those opening moments, Mr. Simon catches the feel of New York existence, the sense of raw nerve ends rubbing crazily against each other, about as well as anyone ever has. If art consists of appropriating the stuff of everyday existence and stripping it down to essentials, he has made a mad, dissonant art form out of ordinary urban clay. His concern is reminiscent of *Little Murders,* but where Jules Feiffer saw the urban world in terms of surreal, unseen, almost Godlike forces at play, Mr. Simon sees it as a congeries of tangible, petty irritations. Mr. Feiffer's Alfred has been deadened by the city, stripped of all his responses; Mr. Simon's Mel still greets each successive indignity with a wisecrack, although he knows it does no good. He has only to turn on his televi-

sion—a large screen appears on the curtain between scenes—to hear of an endless parade of strikes, muggings, abductions, and other catastrophes that make his circumstances pale by comparison.

Still, those circumstances grow worse. His apartment is robbed—denuded of money, clothing, liquor, and TV set. ("Nothing to drink and nothing to watch!" he wails at the point of total despair, and in its evocation of modern loss the cry is as bone-chilling as anything in Euripides.) And in an economy move, he is fired from his job.

At this point Mel's predicament begins to seem a good deal less laughable than it looked at the outset, and Simon wisely cools the play down, forcing your sympathy for a man who is in fact at the brink of mental collapse. Mr. Simon has attempted this tragicomic blend before—notably in the first playlet of *Plaza Suite*, the first act of *Last of the Red Hot Lovers*, and almost all of *The Gingerbread Lady*—but he is singularly successful here because he has set you up so well. His evocation of the daily harassments in urban life has been so meticulous, so concrete, that you know the battered condition of Mel Edison's mind as you have known little else in the Simon canon.

And then Mr. Simon does an unfortunate thing. As Mel stands on his balcony during a shouting match with an upstairs neighbor, he gets a bucket of water dumped on him. Actually, it's not a bad metaphor—the crowning insult, all that—but in this context, in this play by this playwright, it shatters the mood. It's okay, Mabel; we can start laughing again. Curtain.

The second and last act is a mixed assortment. At the outset, Mel has been out of work seven weeks and his wife (Lee Grant) has gone to work to support the two of them. It is a devastating, funny portrait of a bored and useless man that Mr. Simon paints here,

shading slowly toward Mel's total mental collapse. Yet the collapse itself is overdrawn and improbable, and again the playwright draws laughs where he needs them least.

Did he perhaps *intend* to create a laughable breakdown? I don't think so, for he follows it with a break-the-ice sort of family conference at which Mel's brother and sisters agree to furnish him X amount of dollars toward his recovery—so long as X is very small. Another devastating scene, this, and matters proceed briskly to the final curtain, at which—you may have guessed it—Mel is doused for a second time. And by this point, Neil Simon is sounding very much like Jules Feiffer, for Mel and Edna—like Alfred—ultimately conclude that if you can't beat urban insanity, you might as well join it. At the final curtain they stare out from their tastefully upholstered sofa, as alone and indomitable as the couple in *American Gothic,* awaiting their revenge.

This is a different Neil Simon than the one who used to laugh just for the hell of it; if you want to know *how* different, I refer you to a book called *The Comedy of Neil Simon,* and anthology of work from *Come Blow Your Horn* to *Last of the Red Hot Lovers.* Yet in another sense he's not so different; in a sense Neil Simon's journey is the journey of many of us over the past several years.

There's a clear connection, after all, between the 6th floor, walk-up love nest of *Barefoot in the Park* and the 14th-floor, express-elevator straight jacket of *The Prisoner of Second Avenue.* Mel and Edna Edison could be the Corie and Paul Bratter of that 1963 comedy grown up, but the timing is wrong: Mel and Edna have children in college. Wait, however: Suppose we assume that Corie and Paul didn't move into their loft in 1963, but in 1953? Then it all works out.

And they did, you know, for the fact is that comedy

in 1963 dealt with a world that had stopped existing for almost everyone but newlyweds and comedy writers. Mr. Simon and his comperes had their details right, but the mood was wrong; their characters still believed in the perfectibility of man and his works, although many people in real life did not. Today, however, the message reaches us a hundred times a day. And so the toilet that was cute in *Barefoot in the Park,* flushing only if you pulled the handle *up,* has become a gurgling monster in *The Prisoner of Second Avenue,* refusing to stop flushing until the handle is jiggled.

This is the key to the change in Neil Simon, along with the change in many of us: In eight years, that damned toilet has been fixed tens of times, and it still doesn't work. Nothing works. Or as Edna Edison puts it: "Is the whole world going out of business?"

Yet there are still people who choose to ignore all this, who visit a Neil Simon play in the expectation of recapturing the world of *Barefoot in the Park,* of guffawing mindlessly at unreal and untroubled people. That is why the twin dousings in *The Prisoner of Second Avenue* are so unfortunate: Coming from Neil Simon, the old boffmeister, they trigger an avalanche of brainless and cruel laughter that I'm convinced Mr. Simon did not intend. I must ask you to forgive the cliche here, but at these moments, and during Mel's crackup as well, Mr. Simon is asking us to laugh because it hurts too much to cry. But that's not the kind of laughter he's getting.

It's a shame. Directed with *eclat* by Mike Nichols and performed to near perfection by Peter Falk and Lee Grant, *The Prisoner of Second Avenue* is a much better play than it likely will receive credit for being. How now, Pagliacci?

—CLIFFORD A. RIDLEY

November 1971

Where Have Musicals Gone?

I N ONE of the nicer little moments in a nice little movie called *Out of It*—glimpsed briefly, like a comet, in mid-1970—a young man named Paul is attempting to score in a parked car with a girl who thinks him "deep," a philosophical sort. He is defining their relationship. "Who can explain it?" he says. "Who can tell you why?" A pause, and he plunges on. "Fools give you reasons. Wise men never try."

Take that as the text for today: *Some Enchanted Evening* reduced to a make-out line. There is something grimly fitting about it, for we are watching the death throes of the musical comedy.

Want proof? Pass a day or two with the cast albums of Broadway's recent musical hits. That's what I have just done, augmenting my personal observation of about half the shows involved, and the conclusion is clear: the musical comedy has had it.

Consider the evidence:

The Rothschilds, an overdrawn, heavy affair about the House of Rothschild that sometimes suggests a mercantile *Fiddler on the Roof,* sometimes suggests a lot of other things. There is no unity to the music, no wit to the lyrics. (The local man liked the line "May Bonaparte be blown apart," which may give you an idea of the rest.) It is depressing.

Two by Two, a silly embroidery of the Noah story that suggests the Bill Cosby routine inflated to fill an evening. The Martin Charnin lyrics run to rhyming "grass for me" with "blasphemy," but they're still a cut above most of the competition. The Richard Rodgers music is weak at the beginning and end, strong in the middle, and often uncharacteristically derivative.

Coco, based on the later life of you-know-who and starring Katharine Hepburn doing her Rex Harrison impression. Alan Jay Lerner, the lyricist, has sunk to lines like "This kind of a primping is self-service pimping," whatever that means, and to rhyming (?) "bed and board" with "bed and bored." The music, which sometimes goes on and on, is by Andre Previn, and it isn't any better the third or fourth time around. The inspiration for the show was clearly *Gigi;* the effect, more in sadness than in awe, is gee whiz.

Applause, which reworks the film *All About Eve* (having to do with the supplanting of an older stage star by a young one) to fit the demands of the musical stage and the vocal limitations of Lauren Bacall. Miss Bacall generally gets about halfway toward making her material work; but then the material itself is halfway stuff, full of good ideas that remain resolutely routine in the doing. The musical does include a couple of lively modified-rock production numbers, in which a young lady named Bonnie Franklin is something else. But I take it as a sign of a troubled show when the star has almost nothing to do with the biggest things in it.

Well, that's it; and before you carp that I'm serving up some long generalizations on rather short evidence, remember that these are the *hits,* the shows still running. I could tell you about *Ari,* but you wouldn't want to know. Or about *The Last Sweet Days of Isaac,* which isn't a musical at all, but rather a couple of precious one-act plays with some pleasant incidental music. Or about *Jimmy,* or—a couple of years back—about *Mata Hari,* or . . . But instead let me say a word about *Purlie.* Regrettably, I haven't seen the musical version of Ossie Davis' play *Purlie Victorious,* which has to do with how some black cotton-pickers outwit the Old Cap'n down on the plantation; but the score, at least, is a joy. Running from gospel to banjo pluckin' to blues to plain old

belting rock, it actually is informed with the pleasure and pain, the fun and famine, of being alive. In fine, it is what a musical score ought to be—a reflection of the people who sing it.

It would be nice to conclude from this that the musical as a genre is not moribund, that it is simply waiting for a few more *Purlies* to administer mouth-to-mouth resuscitation. But not so. It is quite likely that *Purlie* is no more than the final gasp of what we may call the "ethnic musical," and it is probably about time. Rodgers and Hammerstein gave us the Far East; Harnick and Bock gave us the Jewish *shtetl;* and now, after the Greeks and the gypsies and the rest have paraded through, we are back to Harnick and Bock reprising themselves in *The Rothschilds*. The mine is close to played out.

And to those who would find the salvation of the musical theater in *Hair*, let me suggest that it, too, is an ethnic musical of a kind. No less than most of its fellows, its mood is one of clebration, and its appeal as a piece of theater is largely to middle-class curiosity. Worse luck, the life style it celebrates is so mercurial that the show can seem dated overnight; those who have seen it recently may feel, as I did, that there is a lot of straining behind all that joy and ruction and spontaneity, as if these things weren't quite so accessible as they seemed three years ago. Like other ethnic musicals, *Hair* seems a one-shot phenomenon—beyond, of course, the further question of whether it's properly a musical at all. It's a marvelous collection of songs, but whether its free-form structure is inspired by some dramatic purpose is a matter each man must decide for himself.

Company is a musical; it tells a story, of a kind (although the plot line is the weakest thing about it), that is illustrated by music. But it is a musical unlike any

other. Transpiring on several stage levels at once, dealing not so much with a narrative as a collective state of mind, forsaking celebration for much of its length in favor of tough, ironic satire, and above all presuming that its audience is intelligent, *Company* is a stunning piece of work. It centers on a cool bachelor, Bobby, whose married friends are forever touting the joys of wedded bliss even as they unmercifully flagellate themselves; and on the surface, its lyrics and melodies sound simple, even simplistic. Yet listen closely: Almost everything has a catch in it.

The Stephen Sondheim score is all of a piece—not alone in tone, but even glued together by a little downward minor-third jump that appears again and again, a kind of Bobby-motif that does for the score what the physical Bobby does for the plot. Mr. Sondheim is full of motifs. He is very long on pauses at crucial moments, giving his score a jagged, unpredictable quality that perfectly matches the goings-on. He has caught the essential jitteriness of the conception in several quasi-patter songs. Since *Company* is about precisely what the title says, he has written most of the numbers for more than one person—including a fugue, a duet, some close harmony, and more—and then played them off against three solos, which are logically the loneliest moments in the show.

Contrast: That's still what it's all about, and *Company* draws much of its strength from a contrast between the toughness and newness of what it says and the oft-familiar materials that its thoughts are couched in. There's an Andrews Sisters-type number, a hat-and-cane swisher, a march, a torch song, and so on—but the ideas in them work against the conventions of these genres to produce a remarkable kind of tension.

Can we then conclude that *Company* is the musical of the future? Again, I doubt it. Like *Man of La Man-*

cha before it—and they are *the* musicals of the past 10 years—it is one of a kind, literally inimitable. It is out of the musical mainstream, and it is in the mainstream— *No, No, Nanette* and the like—that one must look for the causes of the current malaise. And the mainstream is running dry.

It is nice to see as perceptive a critic as Alan Rich, in New York magazine, take time out from worrying about Webern and Stockhausen to remark on how pedestrian the music in *No, No, Nanette* really is. One need only hear the score to confirm him, for there is not a distinguished melody in it. Pleasant, of course—but that is all. And the lyrics? They run to archaisms like "girly" and "hubby," and to rhymes like "Don't be a fool, girl/You're just a schoolgirl." Cole Porter would *plotz*.

But if *No, No, Nanette* is a particularly egregious hunk of nostalgia, it is still only slightly more nostalgic than the shows on Broadway that surround it—the ones written in the last couple of years. It is a truism to note that on Broadway even more than in the rest of the arts, movies possibly excepted, yesterday's entree is today's blue-plate special. Yet it is still astonishing to realize how widespread the practice has become. Listen to four allegedly contemporary Broadway musicals, for instance—my examples A through D above—and you will hear echoes of *Fiddler on the Roof, Man of La Mancha, Jennie, My Fair Lady, Hello, Dolly!, The Pajama Game, The Music Man, Gigi,* and, of all things, *Carmen.* That's a good start on an anthology, and an anthology is what the Broadway musical has largely become.

The reasons, of course, are economic. When it costs upwards of $500,000 to get a musical on Broadway—as when it costs upwards to $2,000,000 to get a movie on the screen—it is a brave man who would risk his own time and his investors' money by trying something new.

And Broadway is not populated by a race of brave men.

I am indebted to the local drama man for reporting a *bon mot* that rather nicely makes the point. You may recall, earlier this season, a musical called *Lovely Ladies, Kind Gentlemen*. It was an adaptation of a nice little play called *Teahouse of the August Moon,* which was set on Okinawa after World War II and peopled largely by Orientals. The out-of-town opening, less than two months before the show was to bow on Broadway, was a disaster. At which point someone connected with the show is said to have surveyed the carnage and remarked brightly, "Well, we've got six weeks to make it Jewish."

They couldn't pull it off, apparently, and *Lovely Ladies, Kind Gentlemen* turned up its toes in short order. The point, if it needs making, is that Jewish is In on Broadway, and one attempts something else at his peril. The larger message, however, is obviously that when confronted with trouble, Broadway tends to seek a solution not in effects that are different from the ruck but in those that are the same. But since a given show may have started life at least a little bit different, the result of the tinkering is almost inevitably a hodgepodge.

The old musicals were nothing if not hodgepodges, which may be why *No, No, Nanette* doesn't look nearly so uncomfortable on Broadway these days as it might. But the old musicals didn't pretend to anything else; I take it to be the tough, acerbic Rodgers and Hart score for *Pal Joey* in 1940 that first suggested musicals could be all of a piece—and thereby made the form not an entertainment but an art. Today, largely, we are given entertainment masquerading as art, and not very good entertainment at that.

—Clifford A. Ridley

March 1971

'Nanette': The Bee's Knees

BROADWAY, which has desperately needed a big, fat hit to prove it's alive, has received one as a gift from the year 1925. The revival of the Otto Harbach-Frank Mandel-Vincent Youmans-Irving Caesar musical *No, No, Nanette* is an absolute joy from beginning to end. You are in love with it seconds after the overture starts and swings into *Tea for Two* and shortly follows it with the show's other great standard, *I Want to Be Happy*. Imagine! A musical with hummable songs. What quaint ideas of entertainment they had in 1925!

Then the curtains part on the first of Raoul Pene du Bois' sumptuous period sets (not to mention his fabulous costumes). It is James Smith's home in New York City, and it looks like Grant's Tomb gussied up for the living. You have only to note the staircase curving up one side of the stage and down the other to start tingling in anticipation. After all, the program says this production was supervised by the legendary Busby Berkeley—he who set thousands of girls in patterned motion through dozens of movie musicals—and if ever a staircase was designed for "The Busby Berkeley Girls" (that's what they're called), this wraparound job is it.

Stage center at curtain rise is the bulky rear view of a stumpy maid, cap and all, wrestling with a vacuum cleaner. She turns around and glares at the audience. It's Patsy Kelly, the sour movie maid of all times. "I hate this job," she says with that flat voice that could cause cattle stampedes, and the theater falls apart. For once there is more love than pollution in the New York City air.

Okay, so the production slows down a bit in the first half of the first act as the nonsense plot is set in motion. It is three plots interwoven, all as innocent as Cream of Wheat. First there's Nanette, a sheltered young thing who wishes everybody would stop saying no, no to her when all she wants is a little taste of life before she settles down to marry Tom, assistant to Billy, who is Mr. Smith's lawyer. Mr. Smith is a wealthy Bible publisher who, unbeknown to his wife, Sue, has given lavish sums of money to three young ladies for no reason other than that explained by the lyric, "I want to be happy." But the ladies are threatening to tell Mrs. Smith, so lawyer Billy, married to Lucille, Sue's chum, must do something—is anyone paying attention to this? I thought not, so let's skip right to the lovely heart of *No, No, Nanette*.

It's Ruby Keeler, the tappy-toed darling of all those Warner Bros. Depression show-biz fantasies. The years have been kind to Miss Keeler. Her hair has grayed, her chin line is softer, but that's all that's changed. Her figure is as good as ever, her acting ability as indifferent as ever, and her dancing seems better than ever. When she slams into her two big numbers, the house goes mad. And it isn't only a memory of when we were all younger that is being applauded; it is also Ruby Keeler 1971 who is stopping the show. In the old flick *42nd Street*, Warner Baxter told chorine Ruby "You're going out there a youngster, but you're coming back a star!" In *No, No, Nanette*, Miss Keeler enters as a memory and in her first number proves she is much too young for the Hollywood mothball fleet.

What makes *No, No, Nanette* work so delightfully is that this production hasn't taken the easy route to camp. There is none of it in the excellent adaptation and direction of Burt Shevelove, or the superb choreography of Donald Saddler. The tone is sentiment and

affection for a time gone by, when the world was a better place, where innocence was still credible and wickedness was light years removed from evil.

All of the stars that help light up *No, No, Nanette* are not from the Hollywood past. Helen Gallagher is right out of the Broadway present, but she fits in hand and glove with her special wry-torchy quality. And Bobby Van, looking like a memory of Dan Dailey, is a hoofer to rank with the best of them. A very special bouquet must go to Susan Watson in the title role. Her Nanette has none of the sticky sweetness that one associates with the ingenue roles of yesteryear. This Nanette is really the bee's knees, and that's no banana oil. Little Miss Watson, who wasn't even around to remember 1925 (nor was her juvenile swain, Roger Rathburn, who is also excellent) touches down on the period with all the assurance of an astronaut. Only Jack Gilford, as that odd Mr. Smith who gives girls money without strings attached, seems a bit out of the evening. His approach is built of a sweet innocence that recalls the late Ed Wynn, and there is a feel of slight discomfort about his work. He doesn't detract from the evening, but neither does he add to it.

What else is there to say except get on that line at the 46th Street Theater box office? If you can't, then write for tickets, plead, find a scalper, or break into someone's house who already has tickets, but do see *No, No, Nanette*. It's that old wonder drug, part pepper-upper, part tranquilizer, and it makes you feel good all over.

—HASKEL FRANKEL

January 1971

That Funky, Rousing 'Mass'

WHEN Roger L. Stevens, board chairman of the John F. Kennedy Center for the Performing Arts, commissioned Leonard Bernstein to write a work for the hall's opening, it was rumored that he hoped for another *West Side Story*.

Whether the rumor is true, that's pretty much what he got—and perhaps a little bit more. For Mr. Bernstein's *Mass*, which gave the center its exciting, almost uproarious official opening, is a work very much in the spirit of *West Side Story*—but a *West Side Story* that has been sent to church and transfigured into a Bernsteinian affirmation of faith for our time.

Starting with the Roman Catholic liturgy and juicing it up with what can only be called additional lyrics by himself and Stephen Schwartz, Mr. Bernstein has composed a *Mass* that, whatever its aspirations, has its roots solidly in the Broadway musical theater. Its message is carried not only by choristers and choirboys but by an array of 200 actors, dancers, singers, and musicians.

Of course, Mr. Bernstein is far from the first composer who has turned the Catholic Mass to his own uses. Berlioz made it a fanfare for brass bands; Verdi tranformed it into an Italian opera. Being an Ameri-

can with a compelling theatrical sense, Mr. Bernstein frankly subtitles his version of the liturgy "A Theater Piece for Singers, Players and Dancers."

Actually, it's even more than that; it's practically a compendium of the American musical styles of today. Mr. Bernstein's Mass blesses Broadway, sanctifies symphony, hallows folk song, consecrates rock.

Mr. Bernstein comes as close as anybody could to blending these disparate styles into a satisfying whole, and if his success at the end is less than complete, it may be because it is utterly impossible to fuse all phases of today's music into a single coherent two-hour work. But the attempt is vigorous, exciting, and often exhilarating. The *Mass* quickly moves from tape-recorded voices intoning offstage prayers to a young folk singer, accompanying himself on a guitar, singing a simple tune. The folk singer slips a surplice over his blue-jeans and shirt, as if donning the vestments were the most natural thing in the world; a congregation appears in benches on the stage; and the celebration of the Mass has begun.

With considerable ingenuity, wit, and skill, Mr. Bernstein and his associates—director Gordon Davidson, choreographer Alvin Ailey, set designer Oliver Smith, and conductor Maurice Peress—turn *Mass* into a vivid stage work. A brass band marches out, taking up the melody of the *Kyrie;* small boys turn handsprings and perform cartwheels; the folk singer-turned-priest, splendidly performed by a young man named Alan Titus, mingles happily with his parishioners.

The music is similarly vivid and varied, with the symphony musicians in the pit, the rock band on the stage, and every other conceivable combination having its moment, from a solo bassoonist on one side of the stage to a choir of kazoos on the other. Songs that sound very much like potential hit tunes start to ap-

pear. A syncopated Gospel sermon that starts out "God said 'Let there be light'—and it was good, brother!" may be the best thing of its kind since Gershwin wrote *It ain't necessarily so* in another great work of the musical theater.

For all the brilliance of his *Mass*, Mr. Bernstein's purpose is deadly serious, and the bright melodies and clever lyrics must contend with traditional church-like passages whose music seems more forced and academic. There are references to the war in Vietnam, the Berrigans, the assassinations that have darkened American life. And eventually the music and stage action reflect the doubts and divisiveness of the times. A hippie-type congregant asks bitterly, "I believe in God, but does He believe in me?", and the celebrant of the Mass responds, in a typical Bernstein-Schwartz lyric, "When my spirit falters on decaying altars, I will still go on."

It is at the end of the Mass that music, words, and action are at their least convincing. A theatrical Calf of Gold dance becomes a matter of red spotlights and twisting bodies, with music that is merely raucous. Despite a Bachlike chorale that closes the work, Mr. Bernstein has not really found music to sum up and set forth his affirmation. Although he proves himself the master of his basic style, he does not rise above it.

But even without this final hallmark, Leonard Bernstein's *Mass*—masterfully contrived, marvelously performed, rousingly applauded—was a magnificent work for the Kennedy Center opening. Mr. Stevens knew what he was doing after all.

—HERBERT KUPFERBERG

September 1971

The Wyeths: A Yen for Order

ARRIVING from the south, you reach the brand-new Brandywine River Museum in Chadds Ford, Pa., by way of a pretzel called Delaware-Pennsylvania Route 100, too small for inclusion on the standard maps. You've always heard of "Wyeth country"; now you're in it. Foot-high regiments of corn march primly across weedless fields; glistening Thoroughbreds and black Angus graze placidly behind split-rail fences; estates priced in the hundreds of thousands lurk at the termini of winding drives, cheek-by-jowl with weathered old barns; at one point the road is completely arched over with low-hanging trees. "The Brandywine Valley is the most beautiful place on the East Coast," says one former resident, and for the moment you are not inclined to disagree.

The museum building is no anticlimax. Set back from venerable Route 1 along the leafy banks of the sluggish Bandywine River, it presents a three-story facade of red brick broken at regular intervals by deep, closed shutters of weathered spruce. The building is a 100-year-old grist mill to which has been added a concrete circular core bounded at the rear, overlooking the river, by glass-enclosed brick walkways on all three levels. The visitor enters through a courtyard surrounded by open stables; the white walls of the galleries are played off against huge beams and supports. It is a beautiful piece of restoration for a modern age.

The first exhibit in the $1,200,000 building, owned and operated by the nonprofit Tri-County Conservancy of the Brandywine, is something of a restoration job itself. Called *The Brandywine Heritage,* it is an essen-

tially tripartite affair presenting, on the first floor, works by the late American illustrators Howard Pyle and his pupil, N. C. Wyeth; on the second, works by Wyeth's son, the formidable Andrew; and on the third, works by Andrew's son James, 24. All the artists have lived and worked in the region. Other Pyle students are also represented, and a separate ecology exhibit reflects the conservancy's principal aim.

It is a laudable project, and I wish I could be more enthusiastic about the art on view. But I fear it plays a decided second fiddle to its setting, natural and architectural; and while I mean that as a tip of the boater to the Brandywine Valley, it may not be accepted in that spirit. The good folk of the Brandywine take their Wyeths very seriously indeed. When I visited the museum four days after the official opening, the oohs and aahs, and whispered comments—together, of course, with the discussions of what is located where and who modeled for which—would not have been amiss in a Rembrandt retrospective. But then most Americans take their Wyeths seriously—particularly Andrew, the most popular painter in the land.

To be sure, there is a good deal to admire in the show. In a sense, old N. C. Wyeth comes off best, for he was an illustrator of considerable warmth and gusto with very few pretensions of being anything else. A kind of unself-conscious love of action and human eccentricity emerges from his works on view; in one particularly ingenuous example, a brawling Indian is fetched a blow that literally sends him somersaulting through the air. And in the noted *Treasure Island* series, filling an entire wall, his uses of light—sometimes slashing, sometimes suffusing—suggest that under more subtle circumstances he might have been quite a "serious artist." The impression is heightened by his self-portrait, a self-effacing small oil in which he almost peeks out from be-

hind a desk, his eyes totally in shadow, a stream of light falling on his white shirt-front.

It is not easy to segue to Andrew from old N.C., for there are fewer father-to-son influences evident than you might expect. Mostly, perhaps, you would expect the son to inherit his dad's sense of drama, but what often emerges from this parade of browns and greens and grays is a surprising dullness. In scene after scene (saving, particularly, a couple of wildflower paintings) you enter a world of infinite detail and precious little sense of life, in which nature is everywhere evident yet mostly without awe.

The portraits are particularly disappointing. There is little character in these faces, little sense of the dignity one expects to discover in these Brandywine Valley neighbors. In fact, it is disconcerting to find several of these personal studies a trifle condescending—including, for me, the famous *Drifter,* that Listonesque black man who refuses to look you in the eye. You may suspect the emotional quotient of these works to be preconceived, rather than emerging from the works themselves. And you may be reinforced in that notion by the flagrant sentimentality of such paintings as the quite awful *Children's Doctor,* a portrait of a lady pediatrician that is complemented, in the upper right, by a rear view of her full figure, medical bag in hand, walking into some ghostly mist.

Fair's fair. Mr. Wyeth has his virtues, and they ought to be noted. He has a fine compositional sense, for one thing, when it is not subverted—as it often is—into sheer staginess. There is a firm sense of texture in such subjects as tree bark and forest underbrush and stucco houses. Several works are done in a kind of calligraphic wash style that can come off exceptionally well—particularly in the 1945 *Young Buck,* a brown-and-white study of a deer hanging in a doorway—and the recent

tempera of a young girl called *Siri* is a notable exception to the portraiture on view. Not only is the girl interesting in herself (proud, assured), but she is placed slightly off center against a white door and mantlepiece whose patterns play against her figure to create a sense of movement that bespeaks the artist's concern with the painting as a subject in itself.

As for James, what is surprising is not that many of these assorted Brandywine scenes, waterfront studies, portraits (including the publicized rosy-nosed one of John F. Kennedy), and whatnot are banal—he is, after all, only 24—but that several are surprisingly good. Like his father, young Mr. Wyeth has a fine feel for texture —the rust on a huge buzz saw, the gleaming metal of a kitchen pot. And when he really feels his subject, he makes you want to shout "Right on!"—notably in the sensitive portrait *Draft Age,* of a black-jacketed youth with hand insolently on hip (no condescension here).

But for the moment Andrew is the attraction, and one is left to ponder why. In the end, you get down to nothing more startling than the pervasive search for permanence, for order, for "comprehensibility." It is fitting that Andrew Wyeth should open a museum dedicated to preservation of the environment, for his work probably appeals most to those who would preserve not only the environment but the social order. What many find disturbing is not that he is revered here in the Brandywine Valley, but that his veneration through the length and breadth of the land signals an unwillingness to come to terms with new ideas and attitudes, with spontaneity, with a world of movement and curiosity and noise. It is as if, forced to choose between the irritating quick and the orderly dead, many troubled folk have cast their vote for the latter.

—CLIFFORD A. RIDLEY

June 1971

By their nature, newspapers don't often look back. Our job is to tell you what's happening or what's likely to happen, not what has already happened. Yet our job is also to *explain* present and future trends—and for that, we must determine where they came from, what has gone before.

This section is composed of six backward glances. Two of them are obituaries, and in each of these—dealing with Igor Stravinsky and Louis Armstrong—you will discover an attempt to define not only the subject's accomplishments, but the legacy he left for today and tomorrow. The fact of such legacies, of course, is the reason these two giants deserved such extensive treatment in the first place.

We hope it is also *sympathetic* treatment. A third piece here, a reminiscence of the poet John Berryman, is all of that—suggesting, as we hope the obituaries do as well, something about the life of creation itself.

Two more of these articles deal with subjects still living: Frank Sinatra and the Beat Generation. (The chief Beat, Jack Kerouac, has died, but most of the rest carry on.) The idea here was to pinpoint the end of an era—to say, in effect, The party's over, and what did it mean?

And finally the lead piece, a survey of a German writer— Hermann Hesse—dead for a decade. What on earth is it doing here? Well, what on earth was Hesse doing as culture hero to the American youth of the late '60s and early '70s? The question is journalism, but the answer is history.

Guru From the Black Forest

NEARLY a century ago, in a Black Forest village of quaint gingerbread houses nestled in a storybook setting of wooded hills, a writer named Hermann Hesse was born. And although he emigrated to Switzerland in his 20s and did some traveling during his long lifetime, he never once went to America. Nevertheless, the enthusiasm for his books has grown so steadily among the American young that if a poll were taken today the Woodstock generation would probably discover that it had elected as its poet laureate this German author who has been dead now for about eight years.

A few statistics may prove the point. Although nearly all of Hermann Hesse's novels are now in print in hardback editions—Farrar, Straus & Giroux has been doing an especially fine job of bringing out good, new translations of his less-known works—it is in low-priced paperback editions that they are being bought and read today by college-age young people at such an astonishing rate. Hesse's *Siddhartha,* for instance, is New Directions' best-selling paperback to date: 1,000,000 copies are in print, and a quarter of these were sold just last year. When Bantam brought out the first paperback edition of *Steppenwolf,* it sold 360,000 copies the first month; a year later its total sales stand at 650,000. Another favorite, *Demian,* is also creeping up there; at last look, 750,000 copies had been sold—and the word on this one has just begun to spread.

Why? How to account for the particularly strong appeal of this German author whose works are in many ways so old-fashioned? Sometimes ponderously philosophical in the old, familiar German way, but more

often in stark and simple parable style, Hesse's novels are all essentially religious in their intention—attempts to resolve the conflicts of flesh and spirit in a synthesis that will have some value for the individual. But they are religious works with few certainties and no dogma. This is my resolution, he tells the reader, and now you must do what you can to make your own.

To the degree that this translates as "do your own thing," it pleases his young readers and displeases the critics. Although a Nobel Prize-winner (1946) and an author of classic standing among the German-speaking peoples, he has always somehow put off English and American critics, who seem embarrassed by the sort of artless honesty and lack of guile that is so essentially Hesse's own. There is scarcely an ironic line in all his work. It is characterized by the sort of earnest Truth-seeking that went out with George Eliot. For the most part, the critics have ignored him.

Nevertheless, those American young who seem to value honesty above all other virtues, and who believe they have made Truth-seeking a way of life, find Hesse's work very much to their liking. Kurt Vonnegut, Jr., who is probably their favorite American writer, took a stab at accounting for Hesse's popularity in a recent essay. Devoting most of his space to a discussion of *Steppenwolf* as the most popular of all Hesse's books, he points out: "The politics espoused by the hero of *Steppenwolf* coincide with those of the American young, all right: He is against war. He hates armament manufacturers and superpatriots. No nations or political figures or historical events are investigated or praised or blamed. There are no daring schemes, no calls to action, nothing to make a radical's heart beat faster."

In his curious, cryptic, oblique style Mr. Vonnegut keeps chipping away in this manner, and by the time he has finished, he has made a good case for Hermann

Hesse as the great contemporary, a writer whose works have even greater relevance today than they did in the years they were written. This, he suggests, is the source of his appeal. Hesse's is a recognizable human voice that speaks to the contemporary young in gentle tones of things they can understand: "And I say again, what my daughters and sons are responding to in *Steppenwolf* is the homesickness of the author."

Nevertheless, there is another, darker explanation for Hesse's sudden popularity. Mr. Vonnegut touches on it just long enough to dismiss it, but it is worth dealing with directly. Ask some of the more far-out among the younger generation, and they will put it to you with assurance. "Sure," they will say, "Hesse was an early head. His books are about tripping, drugs, all that stuff."

And how do they get that idea? From none other than Dr. Timothy Leary, the guru of the psychedelic revolution, the former Harvard psychologist who put LSD on the map. As long ago as 1963, a year after Hesse's death and back when Dr. Leary still held a post on the Harvard faculty, an article of his appeared in the Psychedelic Review extolling Hermann Hesse as the "poet of the interior journey." It is a neat bit of business. Dr. Leary does some judicious quoting, makes a few rash insinuations, and then comes rather hastily to his conclusion:

"So there it is. The saga of H.H. The critics tell us that Hesse is the master novelist. Well, maybe. But the novel is a social form, and the social in Hesse is exoteric. At another level Hesse is the master guide to the psychedelic experience and its application. Before your LSD session, read *Siddhartha* and *Steppenwolf*. The last part of *Steppenwolf* is a priceless manual."

Although elsewhere Dr. Leary admitted to his obvious consternation that Hermann Hesse had, accord-

ing to one who would have known, never taken mesca-
line (the visionary drug whose effects he read into
Hesse's writings), nevertheless he continued to promote
him as the herald of the drug age. He even went so far
as to name his independent center for psychedelic re-
search, which he founded in Mexico after his dismissal
from Harvard, "Castalia," after the beautiful Utopian
city of the Twenty-fifth Century in Hesse's final work,
The Glass Bead Game.

But face it: There is a long passage in *Steppenwolf*
that does apparently deal with drug-taking. This is the
last part, the one called "a priceless manual" by Dr.
Leary. In it Harry Haller, the 50-year-old protagonist, is
introduced by a younger swinger to the joys of "long
thin yellow cigarettes" and an "aromatic liquid"
whose "effect was immeasurably enlivening and delight-
ful—as though one were filled with gas and had no
longer any gravity." What follows is a wild, phantasma-
goric experience, the "Magic Theater," at once enlight-
ening to Haller and confusing to the reader, wherein
murders contemplated are committed, imagined orgies
are made actual, and identities of the great are merged
with the mean.

From the time *Steppenwolf* was published in 1927,
Hermann Hesse found that people were enthusiastic for
the book for what he thought were all the wrong rea-
sons. From the beginning, it drew the attention of the
revolution-sex-drug crowd of the 1920s and 1930s, so
that by the time a Swiss edition of the work was being
prepared during the war, he felt obliged to append a
kind of disclaimer in which he complains that "of all
my books *Steppenwolf* is the one that was more often
and more violently misunderstood than any other."

Dr. Leary's enthusiasm for Hesse, and for this book
in particular, is founded precisely on those misconcep-
tions that the author so deplored. I found when I visited

Hesse's German publishers, Suhrkamp, that they are aware of his reputation as a propagandist for the drug culture and are frankly disturbed.

I talked with Volker Michels, the young editor who is preparing a new, low-priced edition of the author's complete works, in the company's light, modern offices in downtown Frankfurt. Mr. Michels fell heir to his task because his great youthful enthusiasm for Hesse's work had led to a personal acquaintance with the author in his last years. The personal quality of the young editor's indignation is quite apparent as he denounces what he considers "a terrific misunderstanding."

Says Mr. Michels: "He has been adopted by these people who smoke hashish and so forth. But Hesse himself wouldn't have had this. He would have denounced this tendency. You can be sure of it."

But Suhrkamp's problems in selling Hermann Hesse to West German youth are of a much different sort. To them Hesse has no glamorous reputation as a drug propagandist or revolutionary; he is rather the classic author who was the favorite of their fathers' generation. (Ah, kiss of death!) His works were assigned in school by war-weary teachers who urged Hesse on the students as a great dreamer, a writer of sweetness and light, a source of inspiration.

"But it was all a matter of emphasis," says Mr. Michels, who points out that Hesse was a dialectical writer, one who always sought to resolve the conflicts within himself, to contain the contradictory impulses that everyone feels. "The teachers can teach him any way they want to. The gentle side is certainly there. But they don't show the aggressive side that was most certainly there too. That is how he has been presented here in Germany. We want only to restore the balance, to show him as he was—interested in his times, always critical, always political."

The night before I left on my pilgrimage to Hesse's birthplace in Calw, Germany, I heard what Mr. Michels had said confirmed by a group of Goethe University students I met in Frankfurt's Jazz Keller. I mentioned to them that I was going to Calw because I was interested in seeing where Hermann Hesse had grown up. They couldn't understand why anyone should pursue such an outmoded writer. When I told them he was probably the favorite author of university students in America today, they were clearly amazed.

In America, of course, Hesse's young readers had no such prejudice to overcome. It is possible, of course, that his appeal to them is that of an exotic: After all, he speaks to American youth from another age and out of a different culture. Yet what he says must, to some extent at least, strike chords of response and give the young that shock of recognition that says, "This is it, the real thing. He felt what I feel."

"What I get from Hesse is, you know, like a sense that he felt the same things I felt and experienced a lot of the same things too." So said a young Northwestern University student in Evanston, Ill., earlier this year. He added: "It's not like I really think of him as a German writer or anything. He's just a guy who's been there and tried to make sense out of things."

The tentative quality of this response would probably please Hesse, for he was undogmatic almost to a fault. And it is understandable, too, that so many young Americans would feel their own conflicts and troubles reflected in his writing, for Hesse—the most autobiographical of writers—wrote directly from his own experience. No matter how exotic the landscape he paints, familiar landmarks reveal it as a chart of his soul.

Hesse's parents had come to Calw only a little before his birth in 1877. His father, a Protestant missionary in Mangalur, India, for four years, had been forced

to return to Europe because of poor health. He had married and settled in Calw and was running the Calw Missionary Press when Hermann Hesse was born.

In later years the author always cited the strong Christian spirit of his family as one of the great positive influences in his life. Yet that didn't prevent him from fighting bitterly against it as he grew up. He was a very difficult child, rebellious to the extreme. Finally his father said he was "too nervous, too weak" to try to control his son any longer and shipped the lad off to a preparatory school *cum* seminary in Goeppingen.

What was it like? Hesse described it minutely and movingly in the novel of his adolescence, *Beneath the Wheel,* a kind of Black Forest *Catcher in the Rye,* a work infused with that sense of home sickness that Kurt Vonnegut, Jr., quite rightly said was so prominent in Hesse's novels. Hesse did brilliantly as a student in Goeppingen, and then suddenly fell into a kind of funk. The strict Teutonic discipline of the place simply became too much for him: "Thus the struggle between rule and spirit repeats itself year after year from school to school. The authorities go to infinite pains to nip the few profound or more valuable intellects in the bud."

Although Hesse did not come to the same sad end as his young hero, Hans Giebenrath, one of those who "waste away with quiet obstinacy and finally go under," he came home in disgrace, ran away from home only to be returned ignominiously after a single night by forest rangers who had found him sleeping in a haystack. Soon his parents were in utter despair over him. He had passed in and out of one school after another, had attempted suicide, and had been turned over to a clergyman with a reputation as an exorcist who tried quite literally to pray the devil out of him.

Finally, at the age of 17 a change came over young Hesse. He dropped out of school completely, took a job

in a local factory, and spent the next two years quietly filing gears. He then left his family and apprenticed himself to a book dealer in the university city of Tuebingen. There he read voraciously, found friends among the students, and began writing seriously. His first book, a collection of lyric poems, was published in 1899 when Hermann Hesse was 22.

It was for his novels, however, that he soon became well known throughout the German-speaking world. The success of his early books—*Peter Camenzind, Under the Wheel,* and *Gertrude*—gave him a certain financial freedom and the opportunity to travel first throughout Europe and then, in 1911, to India, on an extended trip that was to be of great importance to him.

Upon returning in 1912, he settled in Switzerland. He was there in 1914 when World War I broke out—and there he stayed. "I am a German," he wrote in an essay in 1914, explaining his position, "and my sympathies and wishes belong to Germany." But he was also by this time a convinced pacifist, and he refused either to serve in the Kaiser's armed forces or to support with his pen a war he felt was senseless. In this he was quite alone, for except for Hesse all German writers of the period gave enthusiastic support to the war, promoting it as a kind of holy crusade for *deutsche Kultur.* Even Thomas Mann wrote impassioned nationalistic essays at the time that he later came to regret.

In Germany Hesse was denounced as a traitor. Book stores refused to sell his works. Editors declined his poems and stories. And although Hesse never for a moment doubted the rightness of his course, he was thrown into a deep personal crisis, torn by the conflict that he felt between his loyalty to Germany and his sense of individual duty. It was resolved, finally, through psychoanalysis. Through 1916 and 1917 he was treated

in a sanitarium by an eminent disciple of Jung, Dr. Joseph B. Lang.

He emerged from psychoanalysis a much different sort of man and a much greater writer. Although they were fine works of their kind, the novels that Hermann Hesse wrote before World War I fit perhaps too neatly into categories. The thoughts and feelings expressed in them were predictable, expectable, generically similar to those that other writers of that time and in that place were themselves pouring into their poems, plays, and novels. But the intellectual and political sense of isolation that he had experienced during the war had thrown him back upon himself, and the experience of psychoanalysis had forced him to explore that *terra incognita* that every man fears—his own soul.

What Hesse found there he wrote down in *Demian,* a most unusual neo-Nietzschean work that, in the old form of the apprenticeship novel, presents the doctrine of a strong and totally ruthless young man named Max Demian. He acknowledges all the good and evil that is within him. He sees in himself the potentiality for all acts, and thereby derives from that potentiality an actual power that is equal to the sum of them all. Demian taught the lesson that Hesse himself had learned so painfully—that a man must live by the dictates of his own self.

Attractive as it may have sounded to some, this is a philosophy with some rather sinister overtones. There is something of the idealized storm trooper about Max Demian—in his nihilism and his contempt for the little man's notions of morality. Yet Hesse caught in him and his passionate individualism not only a resolution to his own internal conflict, but an expression of the spirit that was to grow in Germany and elsewhere in the coming decade. There is truly something prophetic about the book. Demian says, for instance: "Whether the

workers kill the manufacturers or whether Germany makes war on Russia will merely mean a chance of ownership. But it won't have been entirely in vain, it will reveal the bankruptcy of present-day ideals, there will be a sweeping away of Stone Age gods. The world as it is now wants to die, wants to perish—and it will." As rhetoric, that is a little frightening; as a prediction made in 1919, however, it was breath-takingly accurate.

Demian was a book that took the imagination of a whole generation of young Germans. They were sure it was by one of them, one who was speaking for them all, because Hesse, putting on the new man, had published the book under the pseudonym of its narrator, Emil Sinclair. *Demian* was even awarded a prize for the best first novel of the year before the identity of its author was discovered.

This and three subsequent novels are the major works of Hesse's lifetime. The remainder of his life was devoted to writing them. And it was in the act of literary creation that he was best able to resolve the many tensions of that lifetime.

Siddhartha, for instance, perhaps written in memory of his 1911 passage to India and published in 1922, is anything but the work extolling the Buddhist way to wisdom that many in the West have thought it to be. Prince Siddhartha's path to wisdom is devious indeed. Leaving his parents, he seeks out the Buddha and for a long period lives a life of meditation in his company— yet ultimately without finding satisfaction. And so he crosses over the broad river and seeks prosperity and sensual pleasure in the worldly city. Although he finds both in abundance, he does not find happiness. Yet he does, finally, manage to attain wisdom and true happiness as a ferryman on the boat that plies back and forth between the Buddha's land of meditation that lies on one shore and the worldly city on the other. It is only by

touching in at both ports, in other words, that a balance can be preserved and real wisdom achieved.

Of *Steppenwolf* enough may have been said already to show that Hesse believed the problems it treated were best understood as those peculiar to a 50-year-old man. The precarious balance between the sensual and the spiritual achieved by Harry Haller was not one that Hesse urged as universally valid.

Curiously, Hermann Hesse came closest to achieving a real synthesis of the contending elements in his own soul in creating the character of Joseph Knecht, who is certainly the most sympathetic and in a way the most realistic to be found in any of his novels. Why curious? Because Knecht is the central figure of a Twenty-fifth Century Utopian fantasy dealing with life in a society and time as different as could be from the Europe that Hesse knew as he was writing the book.

The Glass Bead Game was the work of his maturity. He spent over a decade on it in the 1930s and '40s, working and reworking it, finally writing it several times over as he distilled into it those things in life that he felt he knew with some degree of certainty. The novel is most remarkable for its tranquility and wisdom. Far from ignoring the world that was crumbling around his mountain retreat in southern Switzerland, Hesse looked on and was deeply disturbed by the death of Europe that he had prophesied in *Demian*. Yet he transcended it, focusing his attention far into the future, on a society in which the rule is service to all and the occupation of all is the playing of a mysterious game, a sort of cross between the *I Ching* and Herman Kahn's computer probability models, that somehow employs all the elements of human culture in configurations by which problems and theories of all sorts are worked out.

The Glass Bead Game is cast in the form of a biography of Joseph Knecht, a brilliant player of the game, who puts himself completely at the service of his state, Castalia. He rises steadily in the hierarchy there until, after service as ambassador to the monastery capital of Mariafels in a neighboring state dedicated to spiritual discovery, he is invited back to Castalia and elevated to the highest position in the realm, that of Magister Ludi (Master of the Game). But Knecht has been deeply affected by his stay at Mariafels. He feels that even the rational rule of social service must be tempered and guided by the spirit. He criticizes the state and the primacy of the purely intellectual pursuit of the Glass Bead Game. And he gives moral force to his objections by leaving Castalia for a martyrdom in exile. Eventually his criticisms are judged to be valid: changes are made; and the lesson is made clear: It is often only by opposing society that the individual can work real changes in it for the better.

This, of course, is a long way from the league of supermen Hesse posited in *Demian*. The responsibility between individual and society goes both ways here. It is the individual's duty to hold out for what he knows is right, and it is society's duty to listen to him.

A remarkably long journey it was for a man who had so little personal faith to sustain him. Just how little is indicated in this passage from a letter written in 1948, the year after he was awarded the Nobel Prize with a special citation of his novel, *The Glass Bead Game*. Hesse wrote: "Today we all live in despair, all awakened people, and are thus cast between God and Nothingness. Between these poles we breathe, sway, and pendulate. Each day we are tempted to throw away our lives, but we are sustained by that within us which is suprapersonal and supratemporal. So our weakness—without our being heroes for that reason—becomes

bravery, and we preserve a little of the faith that has been handed down from the past for those who will come after us."

Perhaps many of Hermann Hesse's young readers in America today find themselves between those two poles. Perhaps they learn from him that kind of bravery.

—BRUCE COOK

September 1970

The Incomparable Stravinsky

IGOR STRAVINSKY was the master composer of the Twentieth Century, towering over his contemporaries as surely as Bach and Beethoven did over theirs. Last week, at age 88, he died of a heart attack in his New York City apartment.

Famous since 1910, when his first masterpiece, *The Firebird*, set Paris on its ear, he enriched and enlivened the world with a procession of works that never seemed to lack for originality, vitality, or variety. He wrote ballets, operas, masses, symphonies, concertos, cantatas, sonatas, even a polka for circus band. It is not too much to say that without him "modern music" as we know it would not exist.

To musicians, Stravinsky was an integral part of nearly every important musical development of the last 60 years, many of which he initiated himself. To the concert public, he was a composer who, especially in such now universally accepted masterpieces as *Firebird*, *Petrouchka*, and *The Rite of Spring*, wrote scores that for all their exotic colors and unexpected sounds still were part of the musical main stream. To people who enjoyed a good artistic scrap, he was a witty, acerbic, and outspoken commentator on the musical scene, whose views were frequently and freely set forth in an

outpouring of his books, articles, and commentary.

His opinion of music critics ranged from salty to savage, and he could be severe not only on contemporary composers but even on the giant musicians of the past. Of Richard Strauss, he said that he would like to admit all his operas "to whichever purgatory punishes triumphant banality." He called Antonio Vivaldi "greatly overrated—a dull fellow who could compose the same form so many times over." And he dismissed the composer of *The Messiah* with: "Handel's reputation is a puzzle to me."

Yet his enthusiasms were equally provocative, and they extended from the motets of the Seventeenth Century Italian contrapuntalist Don Carlo Gesualdo to the saucy, satiric Nineteenth Century operettas of Gilbert and Sullivan.

His wide-ranging musical activities and travels brought him into close contact with a dazzling spectrum of artistic leaders and creative spirits: Diaghilev and Nijinsky in ballet, Picasso and Chagall in art, W. H. Auden and Dylan Thomas in literature, to name only a half-dozen. From the home in Hollywood where he lived most of the time in recent years, he kept a close eye and ear on the doings of the world's musicians. Few personalities have managed to encompass the artistic activities of their eras as thoroughly or as perceptively.

Igor Stravinsky was born at Oranienbaum, near St. Petersburg, Russia, on June 17, 1882. His father, Feodor Stravinsky, was a famous opera singer, the leading basso at the Imperial Opera. Igor thus received an early indoctrination into music, being exposed to operatic and symphonic works during his winters in the Czarist capital and to the folk music of peasants and villagers, which later colored much of his own work, during his summers in the country.

Despite this musical atmosphere and his own adeptness at the piano, which he started to study seriously at age 9, Stravinsky was sent to the University of St. Petersburg to study law. But he took harmony lessons on the side and decided upon graduation to adopt music as a career, although he never received a musical diploma from a conservatory.

He studied with Rimsky-Korsakoff, composer of *Scheherazade* and master of lush orchestration, and by 1908 had written a symphony that was performed in St. Petersburg. Several other works followed, bringing the young composer to the notice of the impresario Sergei Daighilev, who was looking for composers to provide music for a season of Russian ballet he was putting on in Paris. He offered Stravinsky 1,000 rubles (then $500) to cover the commission and the expenses of a trip to France, and the young musician quickly accepted. In return he wrote a masterpiece: *L'Oiseau de feu.*

The Firebird was a more or less traditional ballet, based on a Russian fairy tale and dealing with a prince who finds his true love by thwarting an evil magician with the help of a supernatural bird. But its music was of such vitality and freshness that it startled its Parisian hearers. Stravinsky's score seemed to be an advance even on Rimsky-Korsakoff's vividly orchestrated works, with a strong infusion of Russian folklorish touches to go along with striking rhythmic and harmonic effects. Two orchestral suites were quickly extracted from the work, and although Stravinsky in later years decided to re-orchestrate the piece to tone down its bright colors a bit, many conductors have continued to play his original version.

Diaghilev, who knew a good thing when he heard it, quickly commissioned further ballets from Stravinsky, who now settled in Paris as a kind of composer in residence with the Ballets Russes. In the 1911 *Pe-*

trouchka, a ballet about puppets at a Russian carnival, he really unleashed his originality and unconventionality. The score was punctuated with explosive rhythms, novel instrumental combinations, and, boldest of all, the simultaneous sound of two different keys (C Major and F-sharp Major, the *"Petrouchka* chord").

Le Sacre du Printemps (The Rite of Spring), which followed in 1913, was still more revolutionary. This balletic depiction of pagan rituals in which a girl is made to sacrifice herself by dancing to death, said critic Nicolas Slonimsky, "severed all ties with traditional harmony, and made use of dissonant combinations without precedent." It took months to prepare *Le Sacre* for performance, for dancers and musicians alike found the work difficult. There were 16 rehearsals with full orchestra—an unheard-of number. When the Ballets Russes gave the first public performance on May 29, 1913, with the 37-year-old Pierre Monteux conducting, a riot broke out in the theater, with hoots and catcalls and members of the audience battling each other.

Remembered Stravinsky years afterward: "I was sitting in the fourth or fifth row on the right, and the image of Monteux's back is more vivid in my mind today than the image of the stage. He stood there apparently impervious and nerveless as a crocodile. It is still almost incredible to me that he actually brought the orchestra through to the end. . . . After the performance we were excited, angry, disgusted and . . . happy."

Later on, the first concert performance of *The Rite of Spring* music in Paris brought Stravinsky an ovation, with an enthusiastic crowd of young people carrying him into the street on their shoulders. Remarked Diaghilev: "Our little Igor now needs police escorts out of his concerts, like a prizefighter."

Both Diaghilev and Stravinsky appreciated the publicity value of the *scandale,* and the story of *Le Sacre* and its brawling reception quickly spread through the world. Still, it took nine years for the work to reach the United States, with the pioneering Leopold Stokowski introducing it to his audience in Philadelphia on March 3, 1922, after warning them: "Frankly, I can't imagine your liking it on first hearing. . . . It is not comfortable music, but it is tremendous music, magnificent music, and important music—the most important, perhaps, of this generation."

Two years later Monteux played the score for the first time with the Boston Symphony impelling one listener to express his feelings in verse in the Boston Herald:

> *Who wrote this fiendish* Rite of Spring?
> *What right had he to write this thing?*
> *Against our helpless ears to fling*
> *Its crash, clash, cling, clang, bing, bang, bing!*

Most people have made the acquaintance of *Le Sacre* through Walt Disney's famous antimated film *Fantasia,* in which it was illustrated with scenes of the earth's creation and of nightmarish dinosaurs battling each other to the death. Stravinsky, who received $5,-000 for the use of his music, later criticized the way it had been cut to fit into the film.

World War I caused Diaghilev to suspend his ballets in Paris, and Stravinsky decided to take up residence in Switzerland. There he continued to find inspiration in Russian folk music and fairy tales, his most notable product being *L'Histoire du Soldat* (The Soldier's Tale). Originally designed to be taken on tour through Swiss villages, it was a piece for seven players and a handful of actors and dancers about a soldier on furlough who sells his soul to the devil in return for earthly wealth. At once sardonic and melodic, with a

particularly haunting violin theme, it maintained a special place for itself in the Stravinsky canon and received several television productions in the 1960s.

Stravinsky wrote other Russian-based works, such as the operas *Le Rossignol* and *Mavra* and the cantata *Les Noces,* but after World War I he gradually moved into a new style of composition, which he and his followers called "neoclassicism."

Gone were the bold colors and explosive rhythms; in their place arose a new austerity and economy. The "neoclassical" Stravinsky made his first appearance in a ballet called *Pulcinella* in 1920, based on music by the Eighteenth Century composer Pergolesi. This was followed by such works as the opera *Oedipus Rex,* adapted from Sophocles by Jean Cocteau, and the ballet *Apollon Musagetes,* commissioned by the Library of Congress in Washington, D.C.

By now Stravinsky had not only abandoned Russian source material for inspiration; he had also turned his back on Russian nationality, becoming a French citizen. In Paris he continued to write masterly pieces in his new style: *Persephone,* a "melo-drama" set to a poem by Andre Gide; the *Symphonies of Wind Instruments;* a *Violin Concerto,* and the *Symphonie des Psaumes,* composed "for the glory of God" and dedicated to the Boston Symphony Orchestra on its 50th anniversary. Stravinsky, who wrote many religious works, was a member of the Russian Orthodox faith.

In 1925, at the age of 42, Stravinsky made his first visit to the United States, appearing mostly as a conductor and performer of his own music. Audiences were curious to see the composer who epitomized "modern music" and had helped wreck traditional notions of sound and harmony. They found a small, thin birdlike man with a lean, sad-looking face, a thin mustache, and intense eyes looking through heavy lenses. He came

again in 1935 and 1937, the latter time to conduct the world premiere at the Metropolitan Opera House of his *Jeu de Cartes,* a satiric ballet based on a poker game.

After the outbreak of World War II, Stravinsky decided to settle in the United States. With him came his second wife, Vera de Bosset Sudekeine, a former Diaghilev dancer whom he married in 1940. His first wife, Catherine Nossenko, a cousin whom he married in 1906 and the mother of his four children, died in 1939. Stravinsky was naturalized an American citizen in 1946.

The move to America provided new impetus to Stravinsky's work. He had long been intrigued by the rhythms of American popular music and had included a "Tango, Waltz, and Ragtime" section in his *Histoire du Soldat.* Now he not only pursued his neoclassical output but began to produce works of a specifically American cast. Among these were an *Ebony Concerto* for clarinet and swing band written for the Woody Herman band, a *Circus Polka* "for a young elephant" commissioned by Ringling Bros., and an arrangement of *The Star-Spangled Banner* with unorthodox harmonies that aroused complaints when it was first played in Boston.

Stravinsky's neoclassical period reached its climax in 1951 with the production of his opera *The Rake's Progress,* first in Venice and then at the Metropolitan Opera in New York. Better than most contemporary operas, the *Rake* has managed to hold a place on the stage and was selected as the inaugural work for the new Juilliard opera theater in Lincoln Center in 1970.

Stravinsky was inspired to write *The Rake's Progress* by a set of engravings by the Eighteenth Century English artist William Hogarth; he said that they seemed to him like successive scenes of an opera. He forthwith invited the poet W. H. Auden to his California home to work on a libretto, and between them they came up with a grotesque yet tender work about such

Hogarthian characters as Tom Rakewell, Anne True-love, Nick Shadow, and Baba the Turk, a bearded lady. Written in a musical style that is almost Mozartean in its use of traditional forms and melodic conciseness, *The Rake's Progress* was regarded by many critics as the pinnacle of neoclassicism. Stravinsky wished to follow it up with another opera to a libretto by another poet, Dylan Thomas, but Thomas' death in 1953 put an end to that project.

Besides, Stravinsky had now begun exploring still another musical style, the serial music technique of Anton Webern, in which notes are played and repeated in a certain specified sequence—an approach that many listeners regard as intellectualizing music to the point where it is drained of all emotional content. In this phase of his work, Stravinsky lost much of his appeal to the mass of the musical public, which found largely unintelligible and indigestible such works as the ballet *Agon,* the religious meditation *Threni,* and the opera *The Flood,* which received a widely publicized television production in 1962.

Some critics, however, particularly the younger ones, praised Stravinsky for working in his new style, and his own attitude was expressed in the statement that "the crux of a vital musical society is new music."

More than any other composer who ever lived, Stravinsky was able to leave a legacy of his own music as he himself performed it. Goddard Lieberson, the enterprising president of Columbia Records, signed the composer to an exclusive contract in the 1950s whereby he conducted on records most of his musical output, from his earliest products to those of his latter years. Not everybody agreed that Stravinsky was his own best interpreter, however, and a great variety of other conductors performed and recorded his works.

Stravinsky was almost as prolific with words as with notes. He wrote reviews and critical articles for many publications, and in 1969 and 1970 served Harper's magazine as performing-arts critic. He wrote an autobiography in 1935, and a set of lectures he gave at Harvard University in 1939-40 were published under the title *The Poetics of Music.*

But his most stimulating literary output came later in life and was written in collaboration with Robert Craft, an American conductor, born in 1923, who came into contact with Stravinsky through performing his music and wound up as his amanuensis and member of his household. In conjunction with Mr. Craft, Stravinsky produced no fewer than six books of "conversations"—dialogs, tape-recorded and edited, in which he recounted his career and expounded his opinions on other music, musicians, and music critics. Stravinsky's views—concise, forthright, and frequently acerbic—made waves throughout the musical world, even though skeptics insisted there was at least as much Craft as Stravinsky in the books.

One volume, *Expositions and Developments,* contained an appendix consisting of a lengthy attack on two critics, Paul Henry Lang of the New York Herald Tribune and Winthrop Sargeant of the New Yorker, who were labeled respectively as "H. P. Langweilich" (German for "tedious") and "S. W. Deaf." The German word for "deaf," *taub,* had already been pre-empted, Stravinsky solemnly explained—an uncomplimentary allusion to critic Howard Taubman of the New York Times.

All such writers, Stravinsky made clear, were "journalist-reviewer-pests." But when he had the occasion, Stravinsky himself could be as cutting as any critic in the business, as he demonstrated when he reviewed Gian Carlo Menotti's opera *The Last Savage* at the Met-

ropolitan. Menotti, who detested serial music, satirized it by having a string quartet play a mockatonal piece during a fashionable party on the stage; Stravinsky promptly wrote that it had been the most interesting music in the opera.

Despite gradually fading health, Stravinsky continued to travel during the 1960s, accompanied by his wife and by Mr. Craft. The year 1962 produced world-wide celebrations of his 80th birthday, including a dinner invitation to the White House from President and Mrs. Kennedy.

But by all odds the most moving event of the year, and one of the high points of his life, was a trip he undertook to Soviet Russia. He had not been back to his homeland in 48 years, since before the revolution. His music, which had created such a stir and exerted so vast an influence in the Western world, went almost unplayed during the Stalin era, unknown to Russian musicians except by reputation.

Now, however, he received a hero's welcome in the land of his birth. There were performances of his ballets, concerts of his music, conferences with students and with Soviet musical leaders. He was hailed as "a great master" even though reservations were expressed about some of his innovations. Premier Nikita Khrushchev attended a concert and later had a talk with him —"not about music," Stravinsky reported.

Stravinsky traveled in subsequent years to England, to Western and Eastern European countries, and to Israel. He also continued to conduct and record in the United States, although recurrent bouts with illness increasingly interfered with his activities.

Although his place in musical history was secure long before he died, Igor Stravinsky was never content to rest on his reputation, to hold himself above the musical struggle, or to acknowledge an end to his works.

Perhaps his philosophy of ceaseless activity and undiminished devotion to his art, even as the years closed in on him, was expressed in the poem which his friend Dylan Thomas wrote to his dying father, "Do Not Go Gentle Into That Good Night," in which he urged him not to give in to death, but to "Rage, rage against the dying of the light."

—HERBERT KUPFERBERG

April 1971

Frankie's Farewell

IT WAS a little like singing at your own funeral. Not that anyone had died, nor was likely to. But Frank Sinatra had announced his retirement, looking forward "to enjoying more time with my family and dear friends, to writing a bit—perhaps even to teaching."

So Sinatra was coming to Memphis for the first of two scheduled farewell appearances. The man had agreed to bury the persona in a pair of benefit performances a couple of weeks apart.

He hadn't planned it exactly this way. As an entertainment industry leader he had made a commitment some time ago to appear in Los Angeles at the big Motion Picture and Television Relief Fund benefit at the Music Center. But why Memphis? In honoring his commitment to appear before a sellout crowd of 12,000 at the Mid-South Coliseum, Sinatra was just keeping a promise to a friend.

The friend was Danny Thomas. The rudder-nosed television comedian, who has made a profession of fatherhood, is a big man in the old Southern city. Memphis has named a city boulevard after him and renamed the Memphis Open golf tournament the Danny Thomas Memphis Classic. All in honor of the work he has done in support of St. Jude Children's Research Hospital.

It was built in 1961 largely through the efforts of Thomas and his St. Jude Hospital Foundation. And the work done there, most importantly in diagnostic medicine and leukemia research, has continued because of the activities of Danny Thomas. It is a very personal charity. He helps maintain St. Jude Hospital by doing benefits like *Shower of Stars,* the one at which Frank Sinatra is making what's billed as his last performance.

Sinatra is just one of several. In addition to Danny Thomas, serving as producer and master of ceremonies, Tennessee Ernie Ford, Vikki Carr, Sammy Davis, Jr., and Bob Hope are on hand. But everyone seems to agree that Frank Sinatra and his announced retirement are why the Mid-South Coliseum has sold out so early. It promises to be a night to remember.

The night of the show, the talk backstage is all about Sinatra. When will he arrive? How long will he stay? Ernie Ford is on hand early. One by one the others appear. Danny Thomas begins pacing the long backstage corridor, still wearing his make-up bib and chewing an unlit cigar; Vikki Carr comes in; Sammy Davis, Jr., arrives with his entourage. Rumor has it that Bob Hope got in some time ago but went right out to a driving range to hit a few buckets of balls before the big event. Where is Sinatra?

They say he is flying into Memphis in his private jet and is expected to land at any moment at nearby Memphis International Airport. His conductor, a slight, dapper man named Bill Miller, has arrived the day before with Sinatra's drummer, Irv Kottler, and has rehearsed the *Shower of Stars* orchestra through the arrangements of the tunes Sinatra will perform.

Frank Sinatra will not have sung a note in rehearsal with this band before walking out on stage tonight. Is this how he always does it? Does it always work out?

"Usually," says Bill Miller with a laconic smile. "It will this time. They've got a fine band together here. Very professional."

A sudden commotion at the door. Flashbulbs pop. "Hey," somebody says, "it's Frank!"

And it is. The crowd at the stage door parts to reveal him there in the doorway, already in evening dress. He pauses there briefly, perhaps to give the photographers time for pictures, perhaps obeying some inner

sense of drama that tells him this is a moment. And then he moves forward into the backstage corridor.

A few at the door shake hands with him. Others on down the line follow suit. They don't know him; they just want to shake his hand. Who are they? Two Shelby County sheriff's deputies, a Memphis policeman, an usher, and a stagehand: the kind of people who stick out their hands to Presidents. Sinatra says something to each of them, gives each a grave smile as he walks by. Even his walk is worth noting: a kind of slow, measured strut, the walk of a champ. Norman Mailer is the only other man I have seen walk this way.

Now the official handshake from Danny Thomas, welcoming Sinatra, moving him along a little faster than he seems to wish, showing him to his dressing room. The crowd backstage is silent for a moment, catching its collective breath. Suddenly that moment is past, and the backstage corridor is instantly abuzz. Everyone is talking about *him.*

This is the way it has been with Sinatra for years. No singer has been on top as long as he. No performer has so dominated broad areas of American culture with the force of his personal style. None has managed to invest himself with anything like the mythic quality that Frank Sinatra most certainly carries with him.

He has been in the public eye continuously since joining the Harry James band in 1939. And although he performed well as a big-band vocalist first with James, then with Tommy Dorsey, not until the war years did he really hit the top on his own with hit records, smash engagements in theaters and nightclubs before audiences of swooning females, and movie roles that presented him as boyish, naive, and innocent.

The image changed. His fortunes lapsed in the early 1950s, and his career went into a spin. He was divorced from his first wife and took off in determined

pursuit of Ava Gardner. He became something of a laughingstock.

This reversed itself abruptly when Sinatra angled his first real dramatic role in Fred Zinnemann's *From Here to Eternity*. As the hapless Maggio, Sinatra won an Academy Award for best supporting actor in 1954.

Since then he has remained on top—hobnobbing with the Kennedys, cruising in his yacht to various romantic ports of call with various romantic companions, filling the gossip columns with speculation on his plans to marry this one or that one. He did wed actress Mia Farrow in 1965. That his reputation remained intact following that short-lived, May-September marriage is a tribute to the strong sense of personal dignity that he projects.

It is that quality that stops people today, that accounts for the charge of electricity that he seems to carry with him wherever he goes. It is certainly here in the Memphis Mid-South Coliseum. Even through the first half of the show, the audience is humming with the excitement of the evening, looking forward to the moment when Sinatra will come on.

Tennessee Ernie goes over with the Tennessee crowd just as well as one would expect. Vikki Carr gets such an ovation that when she returns for her encore she calls out, "Memphis, where have you been all my life?" And Sammy Davis, Jr., is obviously taken aback by his enthusiastic reception by the predominantly white audience.

Backstage, Frank Sinatra emerges from his dressing room to listen to his friend Sammy Davis, Jr., from the wings. Moving down the corridor to stand behind the curtain, Sinatra catches the eye of a Shelby County policeman and holds it until he is past. The cop watches him go and says to nobody in particular, "They say he's tough."

He looks tough. There is a slightly hard, uncompromising look in his pale blue eyes. His visage is somber, almost menacing. Following his comeback performance in *From Here to Eternity,* all of Sinatra's best movie parts have been tough-guy roles—in *Von Ryan's Express, Tony Rome,* and *The Detective.*

It is the role in which he seems to have cast himself in life too. He grew up in Hoboken, N.J. If you want to know what that was like, watch *On the Waterfront* next time it's on the late show. And growing up tough, he stayed tough, always looking for a fight, ready to handle insults and annoyances with his fists.

There were other ties to his Italian street-kid past: persistent rumors of friendship and business association with persons in organized crime. It was because of these, finally, that he split with the Kennedys and became in particular a most cordial enemy of Bobby Kennedy. Sinatra, it is said, knows how to hate.

His public friendships are above reproach. There are his show business associates, the "clan" that includes Dean Martin, Joey Bishop, Sammy Davis, Jr., Peter Lawford, and others less well known. In addition there are those in society, the literary world, and New York theater circles who are proud to call him friend. Mr. and Mrs. Bennett Cerf and Kitty Carlisle came to Memphis tonight with Sinatra to see the show and offer moral support. They are back during intermission for a visit.

As the second half of the show begins with Bob Hope, Frank Sinatra continues to circulate backstage, talking with his conductor and drummer, signing autographs for anyone and everyone who approaches him, even posing for pictures with strangers who want a memento of having once stood by his side.

There is no hint of edginess or arrogance in his manner. He talks easily with people, the Jersey accent

somewhat more pronounced in casual conversation. In general he seems patient and deliberate, determined to keep this a happy occasion for everyone.

His Memphis fans backstage are so persistent that when Danny Thomas announces him—"Ladies and gentlemen, there's only one: Frank Sinatra"—he nearly misses his cue. He must duck beneath an arm encircling his shoulder and shake two more hands to make it on stage.

He appears, and the multitude goes mad. It is the greatest ovation of the evening from a crowd that already has clapped its hands red. As he swings into his first number, *That's Life*, flashbulbs pop so furiously around the darkened auditorium that it is almost as if lightning has struck.

In a way, it has. The atmosphere is so charged, so tense with the excitement of it all that sections of the audience break into applause when he so much as crosses the stage or turns around, getting closer to them.

This is the mood that prevails through *Fly Me to the Moon* as well. When he slows the tempo to do *Old Man River* and *Nancy*, however, the audience is very quiet, savoring the fine sound of his 56-year-old voice.

Just listen to him do *Nancy!* His phrasing and intonation are startlingly the same today as they were in 1944 when Jimmy Van Heusen and Phil Silvers wrote the song especially for him in honor of his now-grown daughter, Nancy Sinatra. Then on to his most recent hit, *My Way*, sung with an intense sincerity that conveys the feeling that for Frank Sinatra this song (a kind of looking back on life and summing-up) is a personal apologia.

Followed by *My Kind of Town, Chicago*. A certain irony in this. Although the song is from one of his movies, *Robin and the Seven Hoods*, and is now a standard item in his repertoire, Sinatra himself shuns Chicago.

It is said that somebody spat on him from the crowd when he last played Chicago, and he vowed never to sing there again. So far he has kept his promise.

Not until he has finished eulogizing the Windy City in song does he say more than "thank you." Then, taking a breather, he talks with the audience in his familiar, hip style, which seems to imply so much more than it says. He cracks one joke about his retirement, noting that this is the year that all the big swingers are calling it quits—"Ed Sullivan, Lawrence Welk, and me."

And then he is into a scene-setting introduction to his last number, *One For My Baby,* calling it a saloon and telling the audience to consider itself "one bartender, listening to me." All this over Bill Miller's barroom piano intro that generates an informal and quite intimate mood among the 12,000 gathered here.

Sinatra starts to sing. Playing with a cigaret during the song's first bars, he manages to light it without losing a phrase: a good trick. Watching him smoke as he sings makes that light and remarkably pure baritone of his all the more impressive (he was not smoking earlier backstage).

But what is finally most impressive is that this is really Frank Sinatra singing this song on his way to retirement—singing it as well as he ever sang anything in his life. The quality of his voice has not noticeably diminished over the years. If anything, it has improved. He is ending his career a far better singer and a much greater performer than when he began.

What a way to go!

—Bruce Cook

June 1971

They Called Him 'Satchmo'

NOBODY expected him to live forever, of course. But over the years, Louis Armstrong had become such an institution, was so apparently indestructible that he seemed to have had a kind of honorary immortality conferred upon him. Well, honorary wasn't good enough, for after surviving a brush with death earlier this year, he died quietly in his sleep at the age of 71 years and two days.

As a trumpet player, he was the first great jazz virtuoso, an improviser who truly deserved the genius label that critics had stuck on him as early as the 1930s. As a vocalist, he created a whole new idiom called "scat" singing, growling out swinging trumpet-style phrases that may have made hash of lyrics but injected real jazz feeling into many weak popular songs that needed all the help he could give. As a performer, he became famous the world over, known and loved by many—even those who understood little of jazz—for his ebullient on-stage manner and his unfailing good spirits.

Although he had been semiretired since the middle of the 1960s, and because of a weak heart had left off playing the trumpet altogether until recently, he had given his life to music and had more than 50 years' experience behind him at the time of his death. It would be no exaggeration to say that during three decades of his career—the 1930s, '40s, and '50s—Louis Armstrong was one of the most famous men in the world.

As late as 1965, Armstrong's name and music drew thousands upon thousands of eastern Europeans in the course of a triumphant State Department-sponsored tour of the satellite countries. In Budapest alone some

91,000 people jammed a huge stadium to hear him play.

In 1956, during a tour of Africa, his performance in Accra, Ghana, threw his audience of 100,000 into a frenzy of enthusiasm. And a subsequent mission to the continent for the State Department brought down upon him the wrath of the Russians. His visit to Leopoldville in the Congo, during the 1960 troubles there, was denounced by Radio Moscow as "a capitalistic distraction."

Before World War II he toured widely in Europe, and there he first attracted the attention of serious music critics and won a wider audience for American jazz. Those were the days when he played for royalty— from Zog of Albania to George V of England. It was, in fact, at a command performance for the English monarch at London's Palladium that he bowed to the royal box and made his famous dedication, "This one's for you, Rex."

Yet "Satchmo"—the misnomer for Satchelmouth that was originally laid on him by the English journal Melody Maker—was anything but unappreciated at home.

From the time he cut his first records he became an almost legendary figure in American jazz. Collectors sought his Hot Five and Hot Seven recordings on Okeh in secondhand shops long after they had sold out in their first issue.

Trumpet players wore their lips to a frazzle trying to get down note-for-note the famous Armstrong trumpet fanfare that opens the Hit Five rendition of *West End Blues*. Improvisers on other instruments—Coleman Hawkins on tenor saxophone and Earl Hines on piano, among them—named him as a major musical influence on them, and it showed plainly in their quite different styles.

His influence on jazz was deep and long-lasting. Even the beboppers of the 1940s, whose music seemed to many such a departure from the traditional jazz mode, were really only carrying out to their logical ends certain musical directions that had been suggested by Armstrong as early as the late '20s. Even a musician as relentlessly modern and restlessly experimental as Miles Davis had this to say of him: "You can't play anything on a horn that Louis hasn't played."

But it is perhaps less as a true genius of jazz that some will mourn his passing than as the most important link in the great jazz tradition. For with Louis Armstrong dies jazz's last direct contact with its origins in New Orleans, the city where the music began.

Daniel Louis Armstrong was born there on July 4, 1900, a child of the century. He was the son of a domestic servant and a turpentine worker and lived the life of a street boy, singing and playing on a cigar-box guitar for pennies around Storyville, the city's famous red-light district.

On New Year's Eve, 1913, he was arrested for firing a .38-caliber pistol into the air and was sent off to a reformatory, the Negro Waifs' Home. It was there he received his first real musical training, first learning how to play a bugle and later a cornet. After he was released from the home in 1915, he spent the next three years doing odd jobs and learning from Joe "King" Oliver how to play jazz on the cornet. By the time the King went north to work in 1917, Armstrong was ready, even as a tender teen-ager, to take over Oliver's chair in the Kid Ory Band.

His real break came, however, in 1923, when King Oliver brought him to Chicago to play second cornet with his band. It was there he first began to attract attention as a jazz improviser. It was there, too, that he formed his first band, the Louis Armstrong Hot Five,

and played first at the Sunset Cafe in the Windy City. The club was run by Joe Glaser, now head of the Associated Booking Corp., who remained Armstrong's personal manager from then until the very end.

Armstrong's recordings made him famous and a great influence on jazzmen everywhere. Yet it was his genial, clowning manner on stage that made him the musical celebrity he eventually became.

Many of his most enthusiastic admirers were put off by his clowning ways and said they better suited a vaudeville performer than a musician of Armstrong's genius. Eventually, in the '50s and '60s, these feelings gave rise among militant blacks and socially minded whites that Louis Armstrong was an "Uncle Tom."

Although he never commented on it publicly, the charge hurt Armstrong deeply. For this reason, he was a generous, though anonymous, contributor to civil-rights causes—and, in the '60s, not unwilling to speak out in his own rough way in their behalf.

Yet he was a musician, an entertainer, and he was really only comfortable before the public in that role. And even there he was considered out-of-date by younger musicians and fans during the latter part of his career. He made no effort to keep up with bop, cool jazz, new thing, or any of the subsequent developments in the music that he helped so much to make known around the world. For the most part, he played and sang his songs in the '50s and '60s, in front of bands of varying quality, just as he had in the '20s and '30s.

But he must have been doing something right, for he kept packing them in whenever he went on tour, and his records kept selling. Decca had hit singles of Armstrong's gravelly vocalizing on *Mack the Knife* and *Blueberry Hill*. And as late as 1964, his recording of *Hello, Dolly!* pushed the Beatles off the top of the charts and sold to the tune of 2,000,000 copies.

Gradually, however, Louis Armstrong was content to relax into the role of the genial elder statesman of jazz that he had created for himself. He played less and less as he grew older, and after an illness in 1969 was advised by doctors to give up his trumpet altogether for a while.

Last year, on the occasion of his 70th birthday, he was given a birthday party in Los Angeles that was attended by no less than 6,700 of his fans. In the course of the proceedings he was presented with a white wicker rocking chair that prompted him to declare, "I'm not in this stage yet!"

And to prove it, he came out of retirement early this year and took a band into the Waldorf-Astoria Hotel, where he played a two-week stand to a house packed night after night. It was his last engagement.

On his 70th birthday, he summed up what he said had been his "beautiful life": "I didn't wish for anything I couldn't get, and got pretty near everything I wanted because I worked for it. Now I live for Louis Armstrong and Lucille—nobody but my wife and I. We don't have no big bills to pay and a whole lot of put-on airs like some people. We live a normal, good life. It's enough."

And to New York Times reporter Israel Shenker he remarked, "In New Orleans I played at as many funerals as I could get, and cats died like flies, so I got a lot of nice little gigs out of that. It's business. They going to enjoy blowing over me, ain't they?"

Maybe not enjoy, but all over the world they honor him as the number one jazz legend of his time.

—BRUCE COOK

July 1971

John Berryman: Headed West

L AST week one of the three people I knew in Minne-
apolis died. The poet John Berryman jumped from
the bridge that separates the east and west campuses of
the University of Minnesota. He missed the Mississippi,
at which he had aimed his plunge, and hit its snow-cov-
ered bank 100 feet below the bridge. The impact of the
fall killed him immediately, they say.

He was identified by a pair of glasses on which his
name was inscribed and by a blank check he had in his
pocket. He left no suicide note, so officially there was no
reason given for his death. But that, of course, is all
wrong. He gave plenty of reasons—so many, in fact,
that he made books of them from time to time. For one
collection of reasons called 77 *Dream Songs* he was
awarded the Pulitzer Prize in 1965; and for another, *His
Toy, His Dream, His Rest,* he got the National Book
Award in 1969. What he failed to do in leaving no note
was to specify the occasion of his death.

I am suggesting in a roundabout way that in the
last few years Berryman's poems were so filled with
pain and suffering that they read—most of the Dream
Songs at least—like suicide notes. Alive, he would have
scoffed at that, for he knew how easy is was to talk
about pain and suffering and how hard to write from it.
Dead, he has conceded.

All this may seem more like hindsight than insight,
but nobody who spent any length of time with Berry-
man could have been very surprised at his suicide. The
evening—actually the better part of a day—that my
wife and I spent following him around Chicago a few
years ago left us with the feeling that the world had

better take a good look at John Berryman, for he might not be around a lot longer.

He had hit town early in the afternoon, down from the University of Minnesota, where he was even then teaching, to do a reading at Marina City for a local poetry group. And he proceeded to scare everybody by drinking prodigiously at a couple of Chicago bars before the event. Would he be interested in dinner? No, he wasn't interested in dinner, but he would have another double.

He had drunk a couple of members of the official party under the table by the time the hour appointed for the reading had arrived. There was good reason to fear that Berryman might not be able to make it that night. We were embarrassed for him in advance, for look—there was Saul Bellow, his friend come to see him from the University of Chicago, and somebody had spotted Stephen Spender in the audience.

Well, we had no need to be embarrassed for Berryman. When his turn came, he marched to the stage with dignity, though rocking a bit on his heels, and gave as fine a reading that night as any poet ever has. Not a word misplaced and not a line dropped, and all of it rolling forth in that great booming prophet's voice of his. But gradually he lowered the book he had been holding—*77 Dream Songs*— and with it, all pretense that he had actually been reading. They were his poems and his totally. He knew them—and think a moment what the old phrase really means—by heart.

It was inevitable that John Berryman would be the center of attention at the party afterward. You had the feeling that he would have dominated any gathering as he did this one: by voice, presence, and power of personality. Stephen Spender, shy and diffident, asked to meet Berryman and finally had to be pulled through the crowd and presented.

And Berryman drank—oh, how he drank! My wife and I later agreed we had never seen anyone slosh it down in quite the quantities he did that night. He had the rather scary ability to drink and drink and show no apparent change. And my wife would have noticed. Through most of the evening he held tight to her hand, just plain scared. Although he had gone to the stage with a swagger, he had come off, by some reverse logic, quivering with stage fright. She went around for a month afterward telling anyone who would listen, "John Berryman held my hand!"

But what did he *say* that night? Alas, the answer: not much. He kept looking around for Saul Bellow and finally gave up with a shrug. "You think I've got problems?" he asked reflectively—and by this time we thought he had problems, all right. "Boy, that guy," meaning Bellow, "has got demons I haven't even met yet."

And he talked about Randall Jarrell, who had just died a suicide. Jarrell may have been his trouble that night, but we had the feeling that on other nights there were other troubles. No end of troubles. Later, though probably not much later, he wrote a poem on Jarrell's death in which he said, "The panic died and in the panic's dying/so did my old friend. I am headed west/also, also somehow."

And west is where he went. R.I.P., John Berryman, 1914-1972.

—Bruce Cook

January 1972

The Legacy of the Beats

"I SOON came to regard the Beats as my generation," Bruce Cook recalls in what is already the most oft-quoted line from *The Beat Generation*. He made the literary acquaintance of the Beats in early 1958, he remembers, and "I felt the same keen sense of identification with them that thousands of others my age did, and I had the same feeling that I was lucky to be in on the beginning of something big, if only as a spectator."

I think *The Beat Generation* is a first-class book. Yes, Mr. Cook is a colleague of mine and yes, we occasionally speak to each other away from the office, so you know my biases and that is all I ought properly to say by way of "review." But it may be worth-while to talk *around* the book for a bit, for among the things that struck me in it was how little I shared that "keen sense of identification" that Bruce sensed in the young men of the 1950s.

Properly, I should have. Now 39, Bruce Cook is a shade younger than the average Beat, and I am a shade younger than that. (I'll never mention it again, kid.) But essentially we are all of the Hiroshima-Eisenhower-McCarthy generation, to call it by the three names that probably influenced us the most, and by rights we should all have been witnessing for roughly the same

ideals. Growing up today, certainly, we would share a common perception of the world and its art that would easily bridge any minor chronological differences.

As it happens, I remember rather well the art that interested me in the year 1958. I passed two weeks of that summer on a Maine lake reading *By Love Possessed*, James Gould Cozzens' gargantuan novel about a man of reason trapped in his own rationality. And back at work in suburban Connecticut, I wrote with some enthusiasm about *Look Back in Anger*, the John Osborne play that introduced the world to England's "angry young men."

No, I am not prepared to disavow either of these enthusiams; I still consider *By Love Possessed* a great book and *Look Back in Anger* a brilliant if somewhat circumscribed portrait of a man altogether at loose ends. But the point is that the Beats passed me by. Perhaps I might have perked up if I had seen the daily New York Times review of Jack Kerouac's *On the Road* (by Gilbert Millstein) that insisted "its publication is a historic occasion," for it was from the New York Times that all literary blessings of that time were thought to flow. But I didn't, and the years quickstepped on.

Oh, I came to know *of* the Beats, of course. I read some snatches of Allen Ginsberg; it was yawping, undisciplined stuff that reminded you of Whitman—and Whitman, I well knew, was something of a drag. I read some Gregory Corso too — *most* unseemly — and of course I couldn't help hearing of that bizarre, knockabout Beat life-style that had something vaguely to do with San Francisco.

I never read *On the Road;* I don't think I ever *met* anyone who admitted to reading *On the Road* until the early 1960s. You see, this *mea culpa* is not mine alone; I passed my time in what I think would be considered an enormously literate milieu, and that milieu was not so

much antagonistic to the Beats as indifferent to them. Or amused by them.

The blame for this state of affairs, as Bruce Cook makes quite clear, lay largely with the mass media: "Once they were established, neither Jack Kerouac nor Allen Ginsberg ever received favorable reviews." And in this the mass media were simply parroting the official cultural line: "This, too, shall pass." It didn't, of course. Literarily, the Beats rediscovered the wanderlust tradition in American fiction and spawned the tough, jagged, and very exciting poetry that is now all around us. And socially—the making of this point is the virtue among virtues in *The Beat Generation*—they gave us the 1960s.

In a very real sense, in other words, the Beats were a race of prophets. They presaged almost all the values of the contemporary young—which are rapidly becoming, in turn, the values of many of the contemporary not-so-young. Including, in large measure, mine— which undoubtedly is what appals me in discovering I was so slow to get the message. Comfortingly, however, I think *The Beat Generation* suggests that the kind of mass indifference or bemusement that greeted the Beats could not be repeated in our own day. Thanks, largely, to the Beats themselves.

What accounted for the Beats' rejection by the mass culture? Obviously, first of all, they were "different," vastly so, and in the late 1950s many of us still believed that the job of changing the world was difficult enough without entrusting it to someone who seemed uninterested in meeting his fellows halfway. Second, they were "anti-intellectual" at a time when the so-called intellectuals were having troubles enough already, when every gibe at Adlai Stevenson had been a gibe at them all. It never occurred to the intellectuals, of course, that perhaps there was something to be said

for the view that they had become too precious and bloodless for anybody's good, but that is not surprising. When the wolf is blowing your house down, you don't question whether you should be there.

And finally, we believed in some kind of artistic order back then—in two senses. We believed that the artist's mission was to make order of chaos, and where in that *schema* could one fit the Beats and their messy poetics, their novels written nonstop on rolls of wire-service copy paper? And we believed in the orderly progress of art through the ages as well. In fiction, in poetry, in drama, we had learned lines of descent from the beginnings to the present—lines clearly anchored in the European tradition. (It is worth noting that *By Love Possessed* and *Look Back in Anger* both lie smack in the middle of the tradition.) The Beats, obviously, didn't fit —or at least we didn't think they did, for the newness of their form blinded their critics to the honorable tradition of their content.

Which was, as Bruce Cook points out, a distinctly *American* tradition, conveying a sense of the power, the vastness, and the promise of this land as no one had since ... well, since Whitman. It was a sense that spat in the face of parochialism—and that, I think, is the key if obvious point. It is probably no coincidence that while Bruce was born and educated in the Midwest, I was born and educated in the East, for the dismissal of the Beat Generation was probably the last major victory of the so-called Eastern literary establishment. It was a hollow and temporary victory, of course, for the Beats rode it out, and today their successors have the Establishment on the run.

Well, the point here is that because the Beats did stick it out and influenced others in their turn, very little of these attitudes survives today. We no longer uncritically revere the "intellectual" at the expense of less

sophisticated kinds of wisdom, and we cannot reject the "different" without rejecting our own children. If we still believe in "order" as the goal of the artist, our definition of it is miles broader than it was a decade ago. And most of all, the very contentiousness that the Beats set in motion has given many of us a new respect for the whole of our troubled but still infinitely redeemable country, for the traditions that are uniquely ours.

For all this, the Beats deserve our thanks. And now, if you will forgive me, I think I'll go read *On the Road*. I suspect it is high time.

—CLIFFORD A. RIDLEY

September 1971